PROGRESSIVE PRINTMAKERS

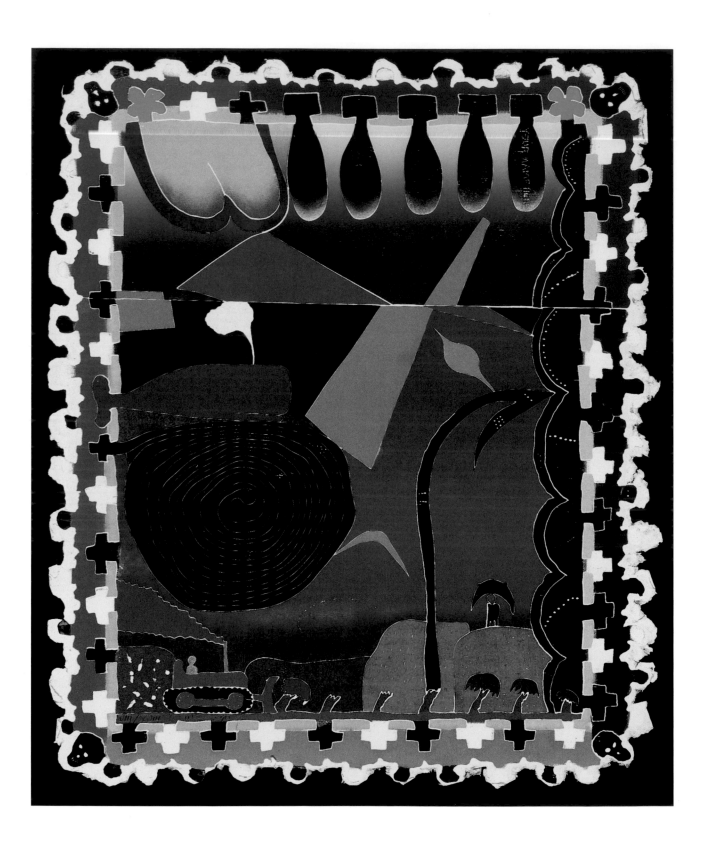

PROGRESSIVE

PRINTMAKERS

Wisconsin Artists and the Print Renaissance

WARRINGTON COLESCOTT & ARTHUR HOVE

The University of Wisconsin Press

The University of Wisconsin Press
2537 Daniels Street
Madison, Wisconsin 53718

3 Henrietta Street
London WC2E 8LU, England

5 4 3 2 1

Printed in Canada

Library of Congress Cataloging-in-Publication Data
Colescott, Warrington, 1921 —
 Progressive printmakers: Wisconsin artists and
the print renaissance / Warrington Colescott,
Arthur Hove.
 236 pp. cm.
 Includes bibliographical references and index.
 ISBN 0-299-16110-2 (cloth: alk. paper)
 1. Prints, American—Wisconsin—Madison.
2. Prints—20th century—Wisconsin—Madison.
3. University of Wisconsin–Madison. Dept. of Art.
4. Tandem Press. I. Hove, Arthur. II. Title.
NE538.M33C65 1999
769.9775'83—dc21 98-51818

Frontispiece: *Your Name Here* by William Weege

To Frances and to Norma

CONTENTS

This book is the product of one of those chance encounters—not quite a "Eureka!" moment, but at least a measurable jump on two personal Richter scales. It was one of those instances when thoughts and ideas that have been rattling around in the subconscious for decades suddenly come spilling out.

The occasion was an otherwise drab mid-March afternoon in 1994. I met with Warrington Colescott in the Rathskeller of the Memorial Union at the University of Wisconsin–Madison to interview him for a short feature article to be included in the university's *DepARTment Newsletter!*[1] I had had a passing encounter with Colescott in the 1960s when I, as editor, had asked him to contribute a statement for a special section of the *Wisconsin Alumnus* magazine.[2] We exchanged pleasantries as I gathered the information for my article, a piece stimulated by the fact that Colescott had recently received his fourth individual artist grant from the National Endowment for the Arts.

As we were preparing to leave, I mentioned to him that I had originally enrolled at the university as an art student in the fall of 1952. Although I had subsequently transformed myself into an English major by the second semester of that academic year, I had maintained an interest in the university's art program, particularly its faculty artists. This interest had stayed with me through my undergraduate years and had continued in the background during a two-year stint in the army at Fort Gordon, Georgia. It had flared anew when I had returned to the Madison campus in the fall of 1959 to begin a career as editor, public information officer, and administrator. I said to Colescott that, throughout my exposure to the university art scene,

I thought there was something special about what had happened at Madison. He fervently agreed. We then mutually lamented the fact that this story had not been told to a wider public and decided that something should be done to rectify that situation; however, how could we get a handle on something that could be ineffable or confusing because of the richness and diversity of the experience? There had to be a focus, otherwise the story could simply be a potentially tedious chronicle of comings and goings. Colescott offered that printmaking appeared to be the most readily apparent thread running through the various aspects of artistic development at the university. This seemed to make sense. It revealed a steady fifty years of innovation and development from 1944 through 1994 and beyond.

Our major premise was that something significant happened in printmaking on campuses across the country following World War II. As James Watrous, whose chapter begins this book, had noted, "When World War II ended with the cessation of hostilities in the Pacific in 1945, many veterans of the Armed Forces used subventions of the GI Bill of Rights to enroll in all kinds of educational institutions during the next several years. Enrollments in art schools and the art departments of universities and colleges swelled."[3] As these returning veterans became more deeply entrenched, the pattern of art instruction began to change. Studio artists replaced faculty members who had previously trained future teachers of art. Like the "intellectual marines" capturing a trend in W. H. Auden's poem "Under Which Lyre," artists filtered into academia to set up what became permanent residency. The presence of practicing artists who regularly exhibited their works promoted a change both in the type of students who enrolled for art instruction and in the makeup of the curriculum and the degree requirements. In the research universities that emerged in the fifties and sixties, the artists' works represented a new and important form of scholarly inquiry.

Actually, the University of Wisconsin had been a pioneer in opening the campus to artists. The noted regional artist John Steuart Curry accepted a position to be the artist-in-residence in the College of Agriculture in 1936.[4] He was given the opportunity to pursue his own work but also was expected to serve as a catalyst in promoting the rural art program envisioned by Dean Chris Christensen. Curry held the position until his untimely death from a heart attack at the age of forty-nine in 1946. The commitment to maintain an artist-in-residence continued with the appointment in 1948 of the Chicago artist Aaron Bohrod to fill the vacancy.[5]

The story of the dramatic shift in academic emphasis from teacher education to teaching studio arts is an interesting and dynamic one; however, it is not the detailed focus of this book. Colescott and I agreed in our initial conversations about the project that primary emphasis should be on the art that was and is being produced as a natural outgrowth of the changes that occurred in the program. We knew the prints would speak for themselves. We also selected representative printmakers who would have an important story to tell. The resulting narratives would include impressions about the university and

anecdotes relating to the official actions and informal relationships that characterized the period when each artist became a member of the faculty. The artists' stories would include information about technical challenges they faced and innovations they made in the various printmaking media along with thoughts about teaching and instruction. Finally, their personal reflections would elicit information about the form and substance of the art they make in response to the time and place in which they create. Fortunately, all of the artists, with the exception of Alfred Sessler, were still alive and actively making art.

With the assistance of Barry Teicher, of the University of Wisconsin–Madison Oral History Project, we began a series of taped interviews in the fall of 1994. The interviews contained in the "Galleria" form the core of the artist-profile section of this book. The interviews were conducted on the Madison campus and in the studios of the artists. The resulting tapes constitute a rich archive that offers valuable information about the university, the cultural environment, and the process and creative decisions involved in making art.

We recognized from the outset that, in addition to conducting interviews, the Wisconsin experience had to be placed in a larger context. We were fortunate to have our mutual friend, the artist and art historian James Watrous, provide that overview. Sadly, James Watrous died on May 25, 1999, at the age of 90, as we were in the final stages of preparing the manuscript for the press. We will greatly miss this distinguished artist, scholar, teacher, and university citizen.

Colescott offers an additional perspective through his own remembrances and his discussion of the faculty artists, graduates, and visiting artists who have contributed to the fifty years of artistic development. With assistance from Andrew Stevens, curator of prints and drawings at the university's Elvehjem Museum of Art, he explains how Tandem Press became an extension of the printmaking activity that began on the Madison campus in the 1940s.

As we neared the end of fathering the raw material for this book, Colescott and I agreed that what we had collected provided a gratifying reinforcement of our original and perhaps jingoistic premise. There is something special about what happened and continues to happen at Wisconsin.

A. H.

ACKNOWLEDGMENTS

Like print publishing, the preparation of the manuscript and illustrations for this volume has been a collaborative project. We have many individuals to thank for their advice and counsel. Foremost is Barry Teicher, director of the university's Oral History Project, who provided the technical expertise in the conduct of each of the recorded interviews with the eight living artists included in the "Galleria." Photographer Greg Anderson also played an essential role, creating color transparencies for the majority of the prints and related work reproduced in this volume.

William Bunce and Tracy Honn read portions of the manuscript at various stages. Others who assisted in numerous ways include Paula Panczenko, Andrew Stevens, Misch Kohn, John Wilde, Theodore Wolff, Karen Sessler Stein, Andrew Balkin, John Ross, and Sylvia Solochek Walters.

Pam Richardson, registrar of the Elvehjem Museum of Art at the University of Wisconsin–Madison, was particularly helpful in making appropriate works of the collection available for photographing and reproduction. Senior editor Scott Lenz of the University of Wisconsin Press provided professional guidance and patience in the implementation of editorial and copy improvements. Designer Kristina Kachele created an attractive format to highlight the text and the artists' works.

Finally, we are particularly grateful to the trustees of the Brittingham Fund, Inc., who provided a generous grant to assist in the preparation and publication of this book.

PROGRESSIVE PRINTMAKERS

PRINTMAKING AT WISCONSIN

An Era of Excellence

JAMES WATROUS

In 1940, no one in America foresaw that printmaking in this country would soon flourish as never before. There was not a single portent that American printmaking was about to assert world leadership for the rest of the century. Moreover, in the early forties, no one could have imagined that a remarkable array of resources for the practice and appreciation of printmaking—creative, technical, and scholarly—would be added to the academic commitments of some American universities, expressly so at the University of Wisconsin in Madison. These were astonishing developments in printmaking, and the individuals who participated during those decades—artists, printers, curators, scholars, and dealers—now recall them as great artistic ventures.

Prior to 1940, printmaking in America had a minor place among the arts. Only now and then did it seem noteworthy, as in the late nineteenth century during a flurry of etching activity led by Joseph Pennell and Thomas Moran; during a decade of successes in lithography and etching by George Bellows, Edward Hopper, and some contemporaries in the 1920s; and during the production of hundreds of thousands of "prints for the people" created under the auspices of the Federal Art Project in the Depression years of the 1930s. Joseph Pennell had been a tireless advocate for an American school of graphic arts.[1] In the mid-twenties, he took over the instruction in etching at the Art Students League in New York City and persuaded the school to hire Charles Locke, an artist-lithographer, and Allen Lewis, a master woodcutter-illustrator. The program must have seemed extensive when compared to those at other professional art schools and at universities during the early years of the twentieth century.

The scant attention to printmaking at the University of Wisconsin was typical. Throughout the thirties, only a single, one-semester course introducing both etching and block printing (linoleum block) was offered. An ill-advised change was tried in 1934 when, for the first half of the semester, lithography was substituted for etching. It was a disastrous printmaking venture. The instructor was inept; the metal plates were printed on an etching press while, unknown to the students, a lithographic press and stones were sequestered

under an obscuring tarpaulin. Fortunately, printmaking at Wisconsin would have better advocates in the 1940s.

Meanwhile, during the thirties, many American artists working on the Federal Art Project had been encouraged to create prints and to experiment with all kinds of media, old and new. Consequently, there was a growing awareness of creative opportunities in the art. Jacob Kainen, one of those artists, recalled a subsequent stimulus: "When Stanley William Hayter came to this country in 1940 to open his experimental [printmaking] studio, Atelier 17, he found the artists ready."[2] The famous intaglio workshop, which Hayter had moved from Paris to New York during World War II, provided a printmaking center for illustrious artist-émigrés who had fled Europe and a place for heady adventures in unconventional printmaking for young Americans.

Even less foreseeable were the lively developments in printmaking at American universities, especially with the appointments in the mid-forties of Mauricio Lasansky at the University of Iowa and Alfred Sessler at the University of Wisconsin. Lasansky was an accomplished printmaker in Argentina when he was awarded a Guggenheim Fellowship and traveled to New York City in 1943. During the next two years, he exhibited widely, worked at Atelier 17, and had his acclaimed engraving *Doma* (1944) included in Hayter's exhibition "New Directions in Gravure" at the Museum of Modern Art. The following year he accepted a professorship at Iowa and established the intaglio workshop, which became influential through its graduates who initiated similar programs at many other American universities. Lasansky was a charismatic advocate of intaglio techniques and avant-garde conceptions of form and content. The spirited prints he and his students created led to an exhibition at the Walker Art Center in Minneapolis in 1949. It was not unlike Hayter's Atelier 17 exhibition in New York five years earlier and bore a somewhat similar title, "A New Direction in Intaglio."[3]

Alfred Sessler, who had developed his skills in lithography on the Federal Art Project and, as a young artist in Milwaukee, through his acquaintance with Robert von Neumann, a German-born and -trained master of both lithography and woodcut, was appointed an instructor in drawing and printmaking at the University of Wisconsin in 1946. His assignments included teaching the only course in printmaking and presenting the semester introduction in Etching and Block Printing. Soon thereafter, he added instruction in woodcut, wood engraving, and lithography, the last his favored medium at the time. Sessler's skills as a technician, his talent as a teacher, and his willingness to be a devoted mentor to gifted young printmakers created an exciting artistic environment within the art department. Warrington Colescott recalled the atmosphere in Sessler's workshop when he arrived at Wisconsin as a young instructor in 1949: "The print studio was a frenetic phenomenon. There were graduate and undergraduate printmakers, and Sessler had them charged up. The presses turned and clattered all day and night. All print techniques were taught. Sessler thrived on this atmosphere, building a teaching structure that mixed follow-my-lead with free-flight zones."[4]

Sessler, unlike Lasansky, was an advocate of all print media, each with its distinctive creative and technical resources. Thus, he was preparing the foundations for many kinds of ventures in printmaking at Wisconsin during the next half century, initiatives that led to an exceptional center of printmaking on the Madison campus. Among them was the gathering of a superb faculty of artist-printmakers, each with his or her special talents and skills in one or another medium. Visiting printmakers from across the country joined the faculty for short or extended stays and compounded the resources of the program through their lectures, instruction, demonstrations, and experiments.

Sessler would share only the initial successes of the thriving program due to his untimely death in 1963. His two decades at Madison had been exceedingly fruitful, both in developing resources for young printmakers and in producing his own creative work. In the earlier years, he created superbly drafted lithographs and etchings bearing compassionate images of the less fortunate of our society—laborers, charwomen, and scavengers. By the late fifties, however, Sessler was creating complex and colorful woodcuts based on fragments of nature with symbolic and expressionistic content, for example, his *Knight Transfigured*. They were among the brilliant, innovative works by American artist-printmakers who, during the fifties and sixties, produced a spectacular pageant of color woodcuts.

A new medium for creating fine prints grew out of the adaptation of the screen printing of lettering and designs on posters, pennants, bottled drinks, and other consumer products. In the late thirties, under the leadership of Anthony Velonis on the Federal Art Project in New York, silk-screen printing was explored as a fine-art process. By 1940, a small exhibition of screen prints was presented at the Weyhe Gallery as an "Exhibition of New Color Prints in a New Creative Medium." For the show, Carl Zigrosser, curator of the gallery, coined the word *serigraphy* [drawing on silk] for the process, a term thereafter used interchangeably with *silk-screen*.

Throughout the forties, American artist-printmakers continued to explore the creative resources of serigraphy. They were joined by young advocates of the medium at Wisconsin. Dean Meeker, a new faculty recruit in 1948, had worked in a commercial silk-screen shop while he was a student at the School of the Art Institute of Chicago. When Meeker arrived in Madison, a few students persuaded him to teach them the basics of screen printing in a series of ad hoc, noncredit, after-hours workshop sessions. The enthusiastic responses to the experience led the art department to add an accredited course in serigraphy in 1951.

In 1951, Meeker's own screen prints were beginning to gain national attention and honors. They revealed an unusual sensitivity to the inherent coloristic nature of serigraphy among print media and the remarkable flexibility it lent to infinite kinds of draughtsman-like and painterly effects. They were features wonderfully adaptable to the symbolic imagery of *Don Quixote* (1951) and other early, award-winning serigraphs by Meeker and to a

boldness of design and color for his mythical, legendary, and biblical subjects in such prints as *Icarus, Trojan Horse*, and *Tower of Babel*.

In a period when venturesome American printmakers were testing techniques in all media, Meeker was continually seeking new processes of screen printing that would enrich the imagery of his striking figures. His experiments eventually led to an additive/subtractive process of polymer-intaglio/screen prints that created deep embossments, richly tooled and textured surfaces, and variations of opaque and transparent colors. Often the effects were gloriously arrayed, as in the re-creation of *Joseph's Coat* (1965). Meanwhile, Meeker's innovative works and teaching would be complemented by the serigraphs of other young faculty members at Wisconsin—Warrington Colescott, Robert Marx, and later William Weege—who also were creating award-winning prints.

American artists who first adopted the medium of screen printing sought to replicate the effects of pictorial landscape and genre painting. Lamenting their conservatism, Dore Ashton, a leading art critic, wrote that "the serigraph has had a hard time coming of age as an expressive graphic vehicle."[5] However, she "was struck by the encouraging departure from convention" shown in a few serigraphs exhibited in "Young American Printmakers" at the Museum of Modern Art (1953) and the "8th National Print Annual" at the Brooklyn Museum (1954). Her compliments were for the colorful, experimental, and semi-abstract compositions found in Colescott's *Magdaleni I*, Meeker's *Trojan Horse*, and Marx's *Migrant*.

Colescott, trained at Berkeley, was appointed an instructor in painting at the University of Wisconsin in 1949; his printmaking was a supplementary venture. The semi-abstractions of his serigraphs were tempered by social commentaries, as in *Atom Boy* (1949), harbingers, however, of the satire that would spark the content of his later graphics. In the mid-fifties, Colescott was introduced to the fundamentals of etching by his senior colleague Sessler. The responsiveness of the medium to Colescott's conceptions led him to seek further tutoring, and in 1956–1957, on a Fulbright, he went to London to work with Anthony Gross at the Slade School of Art. Upon Colescott's return to Madison, Sessler suggested that Colescott take over the instruction in etching and continue his experiments in all of the intaglio media, especially color etching.

By the mid-sixties, Colescott's adroitness in draughtsmanship was matched by his skills in satirical commentary on the failures and follies of contemporary society and its institutions. A free-wheeling wit, combining fact with fantasy, began to emerge in *Dillinger: The Battle of Little Bohemia* (1963) and *Christmas with Ziggy* (1964).[6] An admirer of the great satirists of the past—Goya, Daumier, Gillray, and Grosz—Colescott, as had they of the myths and mores of their societies, ridiculed or hilariously spoofed the "histories" and absurdities of American life, from *The First Thanksgiving* (1973) to *Meanwhile . . . underneath the Oval Office* (1987).

The reputations of Sessler, Meeker, and Colescott were spreading in the fifties as their woodcuts, lithographs, etchings, and serigraphs received innumerable honors and awards at regional and national exhibitions. With those successes came a growing commitment

to the printmaking program at Wisconsin, a commitment affirmed after Alfred Sessler's death by the appointments of Raymond Gloeckler to teach woodcut and wood engraving and of Jack Damer to expand the offerings in lithography.

Even before the printmaking program began to expand in the art department under the leadership of Alfred Sessler, the university had undertaken other uncommon ventures in the study of fine prints and their history. In 1937, Wolfgang Stechow, a distinguished art historian from the University of Göttingen, joined the faculty of the art history department. He introduced both lectures on the history of European prints and graduate seminars on such master printmakers as Dürer, Rembrandt, and Goya. These were new and stimulating studies for students at Wisconsin. I was among Stechow's pupils, and prints and drawings had a singular appeal for me. When Stechow accepted an appointment at Oberlin College in 1940, I, then a young instructor in art history, took over the teaching of Master Prints and Printmakers of the Western World and, in later years, created such additional courses as Modern Prints and Printmakers and the History of Satire in Prints. I further encouraged research by graduate students on contemporary American printmakers. Thus, there emerged unusual kinds of studies that complemented the enthusiastic practice of printmaking at Madison.

For over three decades (beginning in 1939), I was an advocate and planner for an art museum on the Madison campus, a goal that was reached with the opening of the Elvehjem Museum of Art in 1970.[7] In 1952, with a long-range plan for a museum, the art history department began to build a collection of master prints that would trace European printmaking from its origins in the fifteenth century to the present, as well as the great periods of Japanese woodcuts. The prints were acquired as gifts or purchased through private funding and initiated the Elvehjem's eight-thousand-print collection, now one of the largest and richest among American university museums. Those developments, along with the activities in printmaking, were creating an unusual environment for the creation and study of the printmaking arts.

American prints from wood had an astonishing revival during the 1950s and 1960s, notably publicized by the woodcuts of Antonio Frasconi, Leonard Baskin, and Alfred Sessler. Consequently, Sessler's death in 1963 was a blow to the print program at Madison. Nonetheless, the continuation of a strong program in relief printing was guaranteed by the immediate appointment of Raymond Gloeckler. One of Sessler's former students, Gloeckler was a master woodcutter and a superb wood engraver. His skills produced the beautifully wrought chiaroscuro woodcut *Hornblower* (1980), the finesse of wood engraving in *Big Biker* (1971), and the virtuosity of the illustrations from wood for *The Horny Goloch* (1978), an award-winning book. Most of Gloeckler's prints had satirical asides about the absurdities of American life, especially the frailties and follies of political leaders during those troubled times. The wit and humor of Gloeckler's prints, distinctive as they were in style and temperament from the satirical and social commentaries of Sessler and Colescott, complemented the satirical inclinations of his colleagues at Wisconsin.

As printmaking became a major American enterprise in the 1950s, there was a growing concern about the scarcity of competent lithographic printers. To remedy the paucity, the Ford Foundation provided funds in 1960 for the founding of the Tamarind Lithography Workshop in Los Angeles. Its master printers soon lent their skills to the many emerging print workshops. Meanwhile, at Wisconsin during the forties, fifties, and sixties, the succession of Sessler, Gloeckler, and Damer ensured a continuity and strength in lithographic printing.

Jack Damer, a graduate of Carnegie Mellon University, joined the faculty in 1965. He had been inspired to explore lithography by Robert Gardner, an instructor who had experienced the innovative printmaking at the Tamarind Lithography Workshop in Los Angeles. Damer's role, as a leader in lithography at Wisconsin, was to introduce technical innovations of the time, especially adaptations of photo-lithography and experiments in mixed techniques, as used in his *Blacky Carbon's Nemesis* (1968). His own work evolved through color lithography to three-dimensional constructions of printed, cut, folded, and bonded strips, as in the Exacto Facto series. They were ingenious and as aesthetically appealing as spatial prints; in some were the attractions of the sly humor found in *High Roller* (1994), a lithographic printing with color variations on the rippling slats of a bamboo window shade.

Year after year, beginning in 1946, the print program exceeded its expectations regarding necessary studio space and equipment. At last, in 1969, the newly completed quarters for the art department in the Humanities Building provided each medium with its own shop, storage space, and office with adjacent exhibition walls in the public spaces flanking the studios. These accommodations paid tribute to the excellence of the program and were unmatched at any other American university.

During the 1960s and 1970s, the conventional perimeters of American printmaking were being breached by endless explorations in techniques and materials and media adaptations, combinations, and innovations. They were exciting years when like ventures were initiated by the printmakers at Wisconsin, most tellingly in the limitless innovations of "printed things" from the hand of William Weege. His early prints, in the late sixties, were relatively modest in the technical exploration of silk-screen and photo–silk-screen, although dramatically declarative in their anti-war and anti-establishment satirical images and slogans, as in the ironic *All the Way with LBJ* or the series of twenty-five prints, Peace Is Patriotic (1967).

Weege exuberantly explored unconventional printings, inking almost any object that would transfer an image or mark to handmade, color-impregnated papers, which were cut, torn, sewed, or folded onto other carriers, such as the acetate discs for *Record Trout* (1976). The material and technical combinations seemed limitless, leading to innovative print production at his Jones Road Print Shop and Stable near rural Barneveld, Wisconsin. There, Weege was host to Alan Shields, Sam Gilliam, and numerous other visiting

American artists. The enterprise, in conception, prefigured the Tandem Press, later established in alliance with the art department of the University of Wisconsin–Madison.

The awards and honors that the university printmakers had gathered over the decades and the splendid reputations that they had established—nationally and internationally— were matched by younger recruits David Becker and Frances Myers, who at once replaced retiring faculty members and brought different aesthetics, techniques, and styles in their prints. David Becker, who had gained recognition as a master draughtsman while a professor at Wayne State University, was appointed to teach drawing and intaglio at Wisconsin in 1985. His etchings describing imaginary worlds, with subjective feelings and implied narratives, were consummate compositions, finely wrought with the etcher's needle and engraver's burin. He explained that the succinct blacks and whites of etching are compatible with "the sorts of images that I deal with. . . . Before starting, I wind up having a lot of great fantasies in my mind. . . . I hope I will be surprised by what comes out." Some are like morality plays, for example, the intaglio *In a Dark Time* (1973), which received a Gold Medal at the Museum of Modern Art in Cali, Colombia (1976), and was also chosen for the review of thirty years of American printmaking in the great retrospective exhibition at the Brooklyn Museum in 1976. It depicts a path and woods as settings for acts of callow youths, mocking the shrouded dead that lie within a thicket or in a burial case.

Frances Myers, with three degrees from Madison, joined the faculty in 1988. Before accepting the post, she had created prints in London and had taught intaglio in England. There she had begun to indulge her interest in Art Deco architecture. This was a prelude to even more notable translations of the art of architecture into the artistic compositions of printmaking, namely, her Frank Lloyd Wright portfolio of color intaglio prints, commissioned by Karen Johnson Boyd of the Perimeter Gallery in Chicago. The geometric essences of Wright's architectural forms were redesignable into compositions—one art evoking the creative redesigning for another in bold, abstract arrangements. More recently, Myers has explored the possibilities of xerox and color xerox combined with various other materials and techniques, old and new. Concurrently her symbols and subjects have reflected her homage to great women, past or present, typified by her 1992 print *St. Teresa's Seventh Mansion*, which celebrates the life and visions of the seventeenth-century mystic and founder of innumerable Carmelite convents.

During the seventies and early eighties, the innovative "printed things" that were created at William Weege's Jones Road Print Shop and Stable led Weege to the belief that a similar experimental enterprise would be an enrichment of the printmaking program at the University of Wisconsin–Madison and for visiting artists, faculty, and students alike. Thus, with his considerable foresight and persuasion, the Tandem Press was established under the aegis of the art department in 1987 with Weege as its first director.[8] In a commodious old warehouse on the east side of Madison, Tandem flourished with its splendid presses, accomplished printers, and other skilled personnel. An invitation to be a visiting artist and to create a print edition with the help of a superb technical staff was

coveted. More than one hundred artists had their prints editioned and published at Tandem during its first decade of operation.

The Tandem Press is the most recent benchmark of the continuing commitment to printmaking at the university. It has been a commitment renewed again and again during a half century when printmaking flourished in America as never before. It is a commitment that has ensured the university's unique leadership in the art.

POSTWAR PRINTS

A Memoir from a Player

WARRINGTON COLESCOTT

In 1947, fresh from graduate school at the University of California, Berkeley, I was teaching design and certain esoteric branches of the visual arts at Long Beach Community College in California. It was Christmas, and I wanted to make my own cards, as befit a young, ambitious artist. A colleague, Fred Heidel, with degrees from the School of the Art Institute of Chicago and therefore privy to the working-class disciplines denied to a Berkeley art major, suggested silk-screen. This proved to be a way to print little colored images in editions. Heidel showed me how to make wooden frames and to stretch finely meshed silk over them, to create stencils on the silk, and to force thinned paint through the open areas with a squeegee onto paper. The process could be repeated over and over; furthermore, when the paint dried, prints could be overprinted with additional stenciled images. I got my Christmas cards, and as a further bonus I got printmaking, which entered my repertoire, pleasing my graphic sense, which had heretofore fed itself with illustration, political satire, and cartooning whenever I wandered beyond painting. Two years later, tiring of the monotonous Greater Los Angeles sunshine and the routine of sending students in lockstep on to UCLA/Disney/Lockheed or career surfing, I accepted a job at the University of Wisconsin. I arrived in Madison with printmaking as part of my baggage.

I joined the faculty of a department convoluted with growth, in a crowded little city, and a shifting situation. A cadre of art elders were being pushed, protesting and fighting tooth and nail, to retire. A hurly burly of new hires were competing for future position and power. I joined a young faculty growing in number, marked by energy, talent, and ruthlessness. They had been hired quickly and roughly and came from backgrounds as diverse as Cranbrook, Berkeley, the School of the Art Institute of Chicago, and Iowa City, but by some blessed chance, they shared an ability for high-quality art production in their various specialties. Teaching loads were heavy, and the work with graduate students was intense, driven by an over-populated student body made up to a large degree of GI Bill veterans, out of the service at last, playing catch-up with their lives, ranging from those who had held astounding positions of authority to poor sods half broken by war prisons

or debilitating wounds. It was a student body that made demands. We as new faculty were their intimates. We formed close social ties with our veteran students; we had come from the same experiences, and our response helped make university teaching in the fifties a unique period in higher education.

My responsibility was to teach painting and drawing, but in my own studio work, serigraphy captured more and more of my attention. I completed a dozen or so editions, exhibited copies of these in competitive national exhibitions, and formed a certain rapport with department colleagues Dean Meeker and Alfred Sessler, who taught courses in printmaking. Sessler had a small room in the Journalism Building, crammed with second-hand presses and equipment given to him by letterpress and lithography printers who were converting their businesses to incorporate the new offset technology. The prints coming out of Sessler's studio were exciting to me, although I had trouble with some of the stylistic elements and the subject emphasis, which seemed sentimental. I had a strong sense of conceptual propriety that was being assaulted in Madison by work coming from a regional culture far removed from my own. It was a sign of the times that art was in a ferment of competing directions.

One healthy aspect of the Madison art faculty was that we all drank beer, and were thus able to talk to one another. We shared exhibitions and students and made many inter-studio visits for talk and argument and viewings of works in progress. There were statewide juried shows. Artists from all over the region attended the openings, socialized, and competed for little dollops of cash, ribbons, and art-material prizes. I became acquainted with the Milwaukee group, the Beloit people, and even a few frost-bitten survivors from places like Green Bay and La Crosse. I began to recognize some of the sources that made the art of the state so different from the West Coast—the Milwaukee art community still retained close ties to the traditions of northern Europe, and the social concerns expressed in the Works Progress Administration projects that had kept so many of the regional artists alive during the Depression were still pertinent. The dark, ferocious humor and fantasies of some of my colleagues became more decipherable and even attractive.

The print ambience in the department created a lively, productive atmosphere. Meeker's class in serigraphy was well attended and influential. Primarily, I taught painting, but in 1953 I took a break and went to Paris on the GI Bill to spend two years at the Académie de la Grande Chaumière, where I set up my easel in a corner of its Colorossi studio. I was part of the studio's American group (with Frank Lobdell and Walt Kuhlman, from San Francisco), which coexisted with a French group of nonobjective painters, whose attendance was spotty, though they never missed the monthly visit of their mentor, the fearfully abstract Victor Vasarely. I attended the life-drawing class at night (no instruction, just a lovely nude model who timed and calculated her own poses) and ended most evenings with a late glass at Le Select or Le Dôme, often with the Berkeley poet Carlyle MacIntyre. Madison grew faint in my mind, but I found that I began to miss making prints.

I met Sam Francis, who shared my background in painting at Berkeley and whose army

disability payments allowed him to remain in Paris. His wife's small studio on the edge of Montparnasse was unused, so I rented it from him and proceeded to set up a serigraph studio. I built my own equipment and was soon screening editions. Money was tight, particularly toward the end of the month, so I put one of my editions, a fine view of Notre Dame cathedral, into various shop windows down on the quai, assuming I would reap a bonanza from tourists. It was a bitter lesson. I did not sell one. It was the last time I ever designed a piece of art to sell. (I swear!)

The Swiss artist Alberto Giacometti had a sculpture studio on the ground floor of my building. He was definitely a workaholic, and his production of large, thin figures with one foot forward in the Egyptian mode would often be pushed out of his crowded studio into the shared hallway that led to my stairway. It was particularly troubling to come in at night, to turn on the *minuterie* light, and to find the hallway filled with huge, tomb-like grotesques. More than once, I had to rush careening through them to my stairway before the minute of light would expire and I would be in total darkness, trapped with Giacometti's lacerated troops. In 1955, bruised and broke but with a roll of canvas and cartons of prints, I returned to Madison. The momentum in my work had definitely shifted from painting to prints.

The Wisconsin print scene was flourishing. Sessler's and Meeker's classes were popular, and graduate enrollment in print classes was climbing. The three of us were reaching out in our work, forcing the process to do more, experimenting with techniques, finding ways to work larger, to be bolder in color, taking chances and gambling on the outcome of editions. Part of my contribution was to be adventuresome in the selection of printing papers. An importer of Chinese tea in Chicago traded me the last shipment of tea-chest paper (large sheets of gold and silver leaf adhered to fragile rice paper) that he would receive from his sources in China. It was exquisite paper, and I printed a six-color serigraph edition on it, half expecting the paper to disintegrate under the force of the squeegee. Instead, it held up and took the ink nicely; the luminosity of the leaf glowed through my color design and made an extraordinary print. I still have a copy, forty-five years later, as fresh and exact as the day I printed it.

Dean Meeker and I and a new department hire, Robert Marx, exhibited with and were members of the National Serigraph Society, founded in the thirties by remnants of the Works Progress Administration silk-screen workshop and its director in New York, Anthony Velonis. The society had acquired a gallery on Fifty-seventh Street and, under Doris Meltzer, had a program of exhibitions and presentations in the new medium. The society eventually became my gallery representation in New York, showing my work regularly, in groups, and, ultimately, after becoming the Serigraph Gallery, in a solo show of prints and painting that received fine reviews in the *New York Times* and national art magazines. Once every year, *Art in America* featured young artists in a "new talent" issue. In 1960, I was one of the printmaking selectees. My etching shared the page with the year's other printmaker, Andy Warhol.

The expansion of my repertoire to include etching had been encouraged by the richness of the print productions of my colleagues in Wisconsin, particularly by the work that Sessler was doing as he moved from lithography to color woodcut. He developed an amazing process of color-reduction printing—cutting from large planks of pine or sheets of birch plywood an initial design, printing that state in full edition, and then further cutting and overprinting in a range of color until he was satisfied and the original wood was reduced to a few fragments of surface. He literally gambled his entire edition on this phase by phase improvisation. When I mentioned to Sessler an interest in etching, he at once offered to show me the basic plate-making techniques. After making a small plate and printing it under his guidance, I looked at the impression coming out from under the rollers of the press and said the words I would hear from beginning students through the years, "You mean to get another copy I have to ink it *all over again?*"

In 1956, I received a Fulbright grant to study at the Slade School of Art, University College London, with Anthony Gross, dean of English etchers. My introduction to the Slade School was a quiet session with my tutor, William Townsend. He took a bottle of sherry from his desk and over small glasses explained the drill. I was to come in once a month for a tutorial session with him. I would work with Anthony Gross, who was "at school" two days a week. There was one other "foreign student," and we were encouraged to wear our "native costume." He smiled. "In your case I suppose it's blue jeans."

The year at Slade was one of the best experiences of my life. Gross was the perfect mentor for me at that period. He was immensely knowledgeable in prints: technique, history, current activity, and the rich lore of myth. At that time, all Slade students were majoring in painting and sculpture but were required to do a certain number of hours in a print minor. In reality, this meant that young men and women would dash into the etching shop at odd hours and hastily scratch away at a wretched little plate. After a short time, they would bang it into a storage locker and disappear into the sculpture studio. Gross was bored with this routine and, as a consequence, lavished his skills and print erudition on his two foreign scholars, myself and Bartolomeu Dos Santos from Portugal,[1] who eventually would follow Anthony Gross as etching instructor at Slade and who has remained a lifelong friend. Clearly, methodically, Gross took us through the whole litany of possibilities of making marks on a plate and transferring those marks to paper.

Slade was casual and without pressures, and the neighborhood held marvels of all kinds. Professor E. H. Gombrich lectured on Saturday mornings, focusing his commentary on a single object in the British Museum, which was around the corner and across the street. I found his discourse fascinating and would leave the lecture hall each Saturday and rush to the museum to go over my notes with the actual art work in view.

My rapid progress with etching made me a favored pupil of Gross, and he arranged a number of interesting opportunities for me. He sent me to the Courtauld Institute[2] to meet the director, Sir Anthony Blunt, and to see the Van Goghs that were hanging in his office. Blunt was extremely cordial, and we had a long conversation about my reactions

to London and about American abstract expressionism (was the famous spy drawing out secret information?). There was a brief rundown on the two Van Gogh canvases that suffused his office with color, and he advised me to visit San Remy when I had the chance and to see the collections in Paris. I have often thought of my friendly meeting with this composed and articulate gentleman as the details of his double life were revealed years later.

Most important, Gross introduced me to Birgit Skiold, a young Swedish woman who ran a small printmaking workshop in Charlotte Street. I worked there those days that I was not attending Slade, and she became a friend. The cost to work in her shop was about a shilling an hour, roughly a central London parking-meter charge. That crowded little suite of basement rooms contained all of the pleasures of community, which has always been one of the attractions for those of us who do prints. Birgit's basement drew a spectrum of artists, dealers, critics, teachers, and hangers-on who made up the British printmaking scene. Some of Birgit's "chums," who regularly came down the basement steps, were David Hockney, Michael Rothenstein, Julian Trevelyan, John Coplans, Anthony Harrison, and Jennifer Dickson, among the most interesting print artists working in London. Many of these artists would respond to my future invitations to visit and lecture in Madison.

Etching, particularly etching in color, began to dominate my work when I returned to Madison after my Fulbright year. Sessler was undergoing a similar reformation, and he proposed that I teach his intaglio classes so that he could concentrate on a range of classes in lithography and relief printing. I jumped at the chance. There was no extra space in the department, so we shared his teaching studio; three days were mine and two days and two nights were his.

The studio was a large basement room next to the sculpture studio. It was a noisy location, but not without its benefits. At some point, one of my etchers, Jay Yeager, also taking sculpture with Italo Scanga, had a plate that needed considerable erasing. This usually meant a long period of abrasing and polishing—a dreary chore. I saw Jay throw down his burnisher and take the plate into the sculpture room. He returned, grinning, and held up the plate triumphantly. He had removed the offending part with a cutting torch. I was astounded by the brilliance of his action. I honor Yeager as the initiator of the shaped plate, which became something of a Madison trademark and is a technique in common use by printers today.

In the sixties, the print program was riding high. Meeker, Sessler, and I had been invited by William Lieberman, then curator of prints and drawings, to participate in a major show at the Museum of Modern Art. The exhibit, showcasing the centers of printing activity in the universities, particularly in the Midwest, had a successful run in New York and then went on tour to European museums. In addition, the Whitney Museum of American Art did two biennial invitationals—one exhibit focusing on painting, the next on sculpture and prints. At one point I was represented in both biennials, which further complicated my internal dialogue about narrowing my media focus. The dialogue remained ongoing for about the next five years, finally to be resolved for me when I was

awarded a Guggenheim Fellowship in prints in 1965. Madison's print area was on a fellowship roll. Meeker had been granted a Guggenheim a few years earlier; Walter Hamady received one a few years later. Our status in the university surged.

In 1963, tragedy struck, unexpected and devastating. Alfred Sessler died. He was still a young man, with his career opening out before him, our leader in so many ways. His passing was an ultimate blow. We mourned. Eventually, we talked and considered, still being guided by Sessler's ideas. We finally replaced Sessler with two people.

Our idea was to set up a line of print studios, each specializing in one print medium. In addition, there would be studios for specialties closely related to printmaking, for example, photography, the book arts, and graphic design. Two superb artists joined us at this time: Raymond Gloeckler, an experienced teacher and artist who had studied with Alfred Sessler, and Jack Damer, a graduate in lithography from Carnegie Mellon in Pittsburgh. These hirings coincided with the imminent move of the art department into its new building, designed by a fine Chicago-based architect, Harry Weese, to fit our special needs and with room to grow; funds were available to outfit the studios with the latest equipment.

Harvey Littleton was department chair during this period.[3] He was in the midst of his research in hand-worked glass that was to make him an internationally known figure. An efficient manager and an imaginative and aggressive player of the university game, he had a fondness for the print process. He gave us special attention, although of course, his obsession was glass. Whatever project was being considered, Littleton thought it would be better in glass. His admiration for printmaking was not complete until he had originated a print process from glass plates. I printed his first "vitreograph" print on my Meeker power press. It was a sheet of quarter-inch plate glass, etched with muriatic acid, sandblasted, and drawn on with an etcher's diamond point as well as diamond-tipped power drills. This intaglio work was inked and then whirred through the pressure squeeze of my press from whence out came a mess of powdered glass.[4] A stubborn man, Littleton went back to the drawing board, and soon the process was workable. Today, Harvey Littleton's publishing workshop in Spruce Pine, North Carolina, is its most notable practitioner.

Littleton reorganized the art department into an area structure, perhaps to get even for my crushing his first glass plate. Initially the organization worked well, but eventually it would lead to conflicts and infighting between areas as the search for funds grew more competitive. In the sixties, as we anticipated the move into our new building, everything looked fine for the graphics area. We had our own chair, we evaluated our own graduate applicants, and our graduate program was constantly drawing in degree candidates of the highest promise. Outside grants and university research grants and leaves of absence given to our print faculty had increased. My belief, shared by my colleagues, was that time away from the department was good both for us and for the department. Replacement faculty, hired for a year or a semester, brought in new skills and ideas, new contacts and connec-

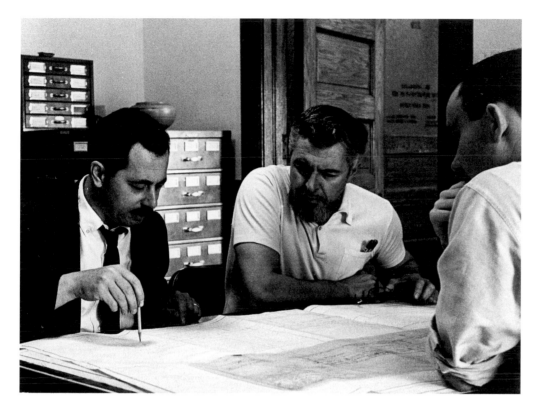

Warrington Colescott, Dean Meeker, and graduate student Richard Paynter in 1965 go over architect Harry Weese's plans for a new Humanities Building designed to house the School of Music, the history department, and the art department. The graphics area would occupy most of the fifth floor.

Photograph courtesy of Warrington Colescott.

tions; women artists were well represented and included Birgit Skiold from London; Jennifer Dickson, formerly assistant to S. W. Hayter in Paris; Frances Myers, who later was appointed to our permanent staff; and Claire Van Vliet, whose classes at the Philadelphia College of Art had impressed me during a visit. She replaced me during my Guggenheim year.

Claire Van Vliet is a marvelous artist and a force to be reckoned with. In her year at Wisconsin, she instituted new courses, secured funding for the equipping of new studios, and was instrumental in the hiring of two faculty members, William Weege and Walter Hamady, who would teach in the book and photo-process areas. This distinguished woman opened up new resources and possibilities for our area and then went on to a notable career, culminating in a MacArthur Fellowship in 1993.

Weege and Hamady developed in divergent ways, sometimes with overlapping interests in handmade paper, posters, broadsides, books, pamphlets, and printed ephemera. Weege's course in offset printing and photo–silk-screen merged media approaches and moved prints toward wider publishing arenas. Hamady's paper mill set in motion research that influenced the development of a new art field, handmade paper. Both men at times coordinated their efforts with the department's visiting-artist program, which at this time brought to the campus such major artists as Jack Beal, Wayne Thiebaud, James Rosenquist, and William Wiley for month-long residencies.

At this point, graphics offerings at the University of Wisconsin–Madison covered the

total range of possibilities in the print field. Graphic design, computer technology, and photography became part of this mix. Schematically, the graphics area could be compared to a train, with a line of specialist studios, entryways linking the units fore and aft, a plan ideal for individual projects or for collaboration up and down the line. The result of this arrangement and the conjoining of faculty inclinations spawned a mingling of media, the use of multiple and cross-over printing techniques, the exploitation of new print surfaces, and the enrichment of imagery through photo-derived resources. This approach became referred to as the Wisconsin print sensibility.

GALLERIA

Artists in academia are academics; artists in the research university are researchers. The graphics area of the University of Wisconsin–Madison through selection and accident in the period after 1945 amassed as faculty a remarkable group of artist/teacher/researchers, as both investigators and practitioners. The resulting group picture immediately dissolves into individuals—people who vary in height, weight, and muscularity. A lie detector or CAT scanner would reveal a great deal about the individual tested. Our instrument of choice, however, is the tape recorder, and we use it to bring our artists into clearer focus. We talk to our artists; we look at their résumés; we are very gentle, possibly a little devious. We discuss topics judged to be of interest, make jokes, lead them on. We visit their studios, get them to talk about their work, their methods, their tools, and their successes and failures. Through this process we gain a mass of material, tapes, and transcriptions. The result is a galleria, portraits of artists who made up a faculty at a particular time and place.

The taping sessions were conducted by Warrington Colescott, Arthur Hove, and Barry Teicher. They were conducted in various locations; in most cases, in the artist's work space. The profiles are based on the tapes and transcripts but are far from verbatim since the artists reviewed and participated in the editing of the initial drafts. Things were added and subtracted and memories were jogged with research bits from footnoted sources. The Sessler profile is based on a taping of his daughter, Karen Sessler Stein, plus reminiscences of his colleagues and former students. Material on visiting artists was obtained through interviews, both firsthand and through written questionnaires.

We felt it was important for the artists to review their tapes and to have the last word over the machine's speech. Artists, after all, walk a fine line, using themselves in ways that are difficult to trace or to display in a conventional biographical format. We promised the artists to write from an attitude of clinical probity, and we present the resulting summary in parallel with illustrations of their work, offering a chance to compare what they say and what they have done.

ALFRED SESSLER

Ethos and Ethics

In 1946, Della Wilson tired of teaching what passed for a printmaking course in the art education department at the University of Wisconsin. The techniques required were messy and vague; the students were unambitious; she had little interest in prints and, further, scented retirement coming closer. The course itself was a little bit of many things, with insufficient time to explore any of the bits in depth. Wilson decided to get out of it. In conference with her departmental executive committee, the decision was made to hire an energetic graduate student who had just received a master's degree in art education, a student whose dedication and production had sent a little thrill of fright through the senior staff—Alfred Sessler from Milwaukee. In the fall semester, he was hired as an instructor and assumed responsibility for the print shop, among other duties. It was quietly done; there were no fanfares, but the era of printmaking had begun at Madison.

In truth, Alfred Sessler was primarily a painter. As an undergraduate at the Milwaukee State Teachers College he had made some student-grade etchings and lithographs with Robert von Neumann, a noted lithographer. During his period on the Federal Art Project in the Depression years, he had mixed a few lithographs and etchings in with his painting and drawing production but specialized on the project as a mural painter. His real commitment was to art, and that had been determined long before. Born in Milwaukee in 1909, the son of immigrant Hungarian Jews, Sessler, encouraged by his parents, sketched and drew from an early age. His talents were fostered in high-school art and in classes at the Layton School of Art, his launching pad into the world of art that existed in that most

middle European of middle-western cities. He took a studio in a rundown center-city area and played a part in the tight-knit social and professional groupings that made up the artist community. He was a prodigious worker with a style shaped by the political themes of the thirties, but marked by originality from the beginning. Writing of an exhibition of Sessler's paintings of this period, the art historian John Kienitz said, "These are recollections of things seen, first hand experiences of the artist with the politically, morally, and socially lame, halt and blind. Sessler is a critic of . . . humanity made weak by pressures in the making of which it had no part."[1]

In the grip of the Depression, artists banded together under the saving umbrella of Roosevelt's Works Progress Administration and the Federal Art Project. Working with his peers, active and respected, Sessler made paintings and post-office murals from 1935 to 1942. His decision to return to school, to earn teaching degrees, was made after the war began, when he was rejected for military service for medical reasons.

As Sessler began tentatively to teach printmaking, the wartime troops were demobilizing. He tried to keep a step or two ahead of his students by practicing wood and linoleum cutting in the evenings.[2] Immense population shifts were occurring, and a flood of new applicants washed over the universities. The unimaginable expansion necessitated extra sections in most departments. New faculty were brought in. Madison filled up and overflowed. It was an environment that was stimulating to a creative, idealistic teacher like Sessler, and he rose to the challenge. The printshop was reorganized, additional equipment was ordered, a new course of study was developed, and a great teacher emerged. As his teaching developed, his interest in and attitude toward prints intensified, and his own production of prints became his primary activity. Sessler began to realize that prints were a superior voice for the ideas that were central to his interests.

There were many battlegrounds during the war years. Art had its skirmishes, victories, and defeats, just like the military. Sessler had absorbed the art of his youth: narrative, socially polarized, recounting moral tales in the form of visual parables. The themes dealt with social and racial injustice, the struggle of unions for better wages and working conditions, and the economic chasm between labor and capital. Sessler's symbols for these conflicting issues were figures—portrait heads, full figures, groups of figures—with simple props and minimal background development. The figures were positioned into class and work orientation by the use of costume and props, in a theatrical manner.

Alfred Sessler was a child of the crash of the post–World War I financial system, which led to the urban realities of unemployment and class struggle. The vigorous art that these conditions spawned was labeled social realism, which was a misnomer in Sessler's case, for he was anything but a realist. His stylized gnomic figures, with their exaggerated features, sometimes suggested the emotional kitsch of Disney but were expressed with the drawing finesse of a Hogarth. One print of his from the forties is a startling depiction of hooded Ku Klux Klan members. The picture reveals a lowbrow, somewhat pathetic bunch, a slapstick lynch mob. In another print, *Night of the Living Dead*, soldiers spill out of trenches

first defined in the World War I etchings of Otto Dix. They are horrific figures, but these grotesques seem to move with a Chaplinesque choreography. These are visions created from the deep malaise of the years of prewar tension, the war that engulfed the whole world in slaughter, followed by the revelations of Hitler's death camps and the horrors of genocide. Sessler's nightmares echoed in the works of other social realists, but a new concept of art had been born in New York during the war, and in the late forties, abstract expressionism broke out and literally swept away social realism. However, Sessler's little figures stood stubbornly against the wash of the new art movement.

As a faculty member of the art department, Alfred Sessler developed a rapport with his students that was not only collegial but also intimate as his tenure extended. His teaching method was to share his life with his students. He was most comfortable teaching his print classes in the evening. After the classroom session ended, he would decamp with his students for an hour or two at the student union's Rathskeller, where discussions ranged from print theory to football to the latest foreign films. Sessler's interests were encyclopedic, and in the plethora of talk he usually had an instructional agenda. The night class would often end up at his apartment, where his daughter would listen, fascinated by the spill of art talk, and his wife would dish up soup, sausage, and bread for those staying late.[3]

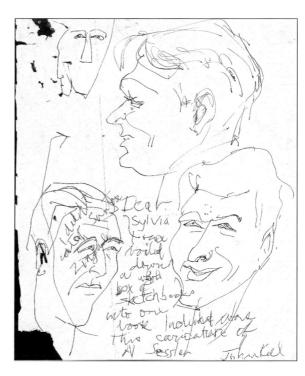

Sketch of Alfred Sessler by a student, John Keel, who was doing caricatures of his art professors. *Drawing courtesy of Sylvia Solochek Walters.*

Sessler gave great attention to exposing his classes to actual work by artists. Generally, the art students at Wisconsin lacked experience of the art world, and Sessler seized every opportunity to make up for this lack, enlarging the department's print, slide, and reproduction collection, organizing bus trips to the Art Institute of Chicago and to the galleries of Milwaukee, and leading his classes in a ragged but enthusiastic line to galleries in Madison when a worthy exhibit was featured. These were sometimes juried shows of regional artists and would invariably include his own work. Although he tended to pass over his prints lightly and concentrate his critiques on the other artists, his students were aware of the professionalism of their teacher and that the techniques he was teaching them were processes over which he possessed the mastery for which they were striving. The discussions in university hallways, in the galleries of the art center, and before traveling exhibits and the one-person shows were notable for fervent opinions aired and argued. Sessler guided from the background, making points, clarifying the aesthetic, and cutting through the excesses. He was a superb guide. His students respected him as an artist and as a teacher, and a number wrote later of their admiration.[4] His reputation grew steadily. The work from his classes was highly visible.

Sessler built a new home with a studio and installed a litho press, which was used primarily to print wood and linoleum blocks. Following the emphasis of his teaching, he

In his home-based studio in 1957,
Alfred Sessler cuts on state three of
a reduction color wood block.
*Photograph courtesy of Karen Sessler Stein
and Gregory R. Sessler.*

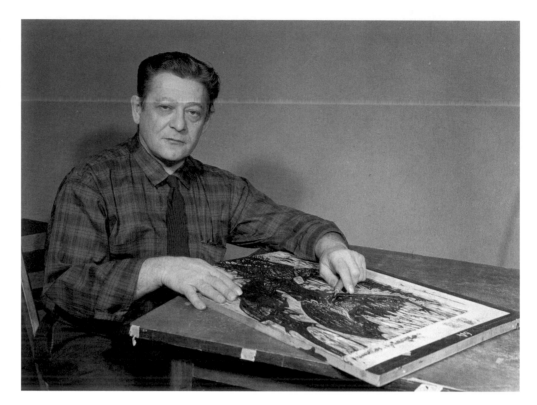

personally shifted from painting to prints, and his focus was increasingly on color wood-cut, produced by using a technique that he had originated—the reduction block. This was in 1957. A year later, Picasso began to use a similar system to print color linoleum cuts and made the method famous. In a book on Picasso's linocuts, the critic Donald Karshan called the process another example of Picasso's genius and "one of the important graphic arts innovations of our times."[5] One of Sessler's former students, greatly upset upon reading this, wrote directly to the author and advised him of Sessler's earlier work. She received no answer.[6] Sessler's method has been described by his former student and faculty colleague Raymond Gloeckler: "Sessler developed an ingenious approach to the color wood-cut in which only one block . . . was employed. Affectionately referred to by his students as the 'suicide method,' it left little room for error. It consisted of progressively cutting or reducing the same block and printing a color after each reduction. Thus the block is carved and yellow is printed. More cutting and orange is printed. Still more and red, cut-ting and printing again and again until the printed image is complete, and little is left of the surface of the block."[7]

As Sessler's working interests narrowed to woodcuts, he gradually altered his themes and stylistic approach. The prints of the thirties had read as bitter comedies featuring re-pressive forces: cops, strike breakers, military personnel, and Klan figures. The depictions of the lithographs and paintings of the forties began to shift from groups toward the single figure, increasingly bizarre, with a minimum of props: clowns, old people with strange

headgear, tightly focused head and shoulder portraits of men and women having a bad hair day, and faces urgently in need of a good dermatologist. These, in turn, became workers, but moving from the heroic loggers and sturdy farmers of his Works Progress Administration days, he focused on dumb work, for example, a railroad crossing guard, dressed in ragged overalls and holding up a small sign reading "stop."[8]

Finally, Sessler became fascinated with the wood grain itself, and his carvings began to be influenced by the twists and turns of hard fibrous currents within the wood pith. The growth rings, turned horizontal by the milling of the planks, caught up the tip of his gouge and influenced its direction and depth. Thus, his figures receded and became trees, twisted roots, snarls of forest and plant, fantasy jungles and decaying organic things, and barely recognizable gourds and tomatillos—exotica that somehow found a way into his studio still-life table. All were in color, garish to earth greens and yellows, textural, and brokenly layered through multiple overprinting, a rich spatter of color fragments resisting the covering layers in weird scars of color and embossment.

This period was one of amazing growth for Sessler, whose personality was so free of pretensions and who seemed so affable and accommodating. The work belied this. His students and his colleagues were aware of this artist's complexities, masked by his manners. Their awe of him showed itself sometimes in their protective impulse to take sides in department politics when Sessler's interests appeared threatened. His colleagues had a

Alfred Sessler *(right)* and John Wilde, in 1959, discuss a student's canvas in the art department's painting studio.
Photograph courtesy of Karen Sessler Stein and Gregory R. Sessler.

love for him, although they would not express it that way until after his death. He was a warm, companionable human being who had his share of flaws. He had terrible eating habits, which he indulged and enjoyed. A compulsive gambler, he had the good sense to remain penny ante. He believed in the nobility of athletics and athletes, particularly boxers and football jocks. At a time when college boxing was a major sport, he was often at ringside in the university's Field House to cheer on one of his favorite print students, Bobby Hinds, who became a Big Ten and a National Collegiate Athletic Association heavyweight champion. Sessler was stingy; that is, he was raised in the Depression and was careful with money. If you grew up in a home where at meal times you had better eat everything on your plate or the mother standing over you would remind you of the starving millions in China, you became careful in matters of currency. In the same breath, he was generous. He would never pass a panhandler without donating a coin or two. He had the heart of a taxi driver. If you needed a lift, you could call on Sessler. He would take you wherever you were headed, all the while talking proudly of the noble attributes of his beat-up jalopy and endangering your life with his driving, but getting you to your destination regardless of the disruption of his own schedule. This fine artist died at the end of the spring semester in 1963, while his abilities and ideas were at flood tide, of a condition that he had lived with for a long time. Without gallery backing and promotion, his work has remained remarkably viable—chosen out of museum collections for curated shows, noted in surveys, and reproduced in books and articles dealing with a print period that art historians are beginning to reevaluate.

Much time has passed, but his students remember him. Bruce Nauman credits his art professors at the University of Wisconsin for reinforcing his own social commitment, and he lists Alfred Sessler specifically in a 1988 interview.[9] He elsewhere has noted, "They were socialists and they had points to make that were not only moral and political but ethical as well. . . . people who thought art had a function beyond being beautiful . . . that it had a social reason . . . to exist."[10] Nauman studied printmaking with Sessler for the 1962–1963 academic year. It was Sessler's last class. Theodore Wolff, also one of Sessler's students and a former art critic for the *Christian Science Monitor*, comments on his debt to the art of the past: "His interest in art history was extensive and vocal. He could and did speak familiarly about the ideas and methods of Rembrandt and Rubens, and his own work frequently reveals a jewel-like quality stemming directly from his love of painting and drawing. He was an artist who faced in two directions: toward the art of the museum, and toward the people he saw in the bread-lines."[11] Sylvia Solochek Walters, a former student who became head of the art department at San Francisco State University, studied under Sessler during the last years of his life and concentrated on the same techniques that Sessler was raising to a major print form. She recollects that "Sessler was short and stocky, had strong, pudgy fingers. I remember them wrapped around various tools as he demonstrated how to hold them. . . . He smoked and smelled of tobacco. Crits (which were conducted in his tiny office with the door closed) were gentle and encouraging. Our mutual

Jewish background was a connection Sessler occasionally played up. Because we were both Jewish, he led me to think we had a special understanding. He lightly broached Jewish topics, occasionally used Yiddish phrases."[12]

There can be no doubt that being Jewish in Wisconsin played out in Sessler's life and entered into the ideas and the look of his art. Coming to maturity in the Third Ward of Milwaukee makes ethnic identity a frontal reality. It has long been an immigrant city, divided into separate communities that tend to coexist rather than blend. It is a city of culture, sophisticated taste, machine and craft skills, discipline, and some crude ethnic politics. Sessler was active in left-wing and union support groups in his early period, as were most artists, driven by the economics of the time. To watch the rise of Hitler and the echo of approval among some German residents of his city must have turned the iron in his stomach. His early politics came back to threaten him in the 1950s, when Joseph McCarthy's allies at the university stirred up trouble for him. His bitterness over this obviously entered into his thinking as an artist, even though the incidents came to nothing.[13]

The sagging faces of Sessler's small stout figures, the drooping eyes (uncertain, wary), the menial and bizarre costumes, the "otherness," even though disguised or in drag testify to the artist's experience being the basis for the narration and casting. The parade of those Sessler figures, garbed variously, but clones in their physiognomy, analyze them as you might, present evidence that Sessler's Everyman is Sessler himself. Humor can intrude (think W. C. Fields, Harry Langdon, Buster Keaton), occasionally with true hilarity, as in *Spring Again* or *Female with Hair Ribbons*. It is the humor of the entertainments of his youth: movie comics and the stand-up/fall-down masters of pratfalls, comics who worked the burlesque halls and the neighborhood vaudeville. An argument also can be made, in looking at the figurative work extending up to the fifties, that Sessler was working from a point of intense depression, visualizing a hopelessness with which he identified, in spite of the success of his career and the warmth of his personality. In his woodcuts, he was pushed by his teaching into fresh material, stimulated by his own ingeniousness, moving into radical new imagery, form, and color, sustained by an enormous burst of creative optimism. This is his finest period and marks the greatest achievement of this unique and increasingly appreciated artist.

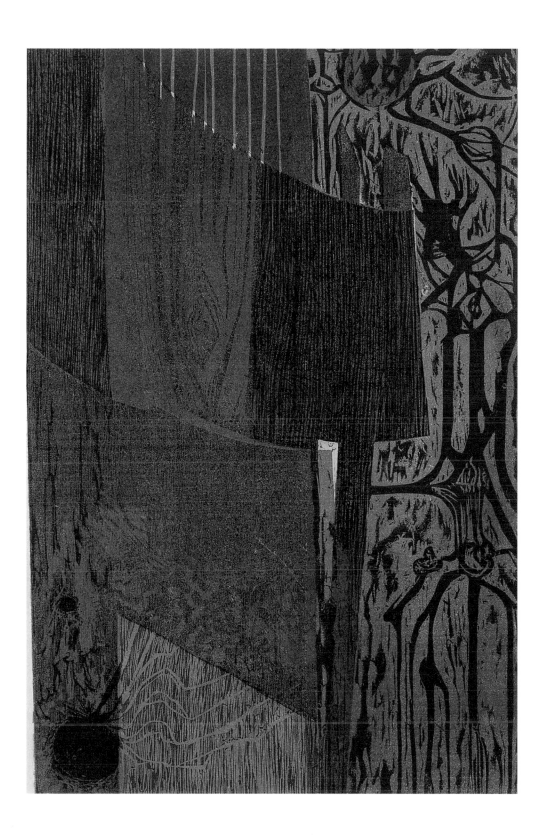

Alfred Sessler, *Forest Edge.* Color woodcut (1952) 20½ x 12⅝. *Elvehjem Museum of Art.*

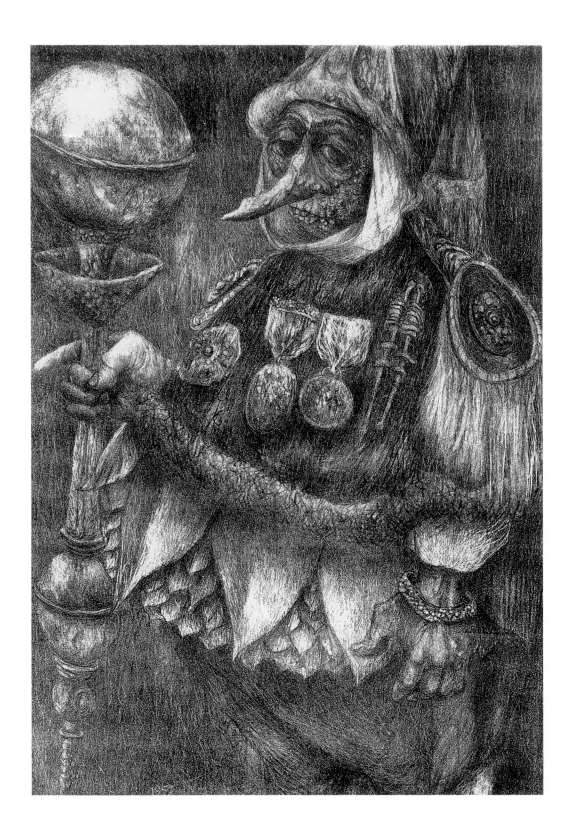

Alfred Sessler, *Clown Major Domo.* Lithograph (1952) 14⅝ x 10. *Elvehjem Museum of Art.*

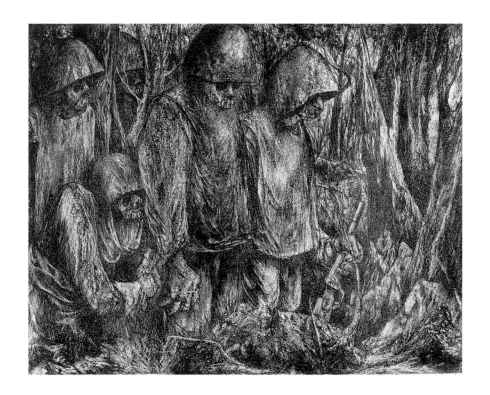

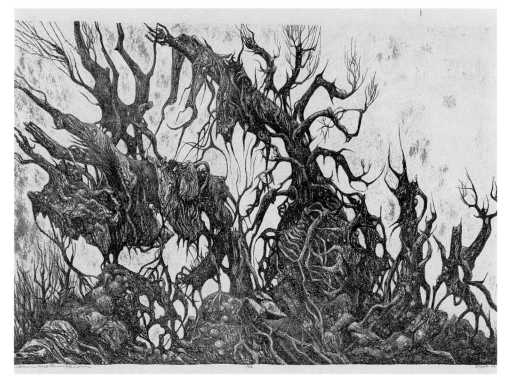

(top) Alfred Sessler, *Patrol.* Lithograph (1953) 11 13₁₆ × 14 15₁₆. *Elvehjem Museum of Art.*

(bottom) Alfred Sessler, *Till Birnam Wood Remove to Dunsinane.* Lithograph (1960) 14 7₈ × 21 1₈. *Elvehjem Museum of Art.*

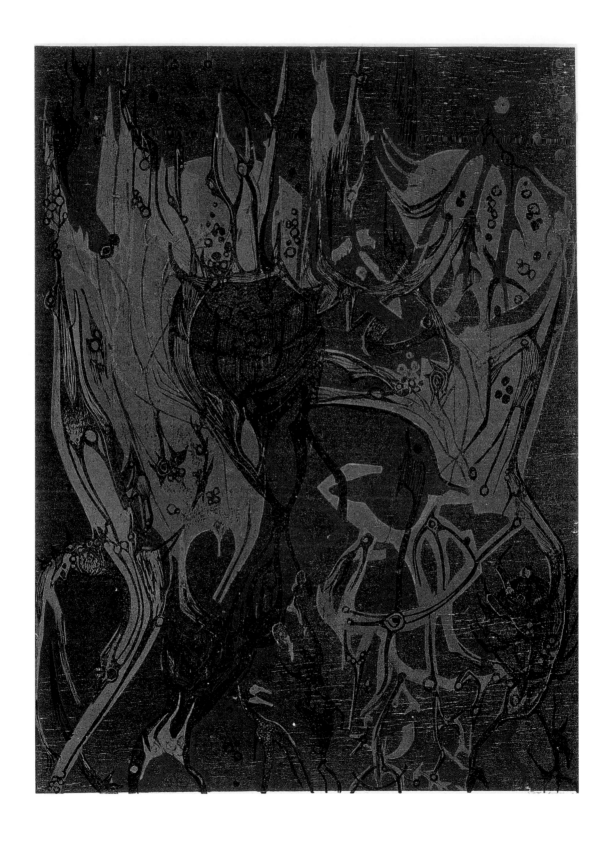

Alfred Sessler, *Germination.* Color woodcut (1957) 18⅜ × 13 ¹¹⁄₁₆. *Elvehjem Museum of Art.*

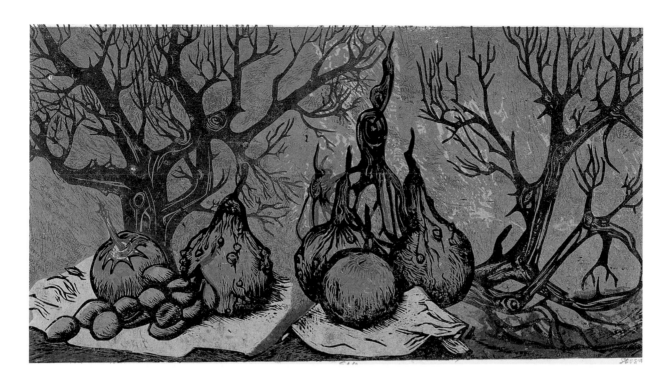

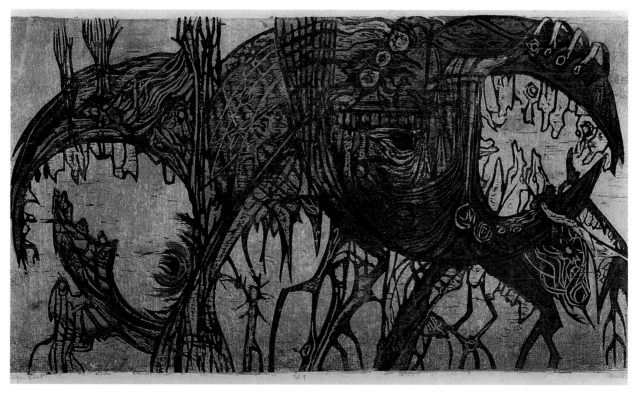

(top) Alfred Sessler, *Arrangement.* Reduction woodcut (1957) 15 × 30. *Collection of Karen Sessler Stein and Gregory R. Sessler.*

(bottom) Alfred Sessler, *Dragon Root.* Color woodcut (1957) 11¾ × 21. *Collection of Karen Sessler Stein and Gregory R. Sessler.*

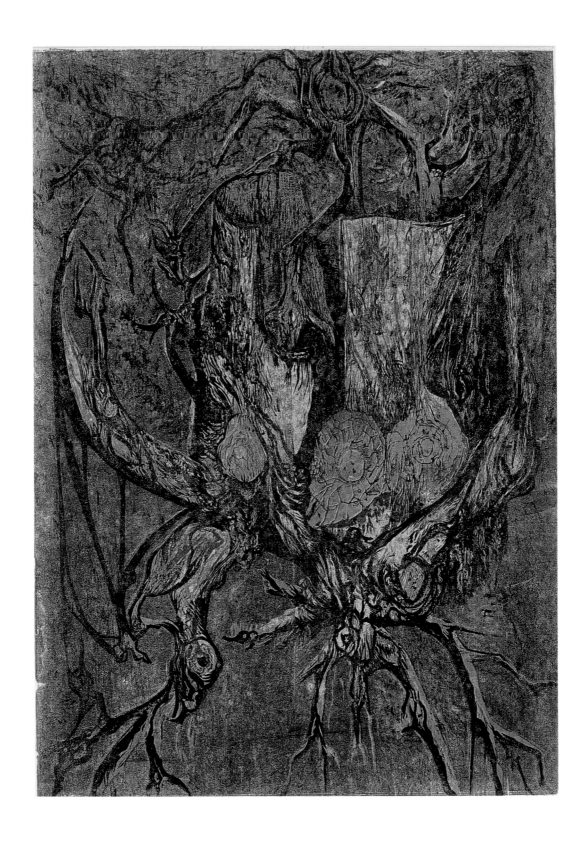

Alfred Sessler, *Burl.* Color woodcut (1958) 22 × 15¼. *Collection of Karen Sessler Stein and Gregory R. Sessler.*

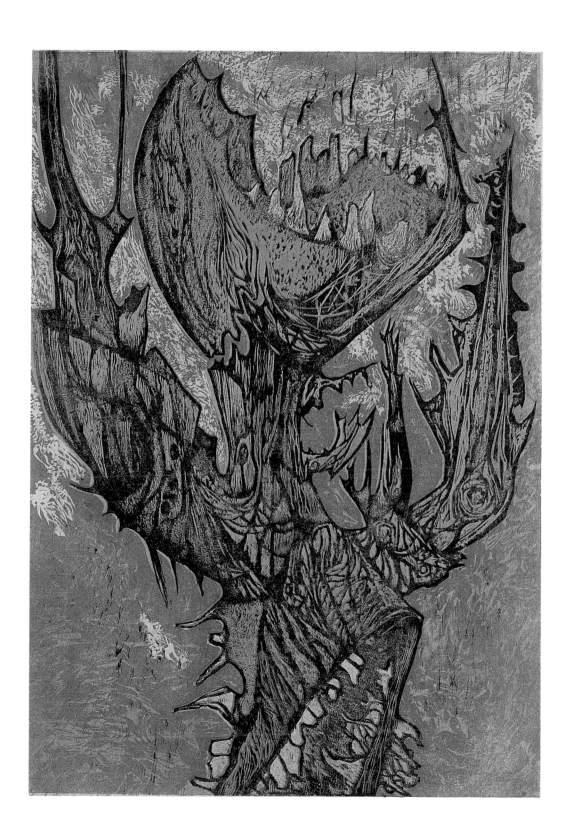

Alfred Sessler, *Look Heavenward Tree.* Color woodcut (1960) 21 × 14 ¼. *Collection of Karen Sessler Stein and Gregory R. Sessler.*

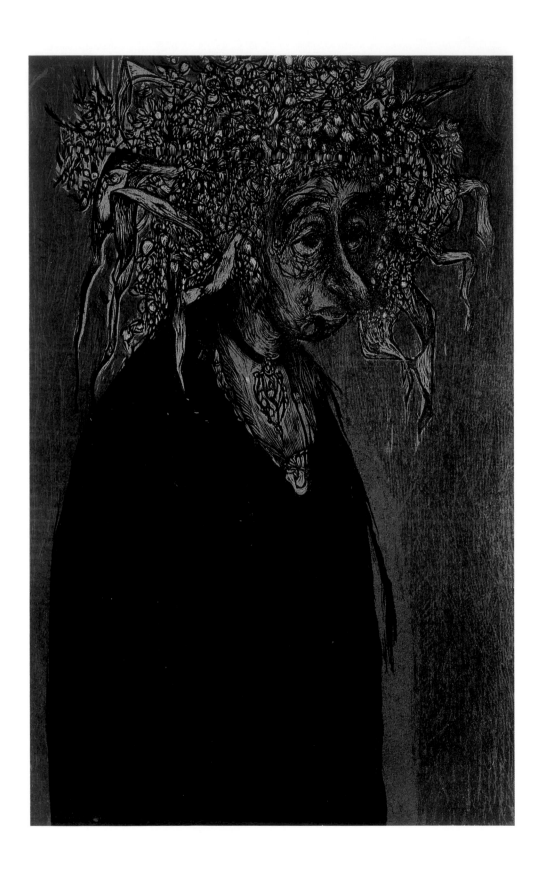

Aflred Sessler, *Spring Again.* Color woodcut (1962) 19 x 12. *Elvehjem Museum of Art.*

The decision to leave home as a teenager in Billings, Montana, was not difficult for Dean Meeker; it seemed to be a necessity. "I was working in a sign company, but I just couldn't see myself being a sign painter for the rest of my life. When you don't spell well and you can't add a column of figures, you look to the things that you can do. So I sold my car, quit my girl, and hitchhiked to Chicago."[1] His choice of Chicago as a destination did have a pragmatic aspect to it; a high school teacher suggested he go there. "One of my reasons for going to Chicago was because I had to find a professional art school, mostly because I had neglected to finish high school." The environment in Chicago was transforming and energizing. "I was introduced to so many things I didn't know existed," such things as the opera, ballet, the symphony. "Everything was new. I hardly breathed regularly for the whole first year."

Meeker enrolled in the School of the Art Institute of Chicago and studied painting under Boris Anisfeld, a man who believed firmly in the idea that students should study at the feet of the master. The result was that most of his students painted the way they thought he wanted them to paint. "I developed my first schizoid attitudes then," Meeker observes, saying he would paint one way in the classroom and his own way in his studio; the outcome, "neither was very good." The strict classical training did have positive aspects, however; it gave him an important foundation for his professional career. The training is reflected in his strong concentration on the figure found in his painting and printmaking and subsequently his work in sculpture. "Life drawing at the Art Institute was a high priority. You had to draw the figure.

DEAN MEEKER

Art as Process

It was understood that you had to draw the figure before you drew the rest of the world. So I got very interested in it and actually did plates and had my own Thompson's anatomy book.[2] I thought I was reasonably good at it and I could teach it."

In order to survive and pay for his schooling, Meeker had to take a night job. His earlier training as a sign painter translated into jobs in various silk-screen shops—initially as a "squeegee pusher." In those days, the late thirties and early forties, the medium was used almost exclusively for commercial purposes, primarily in printing posters and signs. However, a number of artists, supported through the Federal Art Project, explored its potential as a fine print medium. The silk-screen jobs were not something he could immediately relate to his program at the art institute. "Graphics wasn't something that the cafeteria was alive with talk about. The graphics department had litho stuck in a little room, and there wasn't anything at the school to do with silk-screen. Etchings were thought of at the time as something you did if you wanted to illustrate books. Everybody had a small portfolio that they carried them in, but I was more interested in the bombast of painting and got involved in silk-screen by putting myself through school with it."

Meeker's work in silk-screen accompanied him to the University of Wisconsin, where he took his first job as an instructor in 1946. He continued his affiliation with the university throughout his entire academic career. Meeker shared a studio with Alfred Sessler in the old Young Men's Christian Association building next to the Memorial Union on lower Langdon Street. One of Meeker's introductions to the larger university came accidentally through John Guy Fowlkes, an imposing leader who served as dean of the School of Education (administrative home of the art department) from 1947 to 1954. The memorable encounter with the dean was the result of an administrative error. Meeker and his wife were invited to Fowlkes's home for a tea only because of a secretary's mistake in mailing him an invitation because his first name was Dean. As the Meekers walked toward the house, Fowlkes looked at them and thundered, "What the hell are *you* doing here?" Meeker summoned up his courage, showed his invitation, and exclaimed, "I was invited, goddam it!" Fowlkes examined the invitation and responded, "My god, you were! Well, come in, *Dean* Meeker." The fledgling faculty member and his wife then "met virtually every dean on campus, had a couple of drinks, and left." But the dean's personality had made its imprint. "He terrified me," Meeker remembered, "even after I was a full professor and he couldn't do anything to me."[3]

Meeker and Sessler continued sharing studio space in subsequent moves to a quonset hut across the street on the Library Mall and later in the "infamous" etching studio in the Education Building on Bascom Hill. The use of the word *infamous* seems appropriate because of the various legends that surround the activity that went on in the early printmaking classes. Sessler and Meeker were teaching during a time when printmakers did what they had to do without much thought about the potential long-term environmental or health impacts of the materials they were using. As a consequence, the atmosphere in the studio was so potentially volatile that Meeker ruefully recalled, "The things we

were using—talk about toxic paints. We had to carry out our garbage every night to keep it from spontaneously exploding." In contemplating the potential health hazards, Meeker marveled at his own longevity. "I've worked in toxic paint since I was nineteen and I've escaped this whole thing."

Gradually, Meeker's work in silk-screen began to monopolize his time. "When I got here, I was inclined to look at the horizon and think about painting as the queen of the arts." Such a view was soon tempered by the reality of the marketplace. "I did a lot of painting. The first two years I was here, I competed. I got medals at the Milwaukee Art Institute. And then, after two years, it occurred to me that I was in possession of all my paintings—all of them. That tells you something. The first edition of prints I did, I sold. Well, it doesn't take a genius to figure that you should, as the New York artist put it, 'appeal to a broader base.'" The multiple nature of printmaking offered both artistic and economic dividends. "I have a two-drawer collection of a hundred or a hundred and ten pieces, I guess, of people I've traded with. In those days, that was another thing about the print. You could go to art fairs and if things weren't moving, you could trade with other artists, so you wouldn't come home empty-handed. . . . The whole print idea was expanding; it was very vigorous. Besides, you only had to do a couple of really good ones a year and you could cover every show in the United States. And many people did that. You could actually broadcast your work. What it meant is that you can't always sell paintings for $50,000, but if you have the name for it, you can sell enough prints and you might make $50,000." Later in life, Meeker expressed a certain wistfulness about his branching out into other media at various points in his career. "My life would have been simpler if I had stayed with prints. Prints have been very good to me."

Although Meeker's initial interest was in painting, students were interested in his knowledge of silk-screen. "A bunch of kids came to me when they heard I had this experience and said they wanted to do silk-screen, and I, of course, told them I knew nothing about it. I wanted nothing more than to forget about the whole experience of commercial silk-screen. It was headachy. I was working late at night. But they persisted, and so we set up an independent class. At first it was a noncredit class, but the classes got to fifteen, and [department chairman] Fred Logan said you'd better write up a description because you're using heat, light, gas, and whatnot to teach these courses. So we made it official. We described it and put it in the curriculum." It was the first university course in silk-screen in America.[4] After the serigraphy program had been successfully established, Meeker wanted to see how far he could take the medium. The impulse was a natural extension of his lifelong interest in the way art is made and the things that are used to make it. "I always think of Paul Klee's statement that art is process and I've always been interested in process. The newer the process or the more experimental the process, that's essentially what interests me." The interest proved to be so compelling that Meeker found himself working as a painter, printmaker, and sculptor throughout his long career.

In seeking funds to pursue his experiments in serigraphy, he applied for a grant from

the University of Wisconsin Graduate School to study and develop serigraphic techniques.[5] He was successful in his proposal and became the first member of the art department faculty to receive such a grant. "They gave me a semester, and I holed up in the serigraphy studio, canceled my classes, and spent the time developing a lot of techniques—subtractive techniques, things that are inclined to look like the qualities of etching because we still had this inferiority complex about silk-screen. I was trying to make it not look like a traditional silk-screen. . . . I even ventured into imprinting encaustics, which had always been an interest to me. The Fayum portraits in Egypt had just knocked my hat off. I realized it was as permanent a medium as you can get. Wax, other than physical destruction, is going to isolate the pigment and hold it forever. So I invented a way of screening wax, and then, of course, with a sun lamp you could fuse this to remove all evidence of it being silk-screened and polish it up. . . . But there again, I got this confused with a reproductive system which is hard to stay away from. Silk-screen's an amazing medium. You can use any material. You can use it to print a viscous or liquid material on any surface that will accept it and is solid enough to support it."

The efforts of Meeker and other silk-screen printmakers overcame the diffidence of the Art Institute of Chicago about the medium. In spring 1957, Carl O. Schniewind, curator of prints at the Art Institute, invited Meeker to put on a one-person show of his serigraphs. As an adjunct, Meeker was asked by the institute's Print and Drawing Club to do "the first silk-screen that their membership had acquired. That was a real kick." A short time later, Meeker's perspective changed. "I felt I had pushed silk-screen as far as I wanted to at that point and I became very much interested in etching." He applied for another grant. He ultimately won a Guggenheim Fellowship to study printmaking techniques in Paris at Atelier 17 with Stanley William Hayter in 1959.

Meeker spent the summer of 1957 working in Madison with Misch Kohn, who had been brought in to replace Sessler, who was on leave. Kohn "had a whole vocabulary of technical things that I was very interested in. It was wonderful. We threw everybody out [of the etching studio] in the afternoon and we worked like crazy in there." Most of Meeker's experiments that summer involved color and its application to intaglio printing (etching). "At that time it seemed to me that there were two or three ways to use color with etching—printing with separate plates, or roller printing. This seemed ponderous and annoying to me, so, of course, I thought about silk-screen. Silk-screen paint, especially in its thicker state, tends to be rejective to the intaglio plate, especially the copper plate, so I experimented with thinner and transparent silk-screen colors."

When Meeker arrived in Paris in 1959, he found an exciting atmosphere pervading Atelier 17: "There was a wonderful feeling of young people coming there, especially if you wanted to work like Hayter worked—no aquatint, only acid—fast acid and deep cuts." The focus on acid was so intense that it had a literally corrosive effect: "The plumbing had been all eaten out by putting nitric acid in the sinks." Meeker told Hayter "what I was about—that is, combining silk-screen and itaglio." Hayter looked at him and responded

matter-of-factly, "Yes, we've done that." The announcement surprised Meeker. "How did you do that?" he asked. "Well," Hayter replied, "we had to put retarders in the ink and actually print on the plate. It transferred, but we had to deal with some uncontrolled variables."

Meeker soon developed a working relationship with Kaiko Moti, who had left Atelier 17 but maintained a studio close by in Cité Falguière. "He was very essential to my development," Meeker said. "I found Kaiko to be less restricting [than Hayter], so I sort of insinuated myself into his studio." He and Moti traded their knowledge of technique. Meeker taught Moti silk-screen, and Moti taught him viscosity printing.[6] They alternated the roles of master and pupil. "One day I would be the master," Meeker observed, "and have him clean up, and the next day he would be the master, and I had to jump to his instructions."

One significant byproduct of Meeker's fascination with technique and tools is the Meeker/McFee press. When Meeker started his experiments with dimensional prints, he found that the types of printing presses available could not satisfactorily adapt to the variances in depth, the positive and negative spaces on the surface of the plate. "There was the misconception then that weight made pressure. It doesn't. I thought if I silk-screened the print very thin and allowed the image to sink into the paper that I might be able to combine silk-screen and etching." Several experiments revealed that the size of the press roller was the critical factor. "Technically the rule with the plate is that you don't have to

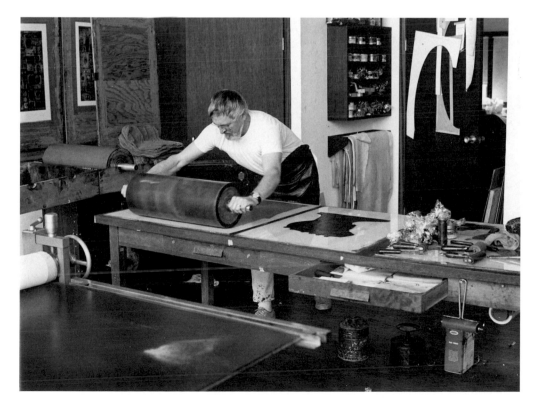

Dean Meeker's printing studio in Dane, Wisconsin. Meeker is loading a large roller with relief ink to sweep the surface of a shaped collagraph plate *(on glass at his left),* which will be printed in the Meeker/McFee press *(foreground). Photograph courtesy of John Ross.*

have more than an eighth of an inch between your highest highs and your lowest lows. If you're interested in a real high and low topography in the plate, you have to have a small roller." Meeker discussed the problem in those evenings when he occasionally shared a bottle of wine with a neighbor, engineer John McFee. Their discussions led to the development of a prototype press, which is "characterized by being light. It has a rather smaller roller that appeals to very deep printing, and it has eight hundred pounds to the lineal inch pressure." The real secret of the press, Meeker noted, is "the relationship of the two rollers. They are matched, the exact same size, the same top and bottom travel, and they develop real definitive pressure." The resultant flexibility of the press provided for further experiments in technique. "This press then allowed me to pursue not only color, but a unique attack on the plate. This press and the experience I had in Paris with Kaiko allowed me to bring together the idea of more pressure and the combining of the plate and silk-screen color. . . . At that time, I also began experiments with what is now called a collagraph plate. Instead of using copper, I used aluminum. I could build a polymer surface on that and work additively as well as subtractively. I used carborundum for darks and lacquered surfaces for the whites." The success of the newly developed Meeker/McFee press had an unanticipated and unwelcome impact on Meeker's time. "I just wanted one for myself. But then we got to improving them and we did some more prototypes, and then, of course, all the students who had worked with these presses wanted one. So I tried to disengage myself because I spent hours talking on the phone about how to print with it."

Whatever process Meeker chose, his subjects were primarily heroic. His works depict individuals of the grand gesture, the impossible dream. They are the seekers, the movers and shakers who relish challenging the fates or fighting against the odds. They are the exemplars, the people we are to take as models. As Frank Getlein has noted, these figures "are metaphors for the artist, finding salvation in dreams, risking death to dare the heights."[7] Meeker has described his fascination with the hero in an artist's statement for a 1964 exhibition at the Washington Federal Bank in Miami Beach: "The Hero, Icarus, Genghis Khan all are out of the fabric that stimulates the detachment and transfiguration necessary to the creative impulse. The Hero and his typical metamorphosis, separation, initiation, return, his love of fate that is inevitably death, is vital to my own feeling. Ultimately one reshapes these impulses and retells a story that is not mythological or literary but graphic."[8] Throughout his career, Meeker has returned to similar subjects and themes as he has worked in various media. Analyzing the success of others, he concluded, "The way to succeed as an artist is to take one theme and just keep with it." He also recognizes the possible contradiction in this approach: "I'm often on the other side—thinking that your return to all these subjects again and again might be a simple poverty of ideas."

Although a continually productive artist, Meeker also considered himself a good and versatile teacher: "I guess I taught everything but jewelry." Early on, he discovered that effective teaching was not necessarily involved in high philosophical or theoretical precepts. "I taught sculpture and figure modeling [early in his career]. Then we had the OTs,

Dean Meeker and Kaiko Moti in conversation in 1981 on the beach-side patio of Moti's home on Ibiza, one of Spain's Balearic Islands. *Photograph courtesy of Dean Meeker.*

which we called 'odd types,' which were the occupational therapy people. Della Wilson [a senior faculty colleague] was at one table and I was at another table, and we had forty of these people, and she was having them take the clay and pull the doggie legs out and the tail, and I thought how simple-minded. And I was showing them slides of Henry Moore and all these great sculptors. Well, the plain fact was that she was getting a better product than I was. So I modified my teaching approach." In a similar way, he has modified his use of various media through the years, thus reflecting a hallmark characteristic of his artistic approach: "I think you get an idea about something you want to do and you look for subject matter that might entertain that technique. Which should be the way it goes. You should have this great, God-sent idea and then find a way to do it."

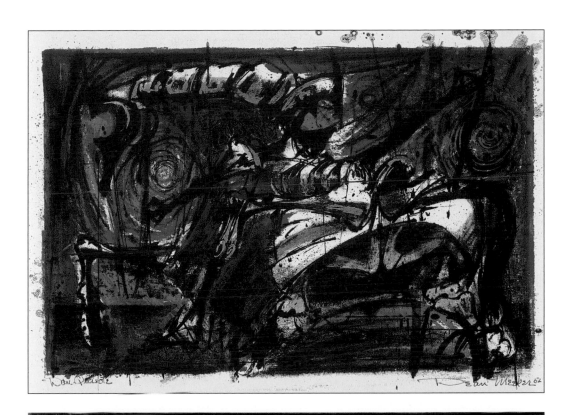

(top) Dean Meeker, *Don Quixote.* Serigraph (1951) 12 × 17. *Courtesy of the artist.*

(bottom) Dean Meeker, *Trojan Horse.* Serigraph (1958) 18½ × 26. *Courtesy of the artist.*

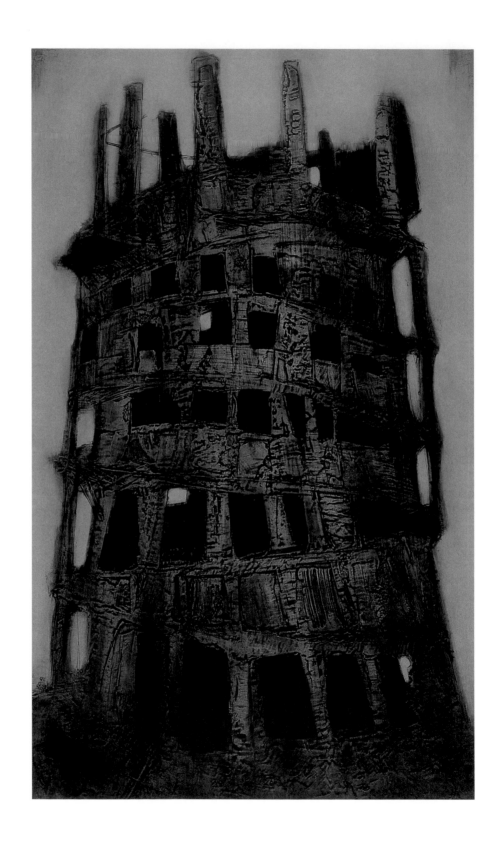

Dean Meeker, *Tower of Babel*. Collagraph with silk-screen (1961) 33½ × 20. *Courtesy of the artist.*

Dean Meeker, *Icarus, Pre Voluntum.* Collagraph with silk-screen (1961) 27 × 20. *Courtesy of the artist.*

Dean Meeker, *Lisa.* Collagraph with silk-screen (1971) 32 × 20. *Courtesy of the artist.*

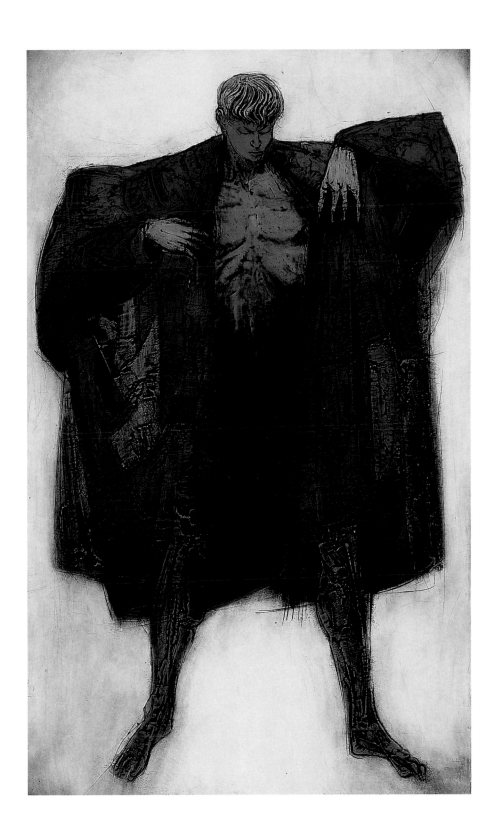

Dean Meeker, *Joseph's Coat.* Collagraph with silk-screen (1973) 34 × 20. *Courtesy of the artist.*

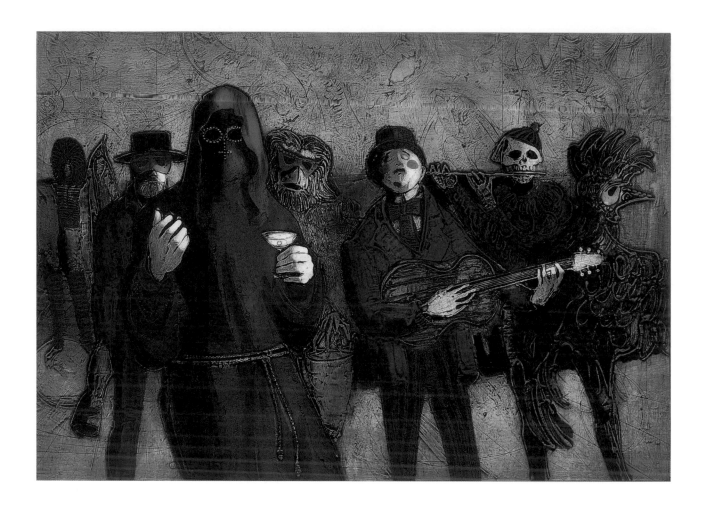

Dean Meeker, *Mardi Gras Monk*. Collagraph with silk-screen (1974) 20 × 28. *Courtesy of the artist.*

Artists make their marks, both physically and metaphorically. From earliest childhood, Warrington Colescott has been making linear and textural marks on paper. The marks have a distinctive look, as distinctive of Colescott as his handwriting. "My drawing style has, in many ways, remained consistent since childhood. The marks of the pen or brush spill out with a kind of attack. Ultimately they all fuse together and become a narration.[1] . . . From as far back as I can remember, I've always been drawing pictures. As a child I drew cartoons, influenced by newspaper comic strips. I drew a monthly cartoon book that I circulated among my cousins in New Orleans. They were intense adventure strips, mostly dealing with detectives and pilots of biplanes."

The activity never stopped. "I drew my way through high school." The high school was in Oakland, California. Colescott was editor of the yearbook and drew cartoons for the school newspaper. More of the same followed at the University of California, Berkeley, where he was the art editor of the *Daily Californian* and an editor of the campus humor magazine, the *California Pelican*. By this time, fewer detectives appeared in his narratives, the handwriting was more diversified, and the themes reflected issues dominant on college campuses during those years of war in Europe. "I did political cartoons for the paper and humorous features and stories for the magazine. The humor wasn't custard pie and pratfall stuff. Our world had gotten very dark, and the material we dealt with was pertinent to our generation. I can tell you it was nervous stuff. The world had gone to hell and the demons were right outside, waiting for us to come through the graduation gates. My caricature targets were Hitler and Mussolini."

WARRINGTON COLESCOTT

Narrative Marks

Colescott had started college as a pre-med major, to please his father. "The old man wanted a doctor. I liked art but had been convinced you couldn't make a living with it." After the first semester and twin disasters in chemistry and German, coupled with success in an art elective, he changed his mind and went into the art major. He was not a model student. "There was too much happening on the Berkeley campus. I cut classes to go to political rallies and demonstrations, and much of my time and energies went into work on student publications."

At this period there existed at Berkeley and at many major American universities a student culture that gravitated around extra-curricular activities: the newspaper, the literary magazine, the humor magazine, the theater, debating society, political clubs, and so forth. At the University of California, there was a large and popular student-run daily paper, which competed with the newspapers in the surrounding cities. The monthly humor magazine had a large staff of writers and artists who specialized in sardonic spoofs through fiction, cartoons, illustrated mockery of various kinds, ribald verse, and outrageous gags that ensured the magazine an enthusiastic undergraduate public. The staff considered their efforts to be on a par with the *Harvard Lampoon*, even possibly with the *New Yorker* (after all, had not former *Pelican* editors graduated to staff positions on that magazine?). Roberta MacDonald and Bernard Taper were mentioned with awe.[2] Colescott's editor at the *Daily Californian* would go on to become the most famous female war correspondent of World War II.[3]

Colescott's first prints were done for the newspaper. As art editor, he was responsible for a daily political cartoon on the editorial page. Budget demands required that each week two cartoons be hand-cut in linoleum rather than photo-engraved. "I cursed and sweated over those little cuts, but I did learn to letter backwards without using a mirror, a skill I still use today in the etchings." The linoleum cuts were the only prints he made at the university since printmaking was not taught in the art department.

As an artist and writer on the *Pelican*, Colescott found the most breadth for his burgeoning sociopolitical ideas and for his attempts to convey these ideas in terms of comedy. He created features that dealt with the war in Europe and the Pacific, with defense matters, and with the growing repressions that were part of a country at war and found ways to couch these commentaries in humor.[4] As a member of the Class of 1942, Colescott graduated immediately into the United States Army.

Colescott returned to Berkeley four years later. As a graduate student, he threw himself into painting and at last took full advantage of the art faculty members, whom he had treated lightly in the past. By the time he joined the art department at Wisconsin in 1949, he was an exhibiting artist on the West Coast, had had a group show at the San Francisco Museum of Art,[5] had taught himself serigraphy, and was seriously interested in prints.

The first interview with Dean John Guy Fowlkes of the School of Education was memorable. "He was a big man, a commanding figure with a voice that would make the art faculty spill their coffee. He growled at me; 'Colescott, I see by your papers you were an

army lieutenant. Well, nothing's changed. Just think of me as the colonel.' And I always did." Colescott's teaching responsibilities at Madison would be in drawing, design, and painting.

Colescott's work was primarily in painting at this time, and he was successful in exhibiting, showing in two Whitney Museum of American Art biennials in New York and winning prizes at the Wisconsin Salon of Art in Madison and the Wisconsin Painters and Sculptors Show in Milwaukee. Increasingly, his attention turned to printmaking, which brought him into competition with Dean Meeker, who was teaching a class in serigraphy. They often showed in the same exhibits and were members of the same New York gallery. "It was a good-natured competition. I loved to beat him, but it was not easy. Dean was at the top of his form." Colescott characterized his painting as being on the verge of abstraction; however, his printmaking was becoming more figurative. "I felt this schism between my media and knew I had to resolve it. I could not allow my concepts to be determined by the material I was creating with." However, the prints pointed the way. "My graphic sense began to call the shots."

Colescott was soon pushing the limits of serigraphy, and his colleague Alfred Sessler encouraged him to explore another print medium, etching. "I made several small plates with Al and found it a difficult but a wonderful medium with which to draw." At that point, Colescott received a Fulbright grant to London. "In London, in 1957, I maintained my own separate studio for painting and serigraphs, but the etching work at the Slade School was fascinating. I had been looking for a print medium that offered great scope in line, and I got it. I found the marks of my scratchy little tools adding up to figures and events. It was hard to believe, but I was back to figurative narration. The evolution of ideas in my new prints began to carry over into the new paintings I started. Suddenly my work in serigraphy moved on to the periphery of my interest." There was a period of transition as he explored further into the dense vocabulary of etching, and then a period when he attempted to combine etching and serigraphy. "In 1957, while still researching the etching medium, I began to play with a mixing of serigraph color with etching line. I loved the fluidity and richness of the intaglio, but black and white was a limit to overcome." In experiments at the studio at Slade, he printed etched plates and then overprinted them with color in his screen-print studio in Fulham Broadway.

Only upon his return to his studio in Wisconsin was Colescott finally able to work out a successful way to mix the media. "I screened directly on the inked copper plate, then took the plate with etching ink in all the intaglio portions and silk-screen ink on the surface, covered it with a good absorbent printing paper, and took it through the press. It was a little tricky; I had to slow the drying time of the silk-screen inks and modify the pressure to keep the silk-screen ink from squishing out in big blots, but it could be done. The combination was very nice," but there were difficulties. "I began to look for ways to get similar results without the excruciating work and the toxicity. The cleanup was so awful; not to mention the fumes from the quantity of solvents needed to clean the

screens. Etching printing is slow, plate-wiping is slow, screen-printing is fast, screen inks dry rapidly, even with retarders. I could manage one print, but before printing a second copy, I had to stop and clean the screens completely, or the ink would dry in the mesh and ruin the screens. It was very slow work." Colescott's solution was to eliminate the silk screens and to use stencil paper for the screening element. The stencils were hinged to a template base in the manner of the silk-screen rig. The template for the stencil was in register with a template on the bed of the press. Ink was then stenciled onto the relief surface of the intaglio plate with a roller rather than a squeegee. The registration system was so exact that after one pass through the press, the printing paper could be left trapped under the roller, and a second intaglio-relief plate could be substituted and cranked back through the press, thus adding its input to the total print. Two or three plates were easily possible, and there was no reason they had to be monochromatic. Colescott had gotten very skillful at *à la poupée* inking. "Finally I had it. A direct, controllable system to print intaglio in multiple color."

In his teaching at Wisconsin, Colescott emphasized color. His color prints were attracting critical attention in exhibits. Graduate students showed up to work with him in color intaglio. "The procedures I was using were so adaptable. The students coming out of our program were leaving with portfolios of inventive and richly colored prints, ranging through all the print media, blending traditional methods with techniques originated in our research and teaching studios."

The printmaking situation nationwide in the sixties and seventies featured a scramble of technical innovation. There was intense competition among university printmaking departments and professional workshops. Colescott remembers that "our immediate competition in the Midwest was the University of Iowa. Fortunately for us, their print program did not emphasize color, and they did not offer lithography. The real competition was coming from Hayter in Paris, publicized by his books and his disciples. Hayter was obsessed with a system of color intaglio generally referred to as 'viscosity printing.' It was as difficult a printing method as my early struggles had been to combine silk-screen and etching. In Hayter's method you had to control overlapping ink layers by using calculated ratios of oil in your inks, moving from sticky viscosity (less oil) to loose viscosity (more oil). The ink layers were rolled on the plates with huge rollers that had to be of specific softness or hardness (durometers) and were expensive and fragile. In a school shop, they were a disaster waiting to happen. To top it off, you had to get all of this ink on a single plate that had been etched into various depths, manipulating the rollers in an intricate choreography, getting the relief inks to adhere to the plate, or to reject each other, all based on the viscosity of the ink film, which was continually drying as you worked and changing its viscosity. It was a nightmare, but for a time it was the system that dominated avant-garde intaglio printing."

Colescott's shop at Wisconsin used the viscosity method as well as his own multiple-plate procedures with stencils for color work. "The swan song for viscosity in my shop

came the day a giant roller, fresh out of its packing case, some eight hundred dollars of equipment for which I had crawled on my knees to the administration to get funds, was mishandled by a student. It fell off a table and achieved self-destruction on its first day of use. At that point, viscosity began to fade at Wisconsin. The results weren't good enough. It was too expensive. There were better ways."

Colescott's platemaking has gone through various stages and techniques. "The technical options in etching are so diverse. My early intaglio had a base in drypoint. Drypoint is resistant, you have to tear at the metal with physical strength: pulling, ripping, gritting your teeth. The act of drypoint affects your attitude toward your subject. On the other hand, drawing through soft ground is easy, casual. Your point glides and pirouettes. It's like an ice capade; you do tricks and get applause. I grew to love it." He also enjoys working with acid. "It is so unpredictable, changing with temperature, with humidity, with use. It gets stronger as the water evaporates, weaker with use. So sometimes the plate comes out of the acid and it is not what you expected. It has to be fixed. In getting back to square one, you may see new possibilities for a really radical change. The acid dares you to take a chance. I love that challenge. It is art at its highest pleasure point. It becomes a sport."

Colescott takes pride in his printing. "I think I have done close to three hundred prints. All of them are printed in edition, and, in the main, I have been the master printer. Now that is a true collaboration, with the artist leaning hard on the master printer, who is himself. As the artist, I can demand that the printer throw in some foul biting, some casual

Mantegna Press, the Warrington Colescott/Frances Myers press in rural Hollandale, Wisconsin, in 1974.

Photograph courtesy of John Ross.

Warrington Colescott in his
Hollandale, Wisconsin, studio in
1978 with proofs of his *History
of Printmaking* folio of color
 intaglio prints.
*Photograph courtesy of Warrington
Colescott.*

Warrington Colescott with
Gene Baro, curator of prints and
drawings, the Brooklyn Museum,
as he selects prints for the Brooklyn
Museum's 20th National Print
Exhibition, "Thirty Years of
American Printmaking," in 1977.
*Photograph courtesy of
Warrington Colescott.*

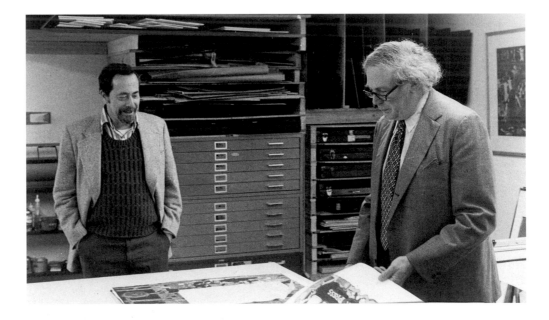

marks to get some life into the etching. I can also demand printing that leaves plate tone. None of this scrubbed printing that is so popular among the publishers. I want the white paper in the margins. Within the plate marks, I want plate tones and a hint of the ink as it has been distributed by the printer's hand." He likes to be in charge, rather than working in a committee of equals. "If the printer is the master, then the artist has to be supremissimo. It is his print; it bears his signature. The reality is that standards in many intaglio print shops are not high. I recently worked with a professional printer, and he was taping the wet prints on the wall to dry and later tearing off the taped edges along with the natural deckles. Unbelievable. You might as well print on butcher paper."

Colescott likes to exhibit. "Who wants to store art? I love to get the stuff out and get reactions back, to win prizes, to make sales. When someone buys a piece, I am truly complimented." Colescott feels this attitude is healthy. "In the early days at Wisconsin, we felt that we were outrageously underpaid—and we were. To live in Madison, an expensive town, with no financial resources and with the miserly salary that a young art instructor was paid, you had to get out and hustle. . . . There was an art public then that didn't have much money either, but was very adventuresome. People bought drawings, bought disturbing art, political art, sexy art. Art that you made essentially for yourself, tough statements with no compromises, had a good chance of finding a patron. . . . Dealing with gallery people was an education in itself. My favorite gallery director was Sylvan Cole, who ran Associated American Artists in New York. When I brought in a new group of prints, Sylvan would pull a long face and groan over my subject matter. 'Colescott, Colescott . . . you are so hard to sell.' The prints would go into the bins, and one way and another Sylvan would manage to sell them."[6]

Colescott sees satire as a periodic outbreak, most prevalent when the social fabric is under pressure. "When the audience is nervous and needs mirrors to see how they're doing, when they need a little help in understanding what's really going on, that's when the satirists thrive. War, depression, social upheaval, riots, rebellion, political assassination are driving forces for comic cuts. Sadly, I have lived through all of those events. Some terrible moments have been recorded in my prints. Times are better today, so many of the comedians and satirists have gone underground. . . . I watch our world and try to find a way to reference in my reactions. It's a tough sell. The field is jammed with paid advocates and lobbyists. Recently, as a responsible citizen, I have been dealing with good-diet and good-health issues. I'm taking a negative position on both."

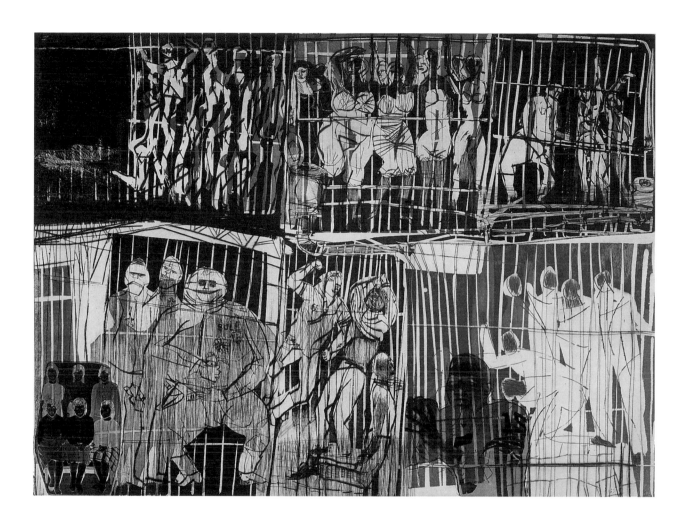

Warrington Colescott, *In Birmingham Jail.* Color etching and drypoint (1963–1964) 18 × 24. *Courtesy of the artist.*

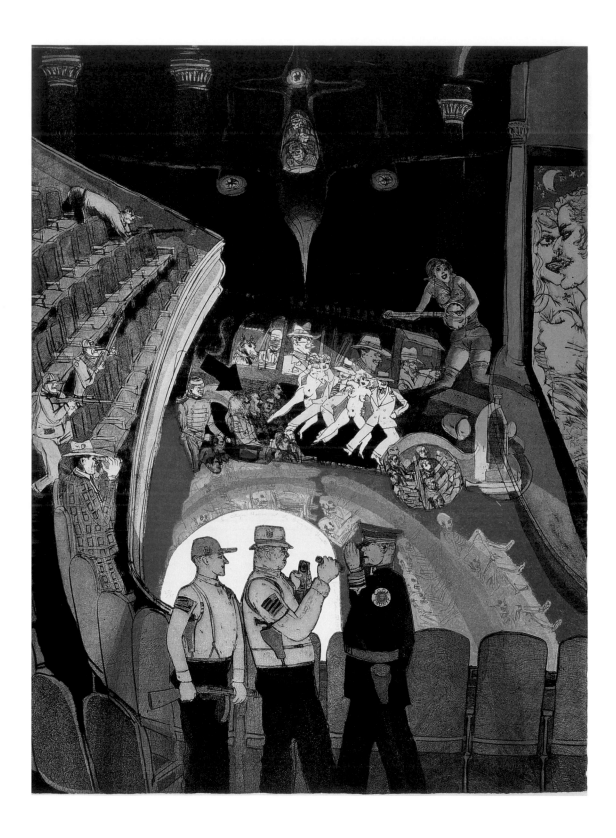

Warrington Colescott, *J. Edgar Hoover at the Biograph Theater.* Color etching and drypoint (1973) 30 x 22½. *Courtesy of the artist.*

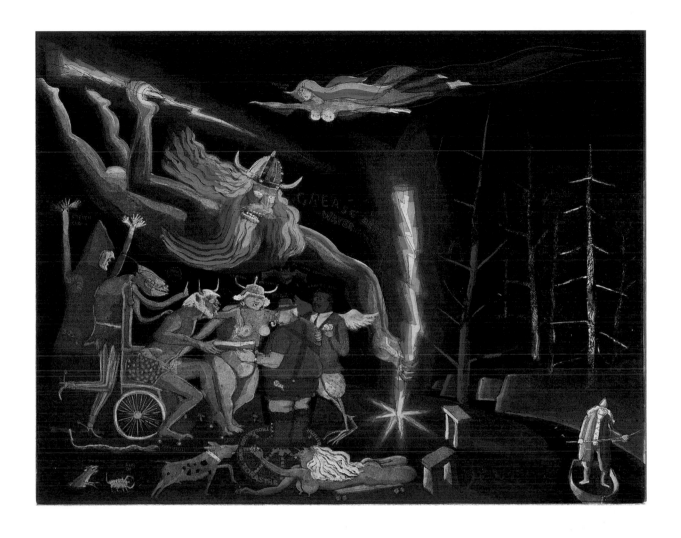

Warrington Colescott, *History of Printmaking: Senefelder Receives the Secrets of Lithography.* Color etching (1976) 22 × 28. *Courtesy of the artist.*

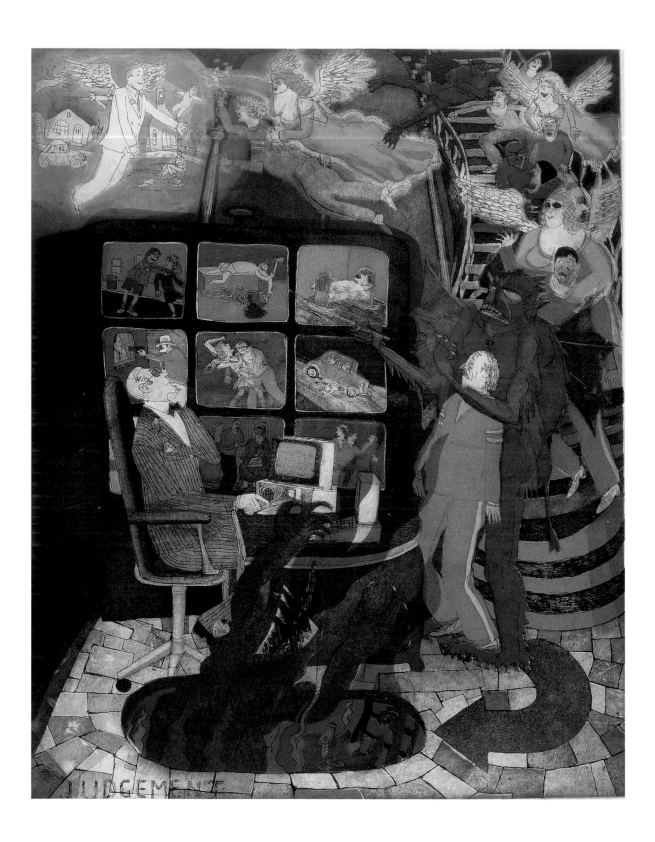

Warrington Colescott, *The Last Judgment*. Intaglio and color relief (1987–1988) 27½ × 21¾. *Courtesy of the artist.*

Warrington Colescott, *Judgment Day at NEA*. Intaglio in color (1991) 28 × 44. *Courtesy of the artist.*

Warrington Colescott, *Suite Louisiana: All you want to know about the battle at Chalmette.* Color etching (1994) 32 × 48. *Courtesy of the artist.*

Warrington Colescott, *Suite Louisiana: Audubon in the Atchafalaya.* Intaglio in color (1994) 32 × 48. *Courtesy of the artist.*

Warrington Colescott, *Tchoupitoulas Street.* Ingaglio in color (1997) 18 × 24. *Andrew Balkin Editions.*

Warrington Colescott, *Hunters and Gatherers.* Color etching (1997) 17 × 23. *Courtesy of the artist.*

For Raymond Gloeckler, as his adjacent poem indicates, wood engraving represents the ultimate test of artistic and technical skills: "I enjoy the challenge of trying to get the most you can just out of black and white—and particularly this tiny little block where you try to put the whole world into two square inches."[1] Like many from his generation, Gloeckler began making art before he had any exposure to actual works found in museums or galleries. As a youth in his hometown of Portage, Wisconsin, he began drawing, an activity encouraged by aunts, who did artwork themselves and gave him drawing books. "I really enjoy drawing and I always did a lot of it. I wanted to be a commercial artist—an illustrator, magazine illustrator." The inspiration for this came from his exposure to such popular publications as the *Saturday Evening Post* and an interest in sports stimulated by the widely circulated panel drawing of newspaper sports artists Thomas Paprocki and Willard Mullin. His first formal art training came during his senior year in high school, and he wound up doing cartoons and illustrations for the yearbook.

Gloeckler enrolled at the University of Wisconsin as a pharmacy major in 1946. During his first semester, he took courses in English, chemistry, physics, and pharmacy. He also took an elective course in drawing from Robert Grilley. That opportunity stimulated his still strong interest in art, and by the second semester, he became an unofficial art student. With the blessing of his family, he made the formal transition to full-fledged art major at the beginning of his sophomore year. Gloeckler chose to focus on art education rather than applied (studio) art based primarily on the practical advice of department chair Fred

RAYMOND GLOECKLER

No Place to Hide

The Woodcut

Without pretense
Black and white
Tool and block
There is no place to hide

Logan, who taught an art survey course. "With a bachelor's degree you found a job teaching in an elementary or a middle-school art department . . . and after graduate work a small college job. . . . if you were lucky, you would find a university job where they gave you time to do your own work and where the emphasis wasn't exclusively on teaching, as it was in the smaller schools."

Gloeckler's career path reflects that pattern. In the early 1950s, he began as an art supervisor for the integrated (urban and rural) school district in Tomah, Wisconsin. His appointment to that position was regarded as secure because he was a male and interested in athletics.[2] In 1952, he moved to Oshkosh to assume directorship of the art education program for the public schools; one year later, he took a position at the state teachers college, which would subsequently mature into the Wisconsin State University at Oshkosh and then the University of Wisconsin–Oshkosh.

Like many of his colleagues, Gloeckler started out as a painter but later shifted to printmaking. Early in his student career, he had an affinity for lithography; this emphasis eventually switched to woodcut. The change was due in part to the nature of the medium. Lithographs required heavy stones and large presses—both of which were not readily available to a teacher in Oshkosh. "That's when I started doing woodcuts, because you could do them in the kitchen, on the dining room table, in the bedroom. And you didn't need a press." His initial work in woodcut represented a reversal in scale. "I started working very large by the standards of those days. I remember doing a four-foot crucifixion. Well, in those days that was huge." He continued to do paintings, but they were smaller; most of those done in Tomah and Oshkosh were conventional in size. Just before leaving Oshkosh and moving to college teaching positions in Flint and Ypsilanti, Michigan, he began to do smaller paintings. "People used to kid me about that all the time: 'Why do you do these tiny little paintings, five by seven inches, and then you do four-foot woodcuts?'"

While at Oshkosh, Gloeckler began to exhibit more aggressively his creative portfolio, which included both paintings and woodcuts. "I started to exhibit nationally when I was in Oshkosh—at the Library of Congress, Boston Printmakers, and the Print Club of Philadelphia. At the same time, we had formed a group called the Seven Arts—people teaching in Oshkosh, Appleton, Neenah-Menasha. We would bring our work and critique it together and then schedule exhibits." It was a time when there was still a focus on local and statewide shows. The major shows were the Wisconsin Painters and Sculptors Show held in Milwaukee, the Wisconsin Salon of Art held in the Memorial Union at the University of Wisconsin in Madison, and the State Fair Show. He also exhibited annually at the Northeastern Art Exhibition in Green Bay. "I was really into exhibiting. That's how you made it. You scored in state shows. That's how you built your reputation. I remember when I was still in Tomah going to the mailbox and checking to see whether something was accepted in a show or not. Because of that, I came to know a lot of artists in the state and a number in Milwaukee that I had little contact with otherwise." However, extensive travel was not appealing to Gloeckler, who found the easy portability of prints an attractive option. "One

of the reasons I wanted to stay in printmaking is because it allows you to stay at home and send your work around. I don't travel much.[3] And I don't fly. It just makes me very uncomfortable, and I don't enjoy it. You could easily mail prints and get your work around that way, and you didn't have to travel with it. And you didn't have to crate it up like a painter or sculptor."

Translating an artistic idea into a physical reality has invariably been a painstaking process for Gloeckler. "I usually do a rather quick drawing, just to get the feel of it and the thrust of it—a kind of thumbnail sketch. And then I develop it more on the board because the grain of the wood influences the final image. I usually make a very elaborate drawing on the board before I ever start cutting. I want to try to cut without having all sorts of design problems to worry about. I want to get into the rhythm of the cutting and the emotion of the cutting and let it carry itself. With an elaborate drawing, which I may or may not follow, I have all sorts of options I can respond to." While the act of drawing may be comparatively free-flowing, there is a concentration on detail. "I get very much concerned with every fingernail, every hair. Every wart and blemish becomes significant and is built into the design. I try to draw it in such a way that it has the same feeling and action as the entire figure, so that the crook of a finger becomes very significant to me. I am always impressed by George Grosz's fingernails. He could make a wretched looking hand just by the way he drew fingernails. Or he would have maybe five little dots placed somewhere on the figure or within the drawing that would make everything look just awful, ratty, decayed. I'm much concerned with that kind of detail. However, it's typical of my work that while I delight in the intricacy, the complexity of the design, I tend to contain it within a single figure rather than a panorama of images."

Once it comes to the actual cutting or engraving of the wood, the real action begins. "It could be a print that's two by three inches or it could be three by four feet, and it takes me at least sixty hours. Don't ask me why. I have students that do them overnight, but it takes me sixty hours. You couldn't really afford to do that if you had to make your living from printmaking, or from the sale of prints. Fortunately, by virtue of being a faculty member, you have the opportunity to do things that a gallery-type, a making-a-living-from-your-art-type artist can't." Each time, he has a confrontation. "Whether it's end grain or plank grain, the ink-stained wood invites adventure. The physicality of the cutting and the resultant organizational challenge becomes a struggle. You develop a relationship with the material that's different from what you have in painting or drawing. In a way, it's like a football scrimmage—not a game, but a contact scrimmage where you're pitted against one of your own teammates. He's trying to overcome you, and you're trying to overcome him. You have to learn to deal with his moves and his actions and his strengths, and he has to deal with yours.[4] But you're helping one another. You're learning from him, he's learning from you, and both of you are developing skills that will help the team. So it's a cooperative venture, but at the same time, you're antagonists. . . . During the best times the cutting is instinctive. The drawing on the board ceases to dictate. In-

Raymond Gloeckler's class in relief printmaking at the University of Wisconsin–Madison in 1982. Gloeckler is working on a woodcut.
Photograph courtesy of John Ross.

stead, you react to the thrust of the image and the character of the wood. Cut follows cut with vigor and certainty. The tool has its way. The image, transformed into sharp black and white, yields a new and different reality. There's a rightness about it all. Ink, image, material, and tool have combined in an inimitable way." Occasionally, he became stuck in the act of creation. That required a momentary distancing from the work in progress. "You work all morning and then you're stuck, and so you set it off to the side, not where you'll see it when you walk in the studio, but maybe around the corner. And then you take a stroll in the afternoon, casually trying to do something else so when you come upon it all of a sudden, you oftentimes see what's wrong."

Both the woodcut and the wood engraving have their distinctive characteristics. With the woodcut, "There are a number of physical restrictions that you have to overcome, that you have to compensate for, or accommodate. They have a bearing on the kind of imagery you develop. It's very difficult to look at a block of wood with the grain and the knots and

everything else in it and draw on that surface without being influenced by what's there. So whether you consciously incorporate the grain pattern and the personality of the board, or whether you do it subconsciously, it definitely has a bearing. But you can't allow that to dominate the work. You can't allow that to dictate to you what you're going to do. Some students fall into that trap. They start scraping the wood to raise the grain, and then they begin to alter their drawing to conform to the grain. Soon the board is telling them what to do, the board is making their image for them. . . . On the other hand, you can't dominate the board. For example, you don't want a drawing that forces you to make most of the cuts vertically when the grain is running horizontally; this would cause physical problems cutting across the grain. The wood tears, it chips off. So you have to develop a partnership with the board, a relationship with the board."

Gloeckler treasures "the simplicity and magic of the woodcut, the black and white of it. Its rudimentary nature. It has been said that all you need to do a print is a jackknife and a block of wood. It takes more than that. Still, there are few encumbrances. . . . The woodcut is an upfront medium. Straightforward. Every cut, every scratch and blemish shows. No mucking about in tonalities and subtle nuances. What you see is what you get. . . . In a culture of excess, media hype, relative values, and high tech, the woodcut provides a refreshing clarity too often abandoned for more seductive media. It offers a center point, a reality that's rock solid, deep-rooted and enduring. What is, is." From Gloeckler's perspective, the line of the woodcut "has a crudity and power that you don't get from a brush line or an etching line." There is no limitation to woodcut "because you can work as large as you want, you can print as large as you want." An example of this freedom is his *Dane Co. Damsel*, a six-foot-high woodcut of a cow on a bicycle.

Wood engraving is inherently more restrictive. "When you look at the end-grain block, which is really a joining of many smaller blocks into one larger block, it has a very intricate grain pattern. It doesn't have the same kind of rhythmic flow, and it doesn't have the knots that a plank would have, but it possesses an elegance, characterized by its precision and refinement, a quality that plank grain wood lacks." Yet, the tightness of the end-grain block provides an opportunity for greater detail. "Wood engraving is done with closed-end engraving tools—burins, rather than gouges—so you can do much finer work. The wood can be cut in any direction without tearing the grain. Traditionally, wood engraving was a tonal medium. You could make all sorts of fussy little cuts to achieve gradations of value. Nowadays, that's often no longer true. In fact, it's difficult when you project slides of the work to tell if something's a wood engraving or a woodcut. I clue my students they can tell it's a wood engraving if the artist's signature is overlarge. Either some egocentric did the print, or it's likely to be a wood engraving."

Gloeckler's early work in woodcut had a specific orientation. "Most of the stuff I was doing was more or less religious in nature. I was strongly influenced by Käthe Kollwitz and Shikō Munakata. The work was humanistic and religious. I remember doing *Ecce Homos* and crucifixions and things like that, because the images were suited to such a pow-

erful medium." After these initial efforts, he moved on to other subjects but returned to religious imagery when he began working again in larger sizes, using such icons as the crown of thorns for subject matter. In the early phase, the religious emphasis arose out of his interest in the power of the medium; in revisiting the topic, another influence emerged: "For years I've been a devotee of Thomas Merton, the Cistercian monk, who in the fifties and sixties did a great deal of writing on racial relations, social issues, Eastern mysticism, Vietnam, and so forth. Because of him, I've always been fascinated by monasticism and that particular ordering of one's life."

Though religious iconography has periodically surfaced in Gloeckler's prints, the bulk of his work represents a primarily satiric commentary on the times through which he has lived. He believes that "satire uses humor as a weapon to wage a war of ridicule against society's ills. The satirist pokes fun at our errors. He needles us in the hope that we may mend our ways. For him, the title is a significant part of the print." A sampling of Gloeckler's titles, much less an examination of his images, points to the direction of his work: *Social Mogul, Convening of the Committee for the Certification of Persons on Points of Political Correctness*, and so forth.

A good portion of Gloeckler's orientation was shaped by the influences he had as a student at the University of Wisconsin. "The people who were teaching in the universities were professors like Sessler and Santos Zingale, who had been artists during the Depression, artist/teachers who did essentially social-commentary-type painting. They were your professors, and you were influenced by them. I certainly had the impression that art had a social function. I was interested in becoming such a social observer and commentator through a visual medium. Some could do it as a writer, some could do it as an actor or a musician, but I chose to do it as a visual artist." Therefore, he focused on the cold war and civil-rights struggles of the fifties and sixties. "Those were dark times," he recalled. His antidote was to pierce the prevailing blackness with periodic flashes of sharp editorial commentary using the power of the print to make an incisive image that captured the folly of the moment. Like the great satiric artists of the past, Gloeckler's images serve as a form of contemporary documentation. At the same time, their artistry and design produce a strong and enduring artifact that ultimately rises above the topicality of the subject matter.

Gloeckler maintains that even though his humor is satire, it is not meant to be savage or misanthropic. "I enjoy people—good or bad—and I'm interested in them. They enthrall me. I don't really enjoy injuring people. One problem that you have with the woodcut particularly is that it's such a powerful medium that even if you employ humorous images, they can get grotesque and become pretty nasty." Unless he was targeting a specific person, he tried to stay away from creating recognizable individuals in his prints. He was not always successful in withholding one's identity, because "when you're delineating human behavior, you tend to ascribe it to certain people and individual personalities." Recognizing this dilemma, he began to employ a fabulist's perspective. "I didn't like

doing to humans some of the things I was doing, so I started doing animals. Many of the earlier human figures I drew began as animals, anyway, or were derived from bird or animal shapes. And then it was only later that they actually ended up as people. It became easier for me to take a swing at or poke fun at or insult a bird or animal form rather than a human form. Since the images were derived from animal forms in the first place, it seemed appropriate to use animal rather than human nature. Also, there are certain characteristics that we associate with birds and animals which can be implicated in the work. You hope people will make that connection." Sometimes the connection is not made. Gloeckler remembers doing a series that he thought represented the interests of a certain underclass. "I felt strongly about these prints. I thought this was art for the people. But the people didn't like the prints. They thought they were big and ugly and terrible."

Quite often, Gloeckler's explorations involve a look inward. "Most of the prints are really autobiographical. The caricatures are clearly someone else. Probably most of the other figures, whether they be warthogs or jackasses, wrens, donkeys or cows, or whatever, are usually me. At least I think of them that way, so they're personal responses. For example, I employ the warthog as a symbol to deal with male mid-life problems—the domestication of the beast kind of thing. The warthog is a special challenge because it's supposed to have the ugliest head of any mammal. So I'm trying to take one of the ugliest things in the world and make it into art, which is an additional challenge."

The artist as biker. Raymond Gloeckler at the conclusion of his daily commute from his home and studio in Middleton, Wisconsin, to the university campus.
Photograph courtesy of Raymond Gloeckler.

Gloeckler has found that the university, with its relative job security, provides somewhat of a sanctuary for someone who wants to make a controversial statement. "I think it provides the opportunity for people to do the kind of work that would rarely sell. The kind of work that's contentious, disturbing, challenging, and confrontational is something that a gallery would prefer not to show because it isn't salable. The university environment provides a freedom that you otherwise might not have to do this type of work."

Invariably, Gloeckler is concerned about how far his reach can actually extend. "I think a question arises when you're doing that kind of thing in a print and your goal is really social, political, or propagandistic and you want to communicate this to the most people. Maybe you shouldn't be doing a wood engraving that takes you sixty hours when you can do a pen drawing and run it off on the Xerox, or when you can publish it through a newspaper or on the Internet. You may have an additional problem if you do this kind of printmaking and then exhibit in the art galleries—who's your audience? . . . Are you just preaching to the choir, scratching one another's back in the monkey cage, or are you really making a difference?"

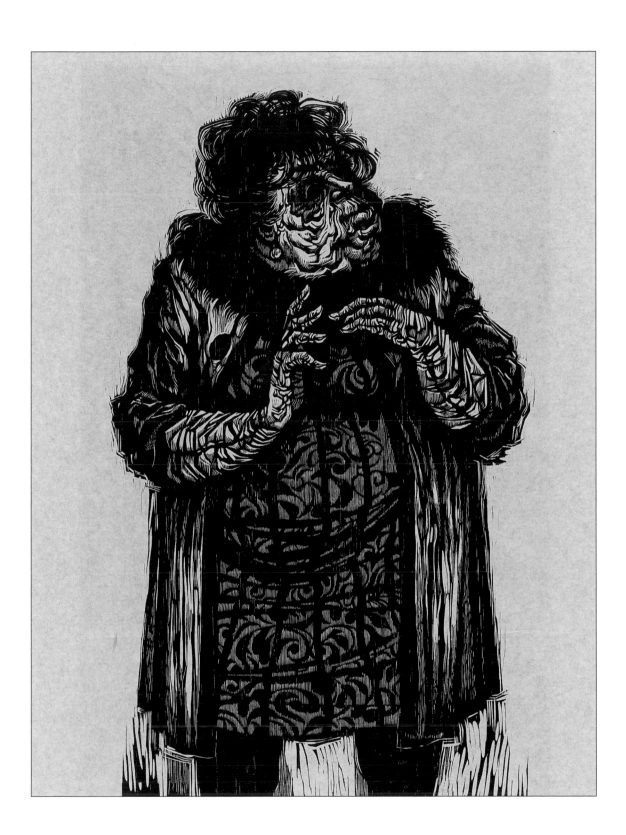

Raymond Gloeckler, *Social Mogul.* Woodcut (1961) 36 × 23. *Courtesy of the artist.*

Raymond Gloeckler, *The Blockers.* Woodcut (1964) 18 × 30. *Courtesy of the artist.*

Raymond Gloeckler, *The Man from Portage.* Color woodcut (1969) 30½ × 21. *Courtesy of the artist.*

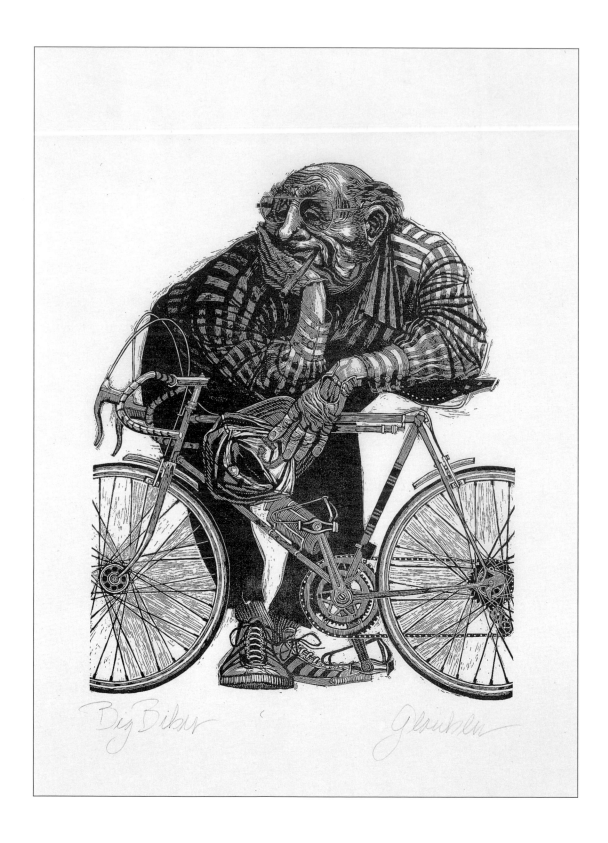

Raymond Gloeckler, *Big Biker*. Wood engraving (1971) 13 × 9. *Courtesy of the artist.*

Raymond Gloeckler, *Political Parade*. Five wood engraving blocks (1972–1973) 11 × 10. *Courtesy of the artist.*

(top) Raymond Gloeckler, *All my friends are over fifty*. Woodcut (1982) 17 × 24. *Courtesy of the artist.*

(bottom) Raymond Gloeckler, *Bugs and boars, pigs and pests, the Red Baron and the mighty Bat Man*. Wood engraving (1988) 10 × 12. *Courtesy of the artist.*

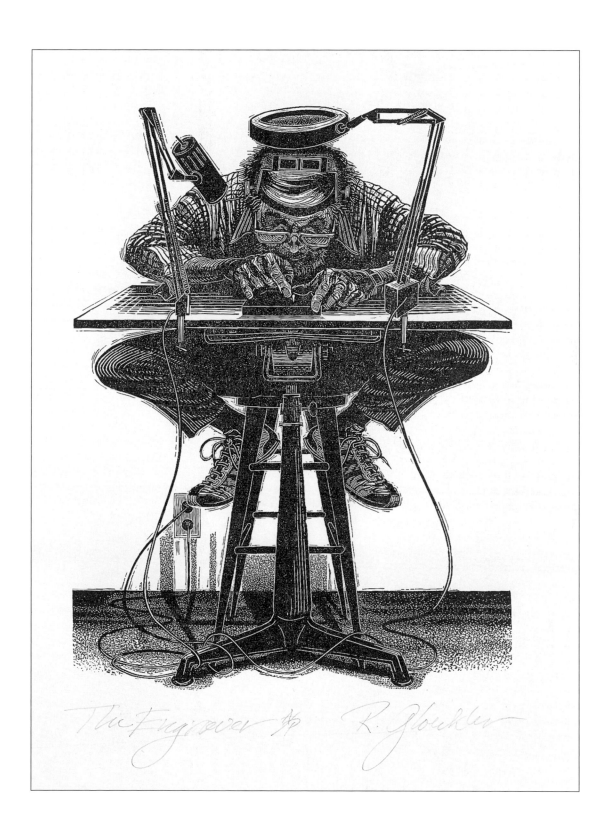

Raymond Gloeckler, *The Engraver.* Wood engraving (1984) 8 × 6. *Courtesy of the artist.*

Reflecting on the direction of his work, Jack Damer points to discrete stages of his personal and artistic development.[1] "One of the things I've suggested is that one's work seems to evolve through five- to six-year cycles of change, but not necessarily in a linear fashion. Call it split personality—a suggestion that I had sympathies with a variety of approaches, from figuration to abstraction. Maybe it was a desire not to be pigeon-holed, but to be greedy and to explore everything one sees on one's own terms. There seemed to be too many options to settle on only one. However, regardless of the image, the work was always predicated on formal structure and refinement. . . . Most of my work started out very traditional from the training I had, using the figure, still life, and landscapes. I then shifted into using machine parts based on wrecked automobiles as subject matter. From there, I introduced more color, and then the color evolved into more nonobjective things, and then I started cutting up the nonobjective color pieces and eventually dimensionalized them. That attempt was, in my view, to push the notion of what printmaking was all about—to push the issue of multiples, duplication, and editions versus the concern for a single precious object. . . . Each cycle generated more interest, as if I'm throwing more wood on the fire. So each cycle I'm sort of upping the ante. In fact, the creative process held my attention more so than the product."

The need to increase the creative ante, Damer believes, is heavily influenced by what he sees as a highly competitive situation forced on the artist by the visual aspects of contemporary media and popular culture. "I felt I was in competition with all this seductive visual stuff. I sought an approach that had more

presence and personal meaning. I sensed a really short attention span in the majority of the audience I was dealing with—they just glanced at things very quickly as if they didn't *see*. They just watched instead. Watching evens things out; everything becomes the same and equally important or not important. The probing visual experience seems to be replaced by the steady veil of TV, the Net, and film equivalents. The strategy was to find a way to introduce work that would stop the viewers in their tracks." Damer sees the contradictions of subtlety and depth versus immediacy as a problem. "My work's always had layering effects, including the repetition of things—marks, images, and editions. It must be the obsessive-compulsive nature I have, but it's also a problem because the pieces demand attention and examination coupled with the suggestion of permanence. Although it may be out of step with the times, there is little doubt that one of my objectives was to make images that were beautiful in addition to being imaginative and perceptive within the realm of recognizable craft."

In spite of the fact that he has created a considerable body of work, Damer finds himself periodically creatively tapped out. "Like other artists, I've had numerous periods of blockages where I've considered giving up art production altogether. There are periods of two or three months or more where nothing happens. One fallow period leads to another, eventually countered with an obsessive streak of energy where one feels the renewal necessary to continue." In reality, these interludes appear to be the transitions between those distinct stages of his work. They can be interpreted as the subconscious ruminations that lead to new perspectives.

An examination of the varied stages of Damer's development reveals a fascinating conjunction of technique and perception. He began as an art student in the late 1950s at the Carnegie Institute of Technology (now Carnegie Mellon University) in his hometown of Pittsburgh, Pennsylvania. He found it a fruitful and exciting time to be an art student. "My original emphasis was in illustration and graphic design. Carnegie was a professional art school and I was fortunate because my schooling was at a time when there was an inordinate amount of interest in art. It was the period after the Korean War, and there was a strong sense of optimism in the country. Many of my colleagues went to school without any idea of what they were going to end up doing with the training. We just wanted to be artists. It was an idealized bohemian sensibility of what art was about."

Following graduation, after fulfilling a six-month army reserve active-duty commitment and holding a one-year graphic-design position in Washington, D.C., Damer returned to Carnegie Mellon, where he completed work on his master of fine arts in 1965. By this time, he had a better idea of the direction he wanted to take as an artist. "When I returned for graduate work, I decided to focus on printmaking. My reasons behind that decision were based on the fact that all the work I did seemed to benefit from a long developmental period of perception, correction, and changes. At the time, I wasn't capable of doing something quickly, with one expressive shot. The images started out and went through extensive distillation and transformation, correction and change. And it seemed

to me printmaking with its many available processes could benefit from that way of approaching the work. In addition, I just plain liked the look of prints, including the processing and press work. . . . Initially, I started out doing etchings and woodcuts. My instructor [Robert Gardner] was at Tamarind [Lithography Workshop in Los Angeles] at that time.[2] When he returned from Los Angeles, he had accumulated all this technical knowledge about lithography. We started working together, and I got completely immersed in that process."

Although it seemed a traditional and antiquated technology, Damer found in 1960 that the process had dramatic new potential. "The so-called Tamarind approach to lithography was producing images I hadn't seen before. Technically, there were properties in terms of size and materials that were unique and broke new ground; for example, new, intense commercial inks. If one looks at prints from the zenith of French lithography—the 1890s to, say, 1910—there's beautiful color, but the colors are generally muted, mixed with white. There's very little of this intense, raw, rich color that the development of commercial inks enable us to exploit now." His interest in lithography only intensified when he was appointed an assistant professor at the University of Wisconsin in Madison in 1965. Lithography "was the medium I was working in and also was the medium I was teaching. There is little doubt that I was obsessed with the process and its creative potential. Maybe it was the fact that litho had a defined history, or the beauty of the stones and the marriage of ink and paper, or that the printing demanded skill, concentration, imagination, and stamina. I wanted to honor the process. . . . Overall, my work to this day is predicated on a sense of draftsmanship and drawing. Lithography was a comfortable fit. One thing I especially liked was that lithography enabled me to print these unbelievable rich value ranges that I couldn't achieve with pencil. My pencil drawings always seemed to be 'thin' in regard to value. For many reasons, lithographic ink would fill in slightly and produce these dense blacks. I was enthralled with that richness because I felt it dramatically improved the look of the print. And of course, surface had always been a personal issue in my work."

Damer's initial choice of subject matter involved a combination of responses to technical challenges, comments on the cultural environment of the moment, and an extension of his boyhood interest in mechanical objects and hot-rod culture. "I was looking for subject matter that gave some sense of identity that I could relate to on a personal level. Much of the subject matter came from second-hand sources, either reconstructed or appropriated using generic photographs, diagrams, or drawings. The sources acted as a trigger for the inspiration." The autos and machine parts in his early lithographs "were fascinating because they seemed current, or up to date in regard to tradition. The automobile held an essential and almost religious place in our culture and seemed like something most people might ignore or think unworthy as subject matter or theme. I kept with machine-form images for a long time; in fact, I never completely abandoned my interest in mechanisms. The forms appeared in etchings, woodcuts, plastic engravings, and of course a lot of lithos." The automobiles resembled the images found in manuals, cata-

logs, or car magazines. Tools and machine parts provided other options. "I've always looked at anything that had some type of mechanical structure and function as possible subject matter, either in whole or as parts. At times, I distorted the size of things. I would put maybe fifty or sixty objects in one composition, distorting the size relationships or completely changing the context. I wanted a 'cool,' detached feel to the compositions, so I attempted to limit the usual aesthetics and sentimentality."

Damer's next period of exploration involved the transition from the black and white and wide tonal variations associated with the traditional lithograph to the use of color. His subtle layering of color relied on the accumulation of large amounts of detail and visual information for its impact. In several instances, the informational detail was realized through the use of templates of engineering symbols to create small, runic-like forms that were incorporated in the composition through repetition. This technical process demanded precision in order to achieve the overall effect desired. He notes that "seldom will a print work if the technique's careless. The German expressionists' lithos are an exception. The amount of detail and information in my initial color work made the technical perfection in printing absolutely essential."

Something new emerged from this experience that took Damer's lithographs dramatically beyond the limitations of the stone—literally into another dimension. "I became disenchanted with just a flat image, so that's why I experimented with printed, dimensional object making. The idea was to extend the notion of printmaking into three dimensions and challenge and use the concept of editions and multiples. . . . My strategy was that I would print ten images and then ten other images and then ten more. Those multiple images would be cut up and used to construct a fourth image that was unlike any of the other three. If I had enough of the edition, I could actually make a fourth edition from the materials of the other three prints." This was accomplished by cutting the various print versions into strips and shapes, overlaying them, and finishing the idea with glue and cutouts, much like collage. "I got a lot of mileage out of just a few plates. That was satisfying because I didn't have to make a new matrix for everything. I saw [the resultant three-dimensional prints] as a theoretical idea of what printmaking could do as an extension of the flat, two-dimensional print; in other words, using editions to make single, rare, unique objects, or using editions to make a different kind of edition. Since the 'raw material' was printed rather than painted or appropriated, it gave the finished piece a different, more-refined look."

The departure from conventional methods also brought Damer a sense of liberation. "I got to a point a few years ago where I stopped worrying anymore about what I did. I didn't care whether it fit in or whether people accepted it. That was a big breakthrough. It came from the revelation that I probably was never going to make it in New York. What I usually saw as 'the art world' didn't interest me anymore. My respect and reverence to what was submitted as higher art and theory was undermined. The solution seemed a self-evident one—just come into the studio and do what I felt like with no qualifications on it.

Consequently, I went from the tightening-up effect that printmaking might dictate to something more expansive."

Damer felt his explorations presented a problem in perception and expectation for some viewers. "Some of those constructions seem to have been misunderstood. The big problem, the misunderstanding, was that some viewers saw them as decorative and over-looked the theoretical issue. That wasn't my intent. I saw them as a printmaking exten-sion. Maybe they were too attractive and this undermined the theory. . . . In terms of an-other view, there is the assumption that art is either/or—you do this or you do that. Maybe it was the sense that I was somewhat limited in the flat surfaces. I had explored so many different approaches to prints, all the different kinds of lithographic techniques I could think of and maybe it was just a matter of being enthralled with the printmaking technique initially. The evolvement into the cutting and collaging of prints gave the work a feel of having more breadth and the ability to expand past the technical labor of edition printing and its potential pitfalls."

In addition to his own development, Damer was very conscious of his responsibilities as a teacher. "I don't consider myself purely an artist. I don't consider myself only a teacher. I consider myself both. Teaching is very critical today, and I take the mission seriously be-cause I'm working with young people, young minds—the future. I'm perpetuating some-thing, and I think my strategy is to teach by example to the degree that I'm involved in what I'm teaching. I believe in it; I work hard at it, and I respect the students as begin-

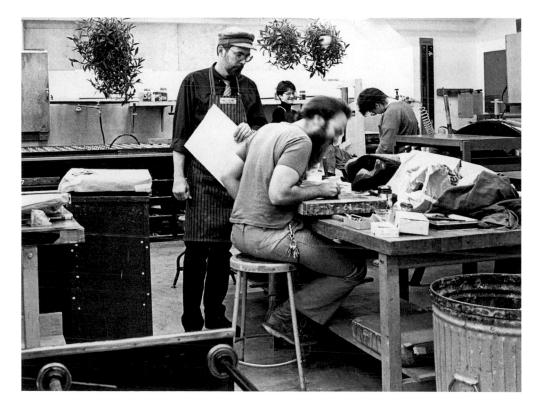

The lithography studio in the Humanities Building at the University of Wisconsin–Madison. Jack Damer reviews students' drawings done on litho stones.
Photograph courtesy of John Ross.

ning artists, . . . who might be going on with deeper research. In my view, teaching and art interlock in a positive and self-gratifying way. Both confirm a positive view of the future. . . . The stone is my favorite medium to teach lithography because its characteristics are more forgiving. It's a much more sensitive, more organic material to work with. It's flexible, and one can't easily destroy it like a metal plate. It's technically superior to plates as a teaching aid, in my view. . . . I see art education as critical because having a non-aesthetic society is depressing and unfortunate. So is the fact that one of the richest nations uses only a fraction of its tax money for cultural support. For that reason, my mission is to give these young people with whom I'm working some sense of aesthetic value in relation to being able to experience something visually, being able to appreciate something on a higher level. I think the mission of the art school should be to graduate people that aren't necessarily artists but . . . have a developed visual vocabulary, rather than 'artists' as recognized by the media and art journals. That will come later as the student becomes more professional."

Damer himself is a student of art and artists. His interest is based on the belief that "art comes from art." For that reason, "awareness in regard to artists of today as well as the past gives one a perspective on accomplishment and a sense of your own proportion. In other words, where is one's place in today's complex and, at times, mystifying milieu?" The answer to that question involves not only the awareness of the work of his peers but also a sensitivity to the tension that exists between the artist and the audience. He finds this is a continually changing relationship. "Contemporary art, as opposed to popular art, has evolved through modernism and postmodernism to a point where it's so rarefied and parochial that the general public usually can't understand it or grasp it. I don't blame them for that, but one must realize that most artists I know spend hours and hours on research—working, digesting art history, looking at new approaches. They try to synthesize and distill that information and come up with something that has originality and meaning. Now how is a person who has no background or research experience in art going to be able to grasp the artist's message, especially if there's a high degree of concept or theory present? Somehow art seems to suggest meaning even to the most naïve, but most likely it's the wrong interpretation of the artist's intent. . . . There is something that the general audience can see in any work, however. There has always been an audience for realism—how close is it to the perceived reality? The second is the indication of labor—how long did it take?"

Artists, in Damer's final analysis, face the challenge to connect with those who see their works. "Working as an artist today is a unique experience because of the vitality and visual experience generated through the media. My motive is to make work that in some way reveals the awareness of a sensitive person living in this period, to expand the ordinary into something extraordinary. . . . [I]mportant art separates from the visual 'noise' around us. It transcends that experience through a transformation based on ideas, vision, and craft. When we look at effective work everything else seems to disappear."

Jack Damer, *Four Stroke Man*. Lithograph (1970) 35½ × 25. *Courtesy of the artist.*

Jack Damer, *Hausmann at Home.* Lithograph (1970) 24 × 34½. *Courtesy of the artist.*

Jack Damer, *Flak.* Lithograph/collage (1979) 30¼ x 23. *Courtesy of the artist.*

Jack Damer, *Exacto Facto.* Lithograph (1980) 24½ × 29½. *Courtesy of the artist.*

Jack Damer, *C. C. Explorer*. Lithograph/collage (1991) 33 × 24¾. *Courtesy of the artist.*

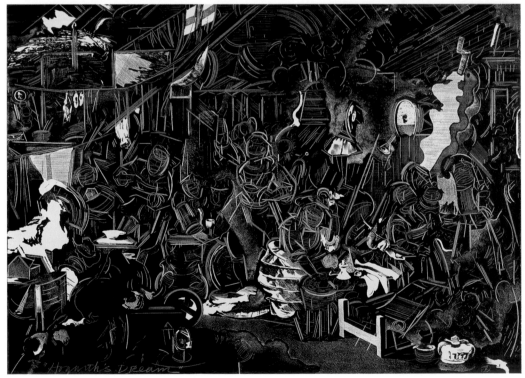

(top) Jack Damer, *Blacklist.* Lithograph/etching (1992) 22¾ ×31¾. *Courtesy of the artist.*

(bottom) Jack Damer, *Hogarth's Dream.* Lithograph (1995) 27¾ × 37½. *Courtesy of the artist.*

Jack Damer, *History Lesson.* Lithograph (1996–1997) 38 × 28. *Courtesy of the artist.*

Walter Hamady's views of the universe are synthesized in a series of self-published "interminable gabberjabbs." In trying to capture the essence of the genre, Francis O. Mattison has said, commenting on numbers 1–5, "A Gabberjabb is, as best I can define it, a series of chatty, continuously footnoted poems printed on broadsides folded into an inventive presentation employing variously sized, colored, and textured papers. . . . The poems are elaborately footnoted with a mixture of information obvious and outré, useful and off target, a wicked parody of the documentation found in the work of the autodidact and in the textbook uncertain of the intelligence of its audience."[1] William Bunce, head of the Kohler Art Library at the University of Wisconsin–Madison, has noted added dimensions in numbers 6 and 7. "They are," he says, "virtuoso explorations of typography and an inventive juxtaposition of stray texts which form a multi-layered, surrealist autobiography." Hamady is recognized as a creative pioneer. He is one of those individuals who believe that the physical act of letterpress printing can be used to produce limited-edition books that combine craft and technique with artistic sensibility. The resultant works have an aesthetic impact similar to that of prints.[2]

Hamady believes his inexhaustible voice is attributable to the fact that he is the product of two cultures. His mother's family is from Keokuk, Iowa, while his father is Lebanese. "One of the things that's been important all through my life has been the 'culture crunch' of two families uniting through my mother and father—one being basically off the boat and the other being an old-line, blueblood family in this country. Growing up, I identi-

WALTER HAMADY

Virtuoso Explorations

fied, and I still do, more with the old country roots than I do with the white, Protestant, Anglo-Saxon traditions. I realized in a visit to Lebanon during the 1950s that being off the boat doesn't mean that you're nobody. . . . It's really incredible to find these roots and to learn some of the things about the Druze. They know where the hell they've been all this time. The saying is that they're sort of the Unitarians of the Middle East. As I learn about things, I see where attitudes come from in my grandfather and the older Hamady guys that I really admired."[3]

Even though he feels this strong connection with his Lebanese ancestors, Hamady acknowledges that the predominant personal influence in his life has been his mother. Divorced from Hamady's father when Hamady was fifteen, she pursued a career as a pediatrician and raised her son and a daughter in Flint, Michigan, and later Detroit. "Walter will be okay," she would reassure others. "He's solved all three of his Oedipus complexes."

Hamady's world view, however, has been heavily influenced through his strong affinity for his Druze ancestors. "One of the things the Druze say is that the power of the universe, the divine power, is in all things and it's accessible to all people, and you don't need a priest or you don't need a hierarchy to interpret it for you." A second major influence has been the quietude found since 1973 on a farm south of Mount Horeb in what is called the driftless (unglaciated) area of Wisconsin. The farm doubles as his family home as well as the site for his Perishable Press Limited, housed in the parlor of the old farmhouse, which he locates in Perry township at a "minor confluence."[4] It is from this observation platform that Hamady has developed both artistically and philosophically as he looks both inward and outward. *The Quartz Crystal History of Perry Township since the Earliest Creation of Life* is a diminutive book (3⅜" × 2½"), published in 1979. It is a collaborative exploration of the cosmos and the natural environment he embarked on with his children. At one point in the text, Hamady reflects that "it is very interesting to think about where we came from. Dolphins know lots and lots more about where we came from than most human beings. All other living things go about their business in harmony with the environments of this planet Earth and know what teeny weeny little itty bitty specks they are in the gigantical space-without-end called the infinity of the Universe."

One expression of the Hamady *Zeitgeist* is the journal he began in 1962. "It started the year I was at the Pratt Institute. The Museum of Modern Art made a calendar book every year and . . . so I just kept a log book and did that until maybe about '65, when I started to write in a separate journal. I was inspired by Paul Blackburn. Paul kept a journal, and he used it as a springboard for his poetry. He put everything in the journal, and then he just refined it. When I saw what he was doing with the journal and the poetry that was coming out in that form, it knocked my socks off. I took my own journal-keeping a lot more seriously. . . . The journal is like this big vacuum cleaner that's in front of your head, and you're going through your life and just sucking this stuff in, and it all finds a respectable place. The journal is not a form like a sonnet and doesn't have any rules, so you can put anything you want in it. It's a wonderful vortex, a whirlpool."

Hamady's introduction to bookmaking occurred in a manner he describes as typical for him: "Everything that has happened in my life that has been beneficial and good has just fallen from the sky, when I was not expecting it." A fascination with geology and land forms had prompted him to take a tour of the Midwest to see and learn how the land got to be how it is. During a stopover visit with relatives in Iowa, a friend—the printmaker Daniel Lang—had introduced him to Harry Duncan, who was printing a book for his Cummington Press.[5] This meeting had revealed to Hamady that books and printing could be utilized as a distinctive art form. This epiphany subsequently found a tangible outlet at Wayne State University, where he worked with Peter Gilleran and Robert Runser. Runser had a hand press. He and Hamady formed a partnership, which included Hamady's teaching and giving demonstrations at various high schools in the United States and Canada. The first two books Hamady printed—*The Disillusioned Solipsist* and *Ephemeral Genesis*—were personal meditations on his life and heritage. The third book was a selection of poems by Robert Creeley, the aftermath of a poetry reading that Hamady had attended in Detroit. Hamady acquired permission, printed the poems, and then sent Creeley a copy of the completed book. "He wrote this glowing letter of approval," Hamady recalls. "So that was it. I'm on the map and it's been gangbusters ever since."

Hamady's eventual settling in Wisconsin was another of those pieces of his life that fell from the sky. He was preparing to visit a girlfriend in Winona, Minnesota, when an inquiry came from the University of Wisconsin art department. Would he be interested in applying for an opening in the graphic area? He decided to stop off in Madison on his way to Winona and see what might develop. He was subsequently hired for the position.

Claire Van Vliet was teaching at Madison on an interim basis at that time and was herself interested in promoting the book arts.[6] Harvey Littleton, an influential member of the department, tutored Hamady in applying for a research grant from the Graduate School to initiate a course in papermaking. Hamady's successful petition, which allowed him to secure the necessary equipment to start up a paper mill, was a turning point. "I never would have stayed in academia had it not been for that grant."

Hamady is noted for his productivity as well as for his ground-breaking efforts. There is a certain urgency to what he does. He seems to be looking anxiously over his shoulder as he races to accomplish the task at hand while the will and the way exist. In keeping with the overtones of the Perishable Press name, he talks regularly about the realities and finiteness of life and about the limitations imposed by one's gene pool.[7] "We're only going to be on the planet once, I think, and when we're gone, we're gone. We have our powers only for a certain period of time and then we're going to lose them." His motor, indeed, is continually running. During the first twenty years of the Perishable Press activity, from 1964 through 1983, he produced 106 individual books, each a literary, visual, typographic, and aesthetic exploration of the potential of the book. By 1998, the number had reached 123.

Hamady's course in papermaking was an outgrowth of his study at the Cranbrook

Academy[8] and proved to be significant not only for his own career but also for the futures of several others. Two byproducts have been Hamady's Shadwell paper, used in a number of his books, and his instructional manual *Hand Papermaking: Papermaking by Hand, Being a Book of Qualified Suspicions.* Joe Wilfer and Sue Gosin are among those students who learned to make paper under Hamady and who subsequently translated their knowledge into artistic and commercial successes.[9] Shadwell paper, although not commercially available, is coveted by numerous printers and designers.

The actual act of papermaking, Hamady says, "can be a craft, or it can be an art. I started doing this when I was fairly young, and it keeps fascinating me, so I keep doing it. From the beginning, I've always used interesting fabrics and sometimes synthetics. It started with incompatible fibers, but since only a small percentage of the whole mass makes the bond, you can contaminate it a long way and still get away with murder."

Hamady's experimentations have sometimes drawn the critical fire of fine-print traditionalists who question his deviations. To this he responds, "I'm a heretic, I know, and I get in trouble for it, for mixing papers in one book. But why should you have just one paper in a book? Why not have a whole bunch of them if it's appropriate? Why not have a hodgepodge, a smorgasbord? As long as it's not disgusting and wildly out of control, although there could be a purpose for that, too."

The strengths of Hamady's work, however, are manifold. As he points out, "One of the things that's different about the books that I've made all these years is that all have been text driven. I've learned a lot from the words and from language and what people are thinking about in terms of language. My greatest stroke of luck was to fall in with real writers on the cutting edge"; for example, Robert Creeley, Paul Blackburn, Toby Olson, Diane Wakoski, William Stafford, Loren Eiseley, August Derleth, Donald Hall, Conrad Hilberry, Galway Kinnell, James Laughlin, W. S. Merwin, Harry Mark Petrakis, Joel Oppenheimer, W. D. Snodgrass, and Gilbert Sorrentino. Similarly, his books have included illustrations and art work from an equally impressive array of artists: Jack Beal, Warrington Colescott, Jack Damer, Henrik Drescher, Sondra Freckelton, Sam Gilliam, Ellen Lanyon, William Weege, and John Wilde. Hamady's books are a collaboration between writer and printer, artist and printer. He welcomes the challenge of such collaboration and the synergy that can result when things go right. As he describes it, "I'm putting together a collage of people and the kind of work that they do. I know about an existing style or an existing kind of an image. When a manuscript comes along, I can tap the image to go with the manuscript and put them together, and they will make a spark. That way the writer is not compromised, and the visual artist is not compromised. Both of those artifacts come into life with their own integrity, and then they come together and . . . make a marriage. Each take on it comes out a certain way, and either you find it interesting or you find it crap. Still the energy is there, and it's happening, and it gets sorted out." The biggest challenge, however, is that "you have to be the censor. You have to do battle with the two opposing senses of making art. One is when you let it all hang out, and the other is when you try

to control the process and direct all that energy into some appropriate channel and achieve some appropriate final solution."

Although his works speak for themselves, Hamady has been a ready commentator on the theoretical nature and substance of the book. "The thing that continues to attract me to the form is that you have to operate it with your hands. It's a kinetic sculpture. You can't plug it in and push a button. The book is a container for a whole lot of cross-cultural, interdisciplinary things. And it's all simultaneity—the sense of time being all out of order and all out of speed. I think that's what the book allows you to do; whereas a single image in a print or painting or sculpture doesn't allow you. . . . to touch and to feel this page and to have the sense that you've been there, you're going here, and you're going there. If you want, you can go

back this way. And, depending on the kind of papers you use, if you use translucent papers, you can see time and space simultaneously. . . . The book is a box. The book is a container for human thought, a container for pictures and textures. I think books are aquifers. The visuality flows through like a river or like a worm."

Hamady's prodigious energy has not been exclusively centered on making books and paper. Alternative creative outlets have included collages and an extended series of boxes, both fashioned largely from found objects. The collages generally feature a layered die cut of the Hamady profile, accentuated by his nose. The boxes have an architectural relationship to the way lead type is put together to make a page layout. "The boxes evolved out of all the stuff that I've always loved and the idea of using the book structure as a metaphor for something else. . . . The collages and the boxes and the poems and the books all start the same way, the way anything starts. One thing likes another thing, and you say, 'Hey, those go together,' so you put them together. You don't make any value judgments; you just do it. Certain things go wham, and things happen. It's a Ouija board or an exquisite corpse kind of play, and it's all aleatory."

Another dimension of Hamady's influence has been his teaching. The roster of former students who, after taking one or more of his courses, have gone into careers in the book arts reflects his passion for using the medium to make distinctive artistic statements. He describes his pedagogical approach in the following way: "The old boy motormouths about what is to be done and how and by when; show and tell; demonstrations; questions, go do it; critique; do some more. Any problems, ask the old boy. In the meantime interstices ask a veteran and check it back with the old boy. The subject matter has never been printing, any more than drawing being about pencils. Nor has it been technique. It has always been an omnifarious discourse on the arrangement of things in a given space;

stretching and pushing expectations, limits and buttons; finding the extraordinary in the prosaic."[10]

Through it all, Hamady keeps talking and keeps making art because, as he has preached throughout his life, he can't conceive of not making art. "Art is the preparing of the meal and eating it, and the artifact and the evidence is scatology. It's not the thing you made that you need to be precious about, that's irrelevant. It's the joy of doing it."

Walter Hamady, *Walter thinking about a new hat.* Collage (1982) 20 × 16. *Collection of Anna Krohn.*

John Wilde, *1985*. Published and edited by Walter Hamady, Perishable Press Ltd., Mt. Horeb, Wisconsin.

Ann McGarrell, *Flora: Poems.* Drawings by Jack Beal, 1978–1990, published by Walter Hamady, Perishable Press Ltd., Mt. Horeb, Wisconsin.

Walter Hamady, *The Enactment of a Metaphoric Transformation . . . box #173.* (1994) 14½ × 11 × 3. *Courtesy of the artist.*

Walter Hamady, *Demonstrated by Counterexample . . . box #144.* (1993–1994) 21 × 12½ × 4½. Collection of David McLimans.

Walter Hamady, *Easily dismissed case of direct discourse . . . box #181.* (1997) 11½ x 16¼ x 2½. *Courtesy of the artist.*

Walter Hamady, *Panorama #8.* Collage (1997) 6¼ × 15. *Courtesy of the artist.*

Walter Hamady, *Panorama #9*. Collage (1997) 6¼ x 19¾. *Collection of John and Shirley Wilde.*

WILLIAM WEEGE

Tools, Technology, and Art

In any taxonomy of artists, William Weege is an example of *Homo habilis*, human as tool-maker. The classification aptly describes his lifelong interest in how tools and technology can be used to make art. A normally taciturn individual who says, "I'd rather make art than talk about it,"[1] Weege becomes uncharacteristically effusive when explaining his passion. "For any excuse, I'll buy a new tool. Anything. Just mention something, and I'll get a new tool because I love it. I love the whole idea that I can do new things with this tool." Some of his enthusiasm appears to be genetic. He recalls that his mother had what he describes as "artistic skills" and that "she was always making things." His father was a mechanical engineer, who worked for the Wisconsin Power and Light Company and "would rather do things than sit around and talk about it. He was always putzing around and doing things." The senior Weege's energy and expertise resulted in several inventions, the most notable being a process for pulverizing coal.

Although there was a certain expectation that the son would follow in the father's footsteps, it did not quite work out that way. The younger Weege began his college career at the University of Wisconsin–Milwaukee, a short distance from his hometown of Port Washington. After two years, he transferred into the engineering program at the University of Wisconsin in Madison, where he was initially enrolled in civil engineering. His choice had been influenced by the fact that he had seen how hard his father had worked as a mechanical engineer and that he "didn't want to be involved in anything like that." He soon, however, switched his major to city planning. One of his professors, Leo Jakobson,

had secured a state planning project grant and involved Weege in preparing layouts of reports for various projects for state and local governments; this assignment included working part-time with a local consulting firm. The experience gave Weege access to the latest printing technology. "It was my job to be the go-between for the artist, the printer, and our company."

The artist who served as designer for the project was University of Wisconsin faculty member Donald Anderson,[2] who encouraged Weege to do page layouts for various reports and suggested that he take art courses to enhance his design skills. Thus began the transformation from engineer to artist. One of the defining moments in that process came when Weege was given a book called *The Selective Eye* as a gift.[3] The visual stimulation he received from looking through that publication was intense. He wanted to have a piece of genuine art, so he asked a fellow planner with a master of fine arts in art to paint a picture for him. Weege agreed to supply all necessary materials and dutifully bought canvas, stretchers, paint, and brushes; the planner never came to do the job. Weege took stock of his financial investment and decided he would put the materials to work. He starting painting. One painting led to another. "I was really into the Van Gogh technique. I did sunflowers, fish, and pigs." He then discovered that he could sell his paintings at a student art fair on campus. Clearing eight hundred dollars in one weekend provided "another impetus to get involved in art."

Weege's decision to pursue art had a primarily practical focus. "I really wasn't a fine artist when I started. . . . I came in to learn how to be a commercial artist, how to do illustration and design and graphics for advertising or publication. I only found out about fine arts after the fact." This commercial art orientation provided a knowledge of reproduction technology that became the foundation for his art career. He learned the latest techniques in using photography for printmaking. "Most of my photographic knowledge in the printmaking area came from Litho Productions [a Madison printing firm]. I spent a great deal of time in the copy camera room learning how to do separations, learning how to make plates. I actually worked as a [film] stripper for them a little bit when they got pushed on jobs. So that's how I researched the stuff that I brought back to the university." The knowledge and experience Weege gained at Litho Productions made him a valuable resource person for the art department at the University of Wisconsin. He received financial assistance in graduate school as a research assistant who helped others create photographic images that could be used in printmaking, primarily lithography.

At the same time, Weege began to make his own statements through the production of posters for campus events and activities.[4] Many of the posters were visual reflections of the volatile anti-war activities that raged on the university campus during the late 1960s. Students and others in the community found the posters so appealing that they were removed as fast as they were put up. "You would get them up on a tree or the wall and they would be stolen immediately," Weege recalls. "I had to do things like staple them up a million times and then slash them with a razor blade so that you'd have to take each piece

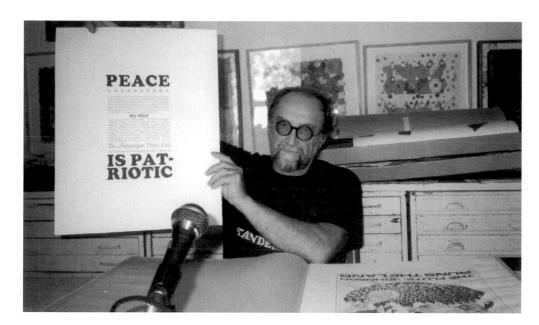

William Weege, while being interviewed in his studio complex in rural Arena, Wisconsin, in 1996, displays his poster portfolio issued in 1969.

Photograph courtesy of Arthur Hove.

off." Instead of giving posters away or having them stolen, Weege discovered that, like his earlier paintings, he could sell them to an appreciative audience. He recalls making as much as fifteen hundred dollars on a single weekend selling an array of posters at five dollars a copy.

His printmaking activity continued as he prepared a portfolio of prints to meet the requirement for his masters of fine arts degree. The portfolio, including twenty-five posters under the title Peace Is Patriotic, provides a rich sampling of the photo reproduction techniques that he had been developing as well as a synthesis of his anti-war sentiments. These sentiments ran deep and strong. "I was very angry. . . . The hypocrisy of what people said and did bothered me the most." As a result, his portfolio "was a documentation of what I saw. You could see the hypocrisy of what was going on yourself. I just showed from a different point of view what I thought was going on. . . . I don't like to have it face up. There's some humor in what I do. You could look at it as humor, but it was pretty sick humor in a way." The portfolio, with its visual and political messages, proved to be an overnight sensation; the success brought Weege's work to the attention of collectors at prestigious museums. During a student trip to New York shepherded by Warrington Colescott, his major professor, Weege managed to sell copies of the portfolio to the Museum of Modern Art, the Brooklyn Museum, and the New York Public Library. By this time he had realized that "the fine arts were more exciting than anything that could happen in graphic design because it was too narrow and you were boxed-in by your clients in terms of what you could and couldn't do."

The recognition that Weege had gained through his technical expertise in printmaking led in 1970 to his selection as the director of an experimental printmaking workshop, organized for presentation at the Venice Biennale by the Smithsonian Institution's National

Collection of Fine Arts.[5] The experience was a welcome source of professional development for Weege. However, the government took a dim view of his ongoing anti-war activities, particularly when he started giving away copies of his *Impeach Nixon* poster. "I was trying to impeach Nixon, even though I was a government employee," he recalls. "I was told to stop giving away government property. So I bought my own paper, and I started charging fifty lira for the posters, which was about a nickel at the time." Nevertheless, "the government pulled out after about three months, and I was left high and dry. So I set up my own little print shop" in Venice. He had met publishers from Milan at the Biennale and had established relationships that generated plenty of work. Part of his shop included a silk-screen workshop, which is still in business.

Weege returned to the University of Wisconsin in the fall of 1971 to take a position as an assistant professor in the art department. His responsibility was teaching courses in production techniques and, later, in lettering, silk-screen, and relief printing. At the same time, his own creative efforts continued to go forward. He continued his anti-war themes but in a slightly different vein. He now commented on contemporary society by using an expanded vocabulary of images. "Now I would be crucified," he noted ruefully, "but then I was doing 'girlie' things. I was using images out of *Penthouse*. I also did a whole series of my own photography that was soft porn. I felt I was taking the images they use in magazines to promote a product. I was taking that same image and promoting war, sex, and violence. They were mixed together. People picked on the sex; they didn't give a damn about the violence."

Some of the responses to Weege's work in this period were overtly hostile. One of his famous posters, *Fuck the CIA*, was slashed with a razor when it was on display at the Whitney Museum in New York City. Others were burned in symbolic immolation. Weege initially found the acts amusing. "Somebody said, 'They're burning your posters at rallies, isn't that terrible?' I said, 'No, it's great!'" Eventually, however, the reactions took their toll. "It was a lot of work. It took a lot of gut-wrenching to do these things, to have a show and have people come down on you and say, 'Why the hell did you do this? Why don't you do something nice?' . . . By then I was working with artists who were doing abstract things, and I was tired of making a statement, because I was being confronted with the 'girlie thing.' Actually, I was taking up the women's movement, but I was doing it with tongue in cheek. . . . I got tired, so I just started doing abstract things."

The transition marked another phase in his career, one which was an extension of the collaborative activities that had characterized his entry into the art world. Weege shifted his technical interest to making paper, something he had previously thought was not worthy of serious consideration. This time, the path led to Jones Road Print Shop and Stable.[6] With underwriting from Cleveland art collector and patron Rory O'Neil, Weege established Jones Road Print Shop and Stable and began a series of collaborations with other artists that has continued throughout his career. As David Acton has noted, "A dilapidated barn on the brow of a hill near the farming village of Barneveld [Wisconsin] became the

Sam Gilliam signs his first print in 1972 at Jones Road Print Shop and Stable with a pencil taped to a rifle as his friend and collaborating printer, William Weege, looks on.
Photograph courtesy of Gregory Conniff.

new home of litho and etching presses, drying racks, a large serigraphic table and photographic equipment, as well as Weege's horses."[7] Alan Shields was the first artist to work with Weege in exploring how technology could be stretched to achieve new effects in printmaking. Others soon came, including Sam Gilliam, Peter Plagens, Sam Richardson, and John Wilde.

The work at Jones Road stretched further in 1974 when Joe Wilfer, Weege's former student and friend, established the Upper U.S. Paper Mill outside the nearby town of Oregon, Wisconsin. As John Loring explains, "These two artists' printed, cut, glued, flocked, painted, layered, torn, and stitched hand-made paper works stand as landmarks in the broad field of collage concepts and the art of 'making.'"[8] Weege's interest in these experiments stemmed in part from the fact that he had "always been interested in surface and textures."

Private funding for the Jones Road activity eventually ceased; however, the synergism developed there later resurfaced through the establishment of Tandem Press,[9] where a great deal of the work Weege was pursuing at that time was influenced by collaboration with Tandem's visitors. When money for his Jones Road activities ran out, Weege moved from Barneveld to an area nestled in the hills just outside of the small hamlet of Arena, located in the Wisconsin River valley a few miles due east of Frank Lloyd Wright's Taliesin. His fascination with the creative and artistic potential of paper continued, and there was a dramatic increase in the size of his work. This was not a sudden development nor un-

characteristic: "When I got to be a graduate student, bigger was always better for me. I always wanted to do big things." He began creating huge paper constructions that were virtually wall-size experiments in texture and color. He collaborated with Sam Gilliam in creating a monoprint that was five hundred yards long. Its length required that it be sewn together in sections and for display gathered into an arrangement that looked like a colorful bundle of laundry.

Weege learned how to apply liquid paper to canvas to give it added strength and to coat the surface with an acrylic that would seal off the paper so it could be dusted periodically. The paper was mounted on stretchers and the surface was printed with various designs or augmented by collaged items, for example, a reproduction of a work by Hieronymus Bosch. Fellow artist Gregory Conniff describes the result: "He has added patterned woodblocks which he has printed into the pieces. These patterns—circles, triangles, spirals, diamonds, lightning, snakes, crosses, pictograms, hieratic writing, stylized gear parts that might also be stylized sunrises or eyes, rodents? Olympic rings? Navajo rickrack?, yucca leaves (yes!), fish skeletons (lizard?), snake tracks in sand, Hopi deities, seaweed, fragments of tire tread patterns—you look, you guess—are hurled together with the violence of a flash flood. Some of them are, in fact, patterns from ancient cultures in China, Africa, Mexico, Pre-Columbian America, and the American Southwest. Weege has given them to the viewer stripped of the contexts of time and place, the way paleontologists sometimes find the bones of non-contemporaneous species in drifts of buried chaos."[10]

As his paper experiments evolved, Weege also developed a new interest in the environment. His interest was reinforced by the professional activities of his wife, Sue Steinmann, a horticultural ecologist specializing in the cultivation of decorative plants. Weege began by using precise and often delicate cutouts made with a scroll saw making a series of colorful, conventional-sized construction and prints. The central figure in many of these designs is a man with a dugout boat—a kind of Everyman who reminds us of our disturbing proclivity to corrupt nature and upset the environmental balance.

The computer is Weege's new tool for exploring innovative ways of making art. It introduces a new dimension to the relationship between the artist and art. "Since I've been messing around with the computer, I can make an image, just like that! But I don't feel like printing it. Why should I print it? I've got the information; it's all there. If I want to print it, I can do it. I don't see a need to do it. In that respect, I'm saving myself a lot of time. I satisfy myself, and I go on to the next image. . . . The computer, to me, is just a tool. I haven't done anything I really want to reproduce, other than what comes out of the printer. That's enough. It's really saving me a lot in terms of materials. I get to see the image at the size I want, then I don't care about it anymore, so I go on."

In the preponderance of his work, Weege concentrates on the connection he feels between his inner thoughts and technology. It is not a process that begins with drawing. As he confesses, "Every once in a while, I try drawing again because I know I can. It's just a difficult thing for me, and I'm probably not the kind of person that is very much inter-

ested in drawing. I'm interested in images, in the way one image plays against the other image. Occasionally, when I'm pushed to drawing, I find that I can do it. But it doesn't interest me. I know people that can do it better. My imagery is not about that. I can make more of a message using collage techniques and graphic design. I've often used typography or calligraphy right in my subject matter to further the process of the image along faster. I use tricks that they use in the advertising business to get your attention and then to keep your attention and make you mad or happy. I think I have that ability."

Weege's vision is distinctively his own, not a conflation of current fashion. "I shy away from reading art magazines. I don't really want to know if there's a trend going this way or that way. I'd rather just experience it in the air. I've always felt that way. If everybody was doing this, I'd like to be doing that. I don't want to jump on the bandwagon." This attitude has its roots in his parochial-school experience. "In grade school, the nuns took away my crayons because I wouldn't follow directions. . . . I would never, never follow directions. Everybody was coloring the trees green. I saw trees other colors, and some people do. And some people never see green, or don't want to."

An explosive energy and an irresistible drive to try new things continually motivate him. "I usually work on one thing at a time. I'm very focused when I do work on things. I'm very prolific. I can turn out a lot, and I can do it quite fast. . . . I store up a great deal of energy and then I go to work and it comes out like crazy. I don't have a constant stream of things. I work fast and furious at given times, and a lot of things will be started and halted quickly and then picked up later and changed and moved around. I have lots of interests. They keep growing, and I think I'm going crazy sometimes. I just have too many ideas."

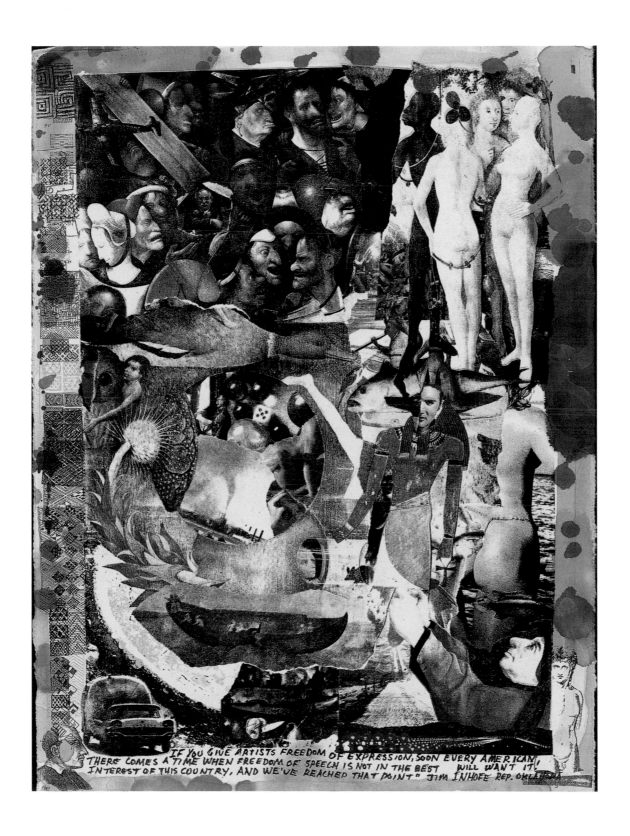

William Weege, *Jessie Ho! With all his scary men.* Screen print (1981) 22 × 16. *Courtesy of the artist.*

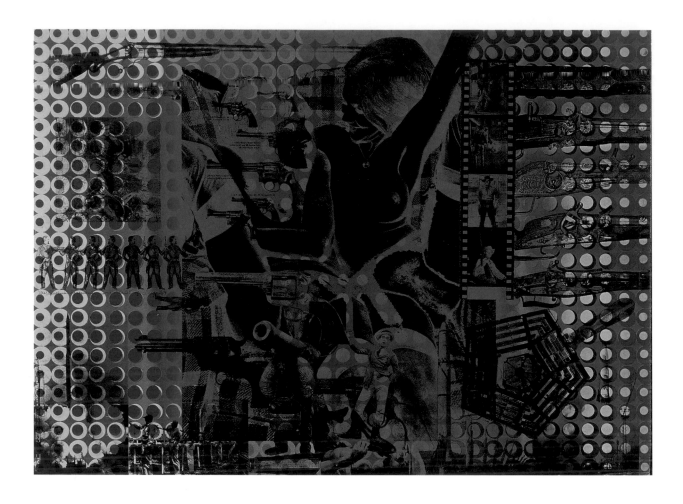

William Weege, *Yes, Virginia, Happiness Is a Warm Gun.* Screen print (1968) 24 × 32¾. *Courtesy of the artist.*

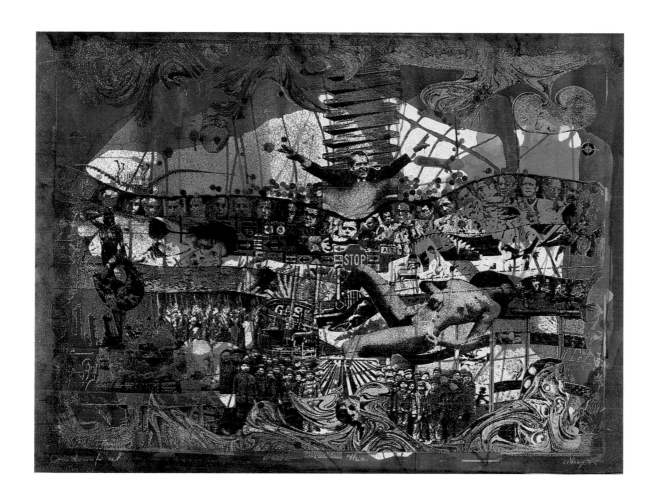

William Weege, *Goin' Down for Oil*. Screen print (1975) 25 × 33. *Courtesy of the artist.*

William Weege, #29. Handmade paper, relief (1982) 26½ × 37. *Courtesy of the artist.*

William Weege, *His Eminence.* Silk-screen, handmade paper (1983) 40 × 27. *Courtesy of the artist.*

William Weege, *Your Name Here*. Color woodcut, handmade paper (1997) 20 × 16½. *Courtesy of the artist.*

William Weege, *Day Lily Sweet Talk*. Computer print (1997) 34 × 33½. *Courtesy of the artist.*

William Weege, *Structure #1*. Computer print (1997) 29½ × 38½. *Courtesy of the artist.*

Keep Your Bags Packed

The city of Racine is a Wisconsin anomaly, a small industrial city separated by rural strips from a large industrial city, Milwaukee. Frances Myers grew up in Racine's class-structured environment. She remembers as a child dreaming of becoming an anthropologist: "From the age of ten, I spent countless hours in the public library on South Main Street literally and figuratively inhaling the dust of the past. Romantic stories from other cultures, from the South Seas to India to Greece, fired my imagination, and I longed to find remnants of those ancient civilizations. Unfortunately, I had not discovered Margaret Mead."

Myers was good at art, "always the best in my class at St. Joseph's grade school. In high school at St. Catherine's, I had more competition but also a role model. She was Sister Monica, an enigmatic, moody teacher, who seemed to have some mystery in her past. She carved modern religious figures in the manner of the German expressionist Ernst Barlach. She gave advice cautiously, neither recommending nor discouraging dedication to a life in art, but 'dedication' was a firm part of her agenda, and mine too."[1]

Myers won a scholarship to Rosary College in River Forest, a wealthy Chicago suburb. There, despite her intense interest in making art, she was encouraged to write about art and to become an art historian; the subtext was that that was a respectable career. She chose to ignore the advice and determined eventually to head to the University of Wisconsin at Madison, which was believed by her high-school principal, Father Witkowiak, who pointed it out over and over while shaking his index finger at the entire school assembly, to be the home of atheism and dialectical materialism. "It all sounded great to

me. I longed to go, to be an artist, to read Marx and be a revolutionary." In the meantime, she played basketball and was the star forward on St. Catherine's championship girls' team.

Myers subsequently did enroll in the university at Madison, received her predicted exposure to atheism and dialectical materialism, completed an undergraduate degree in art, and with a classmate, Sally Hutchison, headed to San Francisco just in time to make the finale of the Beat Generation. She and Sally had read Jack Kerouac, Gary Snyder, and Allen Ginsberg, but a middle-western childhood in the 1950s left much to undo politically, spiritually, and creatively. "In San Francisco, we hung out with Becky Jenkins, daughter of the head of the International Brotherhood of Teamsters, who was herself an activist and organizer of causes. Later I hooked up with Noel Ignatin, who had been sent to San Francisco by a Philadelphia Marxist group to organize at the grass-roots level." Together they distributed leaflets and had meetings with African American groups in the ghetto highrises of the Fillmore, a district originally home to Japanese, who were removed to camps during World War II and replaced by African American families. Ignatin's idealized venture was unsuccessful, but there was increasing ferment by civil-rights activists. Myers went to sit-ins, joined picket lines at Woolworth's, attended meetings and fund-raisers in Berkeley for the Student Nonviolent Coordinating Committee (SNCC), and was among the throng who picketed the House Un-American Activities Committee at the San Francisco Courthouse; her picket line was hosed by the police.

Myers used her Clay Street flat as a painting studio and made prints at the San Francisco Art Institute. The painter of *The Rose*, Jay DeFeo, lived just around the corner,[2] and Bruce Conner opened his Batman Gallery a block away on Fillmore Street.[3] For a time, Myers performed with a theater group that did "Produced Readings" of works like *Faust Foutu* by Robert Duncan and Dylan Thomas's *Under Milkwood*. She met Alan Watts. She studied Subuhdi dharma. The greats of the Beat Generation passed through North Beach and the Fillmore. She met some of them; some she knew only through stories of their escapades and excesses. Gary Snyder was meditating in Japan, but his partner, the poet Jo Ann Krieger, lived at East-West House, a communal-living house frequented by writers and artists. The poet Philip Whalen lived for a time at Hyphen House, not far away in Japan Town. Poet and publisher Lawrence Ferlinghetti was always available for richly obscure conversation in his City Lights bookstore on Columbus Avenue. Vesuvio, the Coffee Gallery, and the Green Street Restaurant, across the street or around the corner, were all popular places to meet and talk of art, literature, and politics—social and sexual. Crowded openings of art exhibitions were a regular feature of the arts-community scene, and Frances Myers, displaying her works at the Greta Williams Gallery on Union Street and at the Grant Street Gallery, contributed to the excitement of the time. James Monty, director of the Grant Street Gallery, would later become curator of painting at the Whitney Museum of American Art in New York City.

By 1962, it became apparent that the Beat Generation's San Francisco activities were cooling down, largely due to its success. Dealers and publishers were elsewhere. The city

was expensive and jobs for artists and poets were scarce in Bagdad by the Bay. There were opportunities elsewhere for artists with growing reputations who had pocketsful of manuscripts and lively ideas. The exodus began to New York, Los Angeles, Mexico, Tangiers, and Nepal. Myers decided it was time for her to see the museums and architectural treasures of Europe and to explore her northern European roots. She booked passage on the liner *Cristoforo Colombo* and arrived in Rome at the conclusion of that old ship's last voyage.

In rapid explorations, she experienced the architecture of Bernini and the surfaces of Michelangelo, traveled to Arezzo for Piero della Francesca, and roamed Tuscany for revelations in dim museums and frescoed country cloisters. She visited the museum palaces of Italy, France, and England. She circled the cathedral at Chartres and went in to look up at the glass, paid to enter Paul Cézanne's studio in Aix-en-Provence, stood in line at the Louvre in Paris, climbed rainswept stairs to the Tate and the National Galleries in London, and finally rode into a wrecked Berlin, passing through the no-man's-land of Unter den Linden to the miraculously intact museums in East Berlin.

Frances Myers in 1960 in her Clay Street, San Francisco, studio/apartment.

Photograph courtesy of Sally Hutchison.

After six months, Myers returned to San Francisco. The city had sobered up. In the summer of 1963, Stanley William Hayter came to the San Francisco Art Institute, like a breath of exuberant air, to teach etching. Hayter's print studio, Atelier 17, on Rue Diderot in Paris, had drawn students from all over the world, including many from the United States. The first day of class at the art institute was an old-home-week reunion as *anciens*, Hayter's term for those who had studied with him before, showed up in large numbers. The newcomers in the class had to go through his notorious five-step process, working on small copper plates, a primer-level exploration of etching and engraving techniques.

Hayter was a forceful teacher, once his initial demands had been satisfied. His way was the only way, but a girl with charm could divert him. Hayter was of the old school—the master, with doubtful gender sensitivity, in Myers's view. However, Myers found him likeable and his enthusiasm for the medium contagious. Myers's experience with Hayter that summer, along with seeing important contemporary print surveys at the San Francisco Museum of Art, rekindled her etching interest. She decided to return to Madison to earn a master of fine arts, for whatever good that would do her in a profession she viewed as rigorously male dominated. At that time, she saw successful artists, particularly those in New York, as "40, alcoholic, and male." It took the feminist revolution of the 1970s to challenge that conclusion.

Myers worked in both prints and painting for her master of fine arts; however, her prints—etchings—took center stage during this period. She exhibited her etchings in

competitive and national shows and received awards and critical notice. After receiving her degree, she moved to London. Some of her reviews had been noticed in England, and she was offered teaching positions at both St. Martin's School of Art in London and at the School of Art and Design in Birmingham. She commuted by train to the Birmingham job once a week for two days of teaching. Breakfast, with its obligatory rose, silver cutlery, kippered herring, and toast and tea, in the train's elegant dining car, was a pleasure, as was the company of the other artists/commuters, including Dennis Bowen, who became a friend. Bowen, a painter who directed a gallery near Oxford Circus, was creating serigraphs with John Coplans in St. John's Wood.

Myers's English experience included time making prints at Birgit Skiold's basement workshop, which not only offered facilities—simple though they were—for etching and lithography, but also took its members into the midst of English print circles. London artists paid attention to having fun. There were parties at David Hockney's and "do's" at Birgit's with artists and theater people. The American print dealer Eugene Schuster held a frequent salon at his Chelsea flat. It was the period of the early Beatles, Carnaby Street, three-piece suits with fitted waists and bell bottom trousers, and scrawny, attractive girls in miniskirts.

Myers was invited to do a solo show at the AIA Gallery, an alternative, artist-run gallery. She also exhibited in the important group show at the American Embassy, "Transatlantics," and her prints were picked up by several London galleries, including the Curwen Gallery, managed by Rosemary Simmons, who was a supporter of the vigorous activity going on in prints. A number of fine-art printing and publishing ventures were gaining a foothold in the burgeoning market for prints. Robert Erskine's St. George's Gallery offered carefully crafted shows of British, French, and American newcomers based on his commissioned editions. Petersburg Press opened facilities to print and publish etchings and had a particular success with David Hockney. Chris Prater focused his attention on screen prints produced with photographic techniques and attracted painters and sculptors like R. B. Kitaj, Patrick Caulfield, and Eduardo Paolozzi.

Myers returned to the United States in 1968 and continued her aquatint series dealing with the Art Moderne buildings she had encountered in London. These prints won many awards for their purity, economy, and elegance during the late 1960s and throughout the 1970s and were partially responsible for drawing significant attention to the Art Moderne period of design. Myers's interest in the architecture of the 1920s and 1930s stemmed from her background in Racine, with its Frank Lloyd Wright heritage, including the 1906 Hardy House and the 1936 Johnson Wax Building. S. C. Johnson had commissioned Wright to design the latter building, and his son, Herbert H. Johnson, had Wright design his residence, Wingspread, and then a house for his daughter, Karen.

Karen Johnson Boyd had a keen interest in the visual arts. A friend, the New York art dealer Lee Nordness, had seen Myers's prints and had mentioned them to Boyd. A meeting was arranged between Boyd and Myers, and she proposed that Myers create a port-

folio of aquatints portraying Wright structures, the first being, of course, the Johnson Wax Building. The portfolio was published in 1981, and Myers subsequently produced prints illustrating additional Wright buildings. This work segued into postmodern architectural images.

Beginning in approximately 1984, an underlying moral structure became more apparent in Myers's work, and her attitude toward the print medium began its long transformation. Almost by accident in 1985 arrived a new impetus, Wonder Woman. A tiny figurine of this comic-book protagonist came on a birthday cake, and its candle-charred remains became, for a time, her "Rosebud." The print technique she revisited for her Wonder Woman prints had been used in her undergraduate work with Alfred Sessler. In four relief prints, she defined in color blocks the gender power game by utilizing the persona of Wonder Woman to parallel events in the life of Christ—the Martyrdom, the Crucifixion, the Resurrection, and the Ascension. She (Wonder Woman) is both the suffering and the triumphant figure. Art critics have been moved to decipher the allusions: "Wonder Woman becomes an expression of the anima—the female element of the male mind—and at the same time an expression of the place of Woman in today's culture, bound as she is, with head bowed, dejected but still determined. . . .the feminine principle is still being suffocated by our social and cultural systems."[4]

Frances Myers in the kitchen of her studio in Camdentown, London. This pencil drawing was done by Warrington Colescott in 1966.
Collection of Frances Myers.

Myers's cultural roots are steeped in ritual and symbols, which appear frequently in her work. A first contemplation on loss and death and its rituals comes in the woodcut series of 1987–1989 and then again in another series in 1991. As photographer and critic Greg Conniff wrote in the catalog for her show in Cologne, Germany, "The 'Lost Dog Cycle' is an encounter with mortality. . . .That is her hand in the piece—slashed, stitched and photocopied and etched into a visual essay on lost things, dead things, things that get sloughed off in the process of living. . . .an earring, oyster shells, shards of pottery from a broken vase, the tracks of an errant dog, a castaway animal, a leash, and tellingly, seeds. The muted quality of this work is a mark of reflection. It is a mark of Myers' mature sense that daily life is epic enough."[5] This was Frances Myers's first installation piece, twelve 32" × 48" etchings that lap and overlap and repeat in surprising sequences and that covered a large gallery wall from top to bottom. This method of print installation was new then and has been used by Myers subsequently. Another installation piece from 1994 concerned with the rituals of death, "To Come to Terms (acts, words)," consists of sixteen black-ribbon wreaths and eight diamond-shaped pieces of wood, lead, satin, and hair spanning a fourteen-foot wall. This piece is the work of an artist who is deeply conscious of prints but who refers to the medium more by its use of print devices and repetition than in any actual use of a press or matrix.

The symposium in 1980 at the Detroit Institute of Arts in honor of Norwegian printmaker Rolf Nesch. Frances Myers and Warrington Colescott demonstrate intaglio printing. Alan Fern *(upper right)* was the symposium director and is presently the director of the National Portrait Gallery. *Photograph courtesy of Warrington Colescott.*

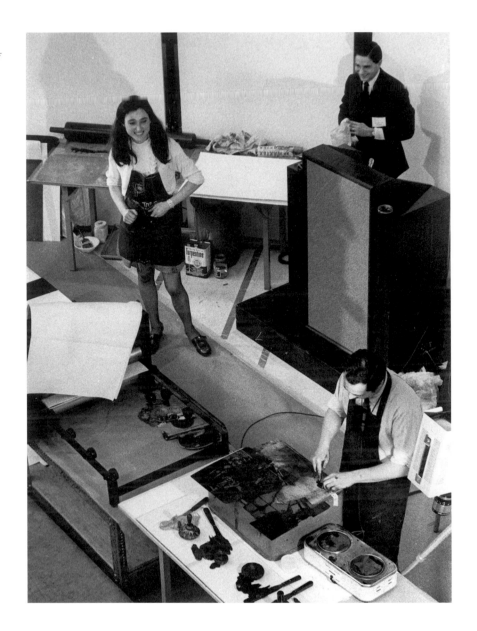

From 1991 to 1993, Myers embarked on a group of works that focused on the life of Saint Teresa of Ávila, a fifteenth-century Spanish nun whose spiritual writings survived the Spanish Inquisitors' probings and who was known to have spiritual ecstasies that seemed to separate body from soul. She is, in fact, the patron saint of Spain and was declared, four hundred years after her death, a Doctor of Theology of the Catholic Church, the first woman so designated, and only "passed" because the church fathers deemed her to have "a manly soul." The irony of such statements, awe at Teresa's spiritual convictions (in contrast to this generation's loss of faith and certainty), the beauty of Roman Catholic ritual and its accouterments, along with an examination, again, of the encounter with death, all mix in these works. Myers's ultimate statement at this time came in the form of a forty-

four-piece installation titled "A Consideration of the Phenomenon of Ecstasy," which included etching, video tapes, computer disks, xerox, book pages, x-rays, dried plants, hair, silver medallions, and so forth, and each section is encased in a Plexiglas filing envelope. The total effect is powerful, mystical, and ironic. The prints/objects pose as icons, but Myers ultimately subverts the holy and proclaims a secular conclusion.

Myers has been called a feminist artist, not only because of her use of woman icons but also because of her use of materials that stem from the traditional domain of women. She has recently shown installations with actual cloths (for example, hand-embroidered tablecloths) as well as digital and electrostatic prints of cloth and embroidery and etchings that refer to decoration. She says of the "Prague Chasuble" pieces, "My reason for using such a 'beautiful' object comes from my interest in ritual and the attendant artifacts with which ritual actions and events are clothed and enriched. In other works of mine, I incorporate the substrata of the beautiful and delve underneath the surface to find other realities, to present society's designation of gender roles—who *does* the embroidery; what gender is a bishop?"

Frances Myers's work has become increasingly radical, if one considers the traditional print as limited to single formats and printed from a block, stone, or plate. The scope of her printing has become at times gargantuan, enlarged, altered by Xerox, photography, and direct hand methods of collage and actual material. Her computer is figuratively plugged into her power press. She has said she would even accept a computer virus if it made distinctive marks.

Frances Myers, seeking the new, dominating and then discarding until the need again arises, has moved through a complex range of ideas and materials. Her works are still labeled "prints" only because she is seen as an artist working from a print sensibility, and she retains an element of edition in the repeating of images through serial techniques. Intellectuals and poets, seeking to penetrate the mysteries of spare décor and her severe arrangements of the commonplace, have been drawn to her ambiguous installations. Chicago critic Tim Porges wrote, "Long ago, when Capital was young, industry learned to reproduce the domestic handiwork of material culture. Myers has, with the industrial tools of her artist's workshop, given these images, originally social, yet another bath of reproduction, and what she manages with this kind of return; a social reinvestment of a commodity. These works are not fetishes."[6] He may be wrong; they might be fetishes. In this time of gender confrontation, it is wise for young male critics to keep alert for totemic predictions. Frances Myers, busy with production, keeps her own counsel and tolerates interpretation. The work of this restless artist moves and changes; she weaves and searches as she follows her muse on an infinite vision quest. Her bags are packed.

Frances Myers, *The Martyrdom.* Color woodcut (1985) 20½ × 15. *Courtesy of the artist.*

Frances Myers, *Madame Hoo?* Color woodcut (1987) 44 × 31. *Courtesy of the artist.*

Frances Myers, *Exotic Dangers*. Color woodcut (1987) 44 × 32. *Courtesy of the artist.*

Frances Myers, *Tending Jan's Garden*. Etching/relief (1991) 42 × 62. *Courtesy of the artist.*

Frances Myers, *Untitled (Proof of Stigmata)*. Etching (1992) 41 × 27. *Courtesy of the artist.*

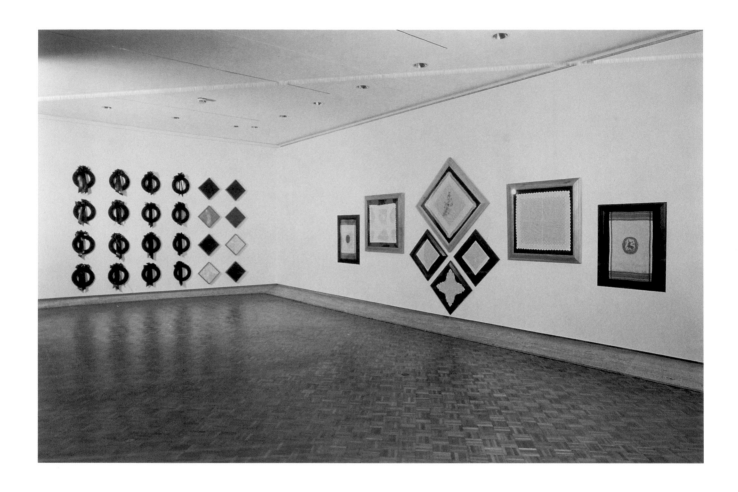

Frances Myers, *To Come to Terms (acts, words)* and *Parts of the Performance (acts, songs)*. Mixed media (1994) 8' × 12' and 8' × 11'. *Photograph courtesy of the artist.*

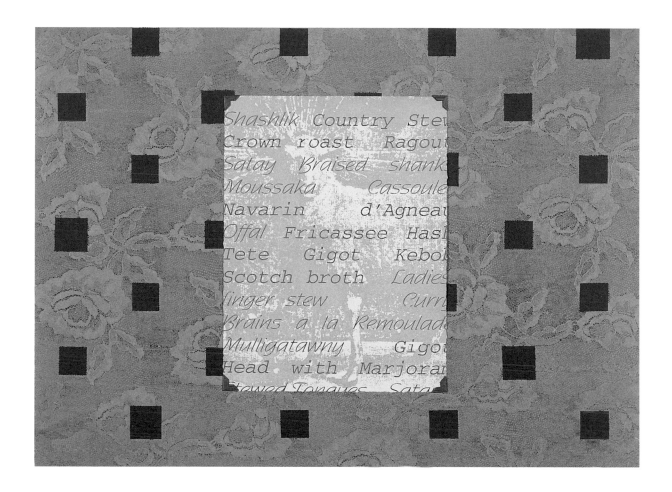

Frances Myers, *Favorite Recipes.* Etching/digital text (1996) 15 × 20. *Courtesy of the artist.*

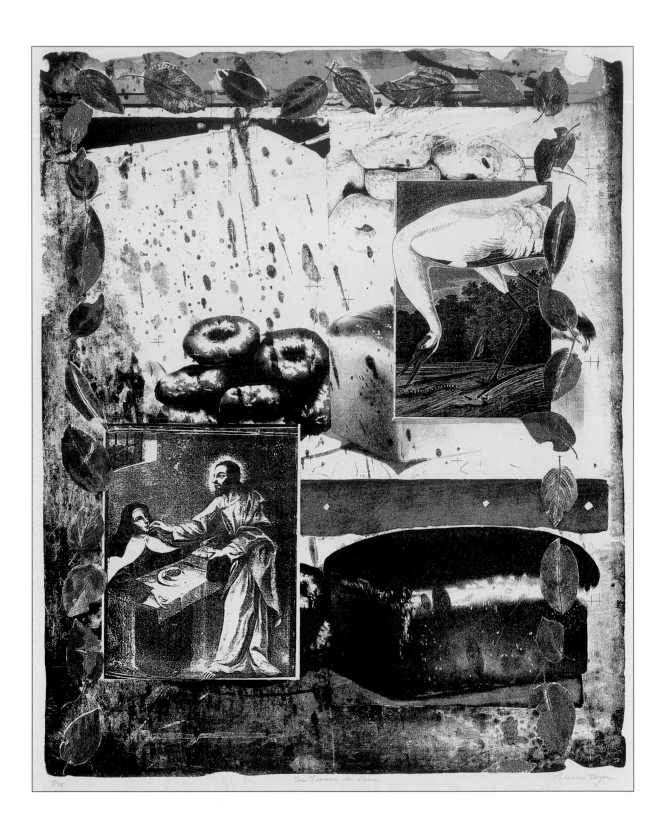

Frances Myers, *Les Faveurs de Dieu*. Lithograph (1993) 29½ × 23¾. *Courtesy of the artist.*

David Becker spent the first ten years of his printmaking career, from 1968 through 1978, in his basement. It was the only space he could find at the time to begin what led to a series of etchings and drawings of unconventional landscapes filled with tableaus of people and objects. The Washington, D.C., critic Michael Welzenbach, commenting on Becker's work included in a show at the Jane Haslem Gallery in 1990, noted that "Becker is something of a contemporary Hieronymus Bosch, a fine draftsman who graphically details the absurd reactions and grotesque appearances of what would appear to be insane asylum inmates. . . .he depicts a kind of nightmarish world where people variously sit in corners laughing hysterically, shoot and strangle each other or stand in foul water up to their knees and vomit. Some float impossibly in the air, hovering over fantastic and superbly rendered landscapes. Others operate bizarre but feasible-looking instruments and equipment."[1]

After his tenth year, Becker managed to secure a warehouse studio in inner-city Detroit, then spent time in a faculty studio at the University of Wisconsin–Madison, and finally migrated to a studio in a pole-barn in rural Wisconsin.

"It's always been difficult for me to get ideas," he has confessed. "I had to make seemingly random marks on a blank surface until an image emerged, and if it looked fairly decent I was happy with it. It always started with a figurative image, which then suggested another, as in a chain of associations. However, the figure would have to be unexpected, one that I hadn't thought consciously about in advance. The development of the figure was a slow process, sometimes painful. I discov-

DAVID BECKER

A Singularity of Vision

ered as a student that if I persisted at this, I'd get an idea I could pursue." In the process, Becker developed a rhythm that seemed to work as far as his creative process and exhibition schedules were concerned. "I was on sort of a two-year cycle. I'd get one print done, and I'd send it out to the competitive shows. When that ran dry, I'd have a new print done."

Becker happened into art through a somewhat haphazard route. There were no particular connections in the Becker household in Milwaukee to art or to the artistic community. He notes, however, that his father did have a strong musical interest and introduced him to the Metropolitan Opera Saturday-afternoon radio broadcasts. This exposure generated a continuing interest in opera, both the music and the staging, as a corollary to his art. He thinks his compositions often have somewhat of an operatic flavor as a result. Early on, however, Becker "was one of those kids who was the class artist in grade school." He was influenced at that time by the *Let's Draw* program, which was broadcast over the state radio network as part of the Wisconsin School of the Air. He also frequently copied cartoons out of the *Milwaukee Journal* green sheet, a feature section of the paper that contained the comics. At one point, he entered a contest to draw Lena the Hyena, a character in Al Capp's *L'il Abner* comic strip. He did not win.

Despite this disappointment, Becker followed his continuing interest into high-school art classes. "They were the typical art classes in which there was little formal instruction and not taken seriously, but I was left alone, so I drew cartoons." His cartoons typically appeared in the school yearbook. He did, however, have other thoughts about art at the time: "At one point, I thought it would be neat to be a sign painter and letter trucks."

That aspiration changed as he faced the prospect of college. "I knew I wanted to go to college, following my father's example." Becker began attending the Milwaukee State Teachers College, which was transformed one year later into the University of Wisconsin–Milwaukee, with the idea of becoming a teacher but transferred to the Layton School of Art with a career in commercial art in mind. At the time, he particularly admired the work of the artists whose works appeared regularly in *Mad Magazine*.

After two years, however, Becker returned to the University of Wisconsin–Milwaukee to enroll in a science curriculum and subsequently transferred to the University of Wisconsin at Madison. His thinking at this time was that he wanted "to do something more socially useful" and become a veterinarian. Soon disillusioned, he took an aptitude test that indicated he was best suited to be a mortician or a musician; neither option appealed to him. A visit to the art department proved more helpful. Following a conversation with department chair Warrington Colescott, he recalled that "I felt at home in that atmosphere."

Becker dropped out of his science program at Madison and took a factory job before re-enrolling in the University of Wisconsin–Milwaukee to finish a degree. He tried art education again but still did not feel comfortable in that field, so he switched to studio art and, encouraged by some success in competitive exhibitions, decided on a career in fine art. Becker had been influenced positively by several teachers during the time he spent at

Layton and the University of Wisconsin–Milwaukee: John Colt, Joseph Friebert, and Robert Burkert, with Burkert serving as a mentor during the early years following graduation. "The teachers that I liked the best seemed to leave me alone. I never got along well with artists who tried to tell me how to do it. I would try hard to imitate what was demonstrated or described, and it would become a failure, so I resisted that."

Becker finally received his degree and, like many male college graduates of the time, received a commission through the Reserve Officers' Training Corps and began a two-year stint in the army, serving as an induction officer in Buffalo, New York. He had married during his last year of college, fathered his first daughter while on active duty, and decided that he would have to go to graduate school if he were to continue to pursue his art career. Applying to several graduate schools, he received an offer of a teaching assistantship and tuition remission from the University of Illinois at Urbana-Champaign.

As an undergraduate student, Becker had felt somewhat of an outsider. Abstract expressionism had been the predominant focus throughout his training, and he had found it insufficient. Nevertheless, that environment had had a decided influence. "I learned how to think in abstract terms despite an inclination to resist it. I think it was crucial in deciding how to approach a work." In graduate school in the 1960s, he was faced with a confusing succession of new "isms." His real interest, however, was figurative work. At Layton, he had developed an intense interest in anatomy. While at Illinois, he managed to gain access to a cadaver, perhaps an atavistic response to that mortician aptitude he had shown earlier. This led to a painting that displayed a cadaver on a meathook. His fellow graduate students responded positively to the image, but the faculty did not. "I'm sure the imagery I was trying to do was seen as strange," he recalls with characteristic understatement.

With a master of fine arts in hand, Becker and his family moved to Detroit, where he had been hired to teach life drawing at Wayne State University. His teaching interests also included printmaking, particularly because he enjoyed working with the processes and equipment. He found teaching printmaking somewhat frustrating, however, since students, unlike those in his drawing classes, were relatively slow in developing their ideas. His unease is certainly paradoxical since his own creative history shows long intervals between individual works. "I've always been painfully slow," he admits, "and take anywhere from two to four years to complete a print."

During the time he was beginning his professional art career, Becker found himself pulled between his primary involvement in painting and his growing attraction to printmaking. "I liked the painting but also etching and thought the two were an ideal combination of expression. I never found myself able to switch off one and go to the other. But I naturally would get fixated on one work, so I either had to be painting or working on a print." The etching consequently won out. Two factors led to this preference. One was a growing conviction that the imagery that he employed was better suited to the etching medium. While painting relied more heavily on formal issues, a graphic medium, he felt,

David Becker draws through
hard ground with an etching
needle on his copper plate,
Monuments, in 1978.
Photograph courtesy David Becker.

was more accepting of his disregard for formal structure. The other factor was the demise
of the competitive, juried painting shows, which were replaced by exhibitions selected
by museum or guest curators. Competitive print exhibitions seemed to Becker a more
honest evaluation of work, especially when judged by practicing artists—peers selecting
the work of peers. It seemed to him that at the time pure visual imagery was being given
primary consideration in the selection process rather than the fit of content with current
theory. Becker saw first-hand the impact of the rise of the curatorial influence when Sam
Wagstaff was hired as curator of contemporary art by the Detroit Institute of Arts in 1968
and aggressively moved to set the artistic agenda for the museum.[2] Becker, anticipating
the possibility of working for a year on a single painting with limited chance for exhibi-
tion selection, abandoned painting and began to concentrate on making a series of etch-
ings that are dense in both technique and imagery. He would spend six to eight hours
working over a plate on his nonteaching days. "I thought of etching and engraving as an
extended drawing process, building the image right on the plate."

Becker's prints are so filled with information that they invite interpretation. There is a
natural tendency to read them as a narrative that he has set forth. Becker rather vigorously
denies that intent. "I never worried about that part; the narrative would take care of itself.
I was told as a student, 'If you want to tell a story, write a book.' To this day I do not con-
struct a story but try to get images to work together formally. But as soon as you put a

couple of figures together, you've got a story, and the viewer's selection of images and their relationships is done by subconscious means. The narrative can then be read into it later." As a result, Becker feels "the viewer tells the story, and his participation is assured."

Becker's paintings and prints did not always meet with particular favor from his peers. Comments that his paintings were "emotional catharsis" and his prints were "new-old and stuck in the sixteenth century" did not disturb him that much, but instead spurred him on as he enjoyed his outsider status. His positive attitude was due in large part to the fact that he was experiencing growing success in national print competitions. Eventually, he was elected to the National Academy of Design as a printmaker and later was commissioned by the Detroit Institute of Arts to do a print for its members. His prints had found their way into permanent collections. The ultimate reinforcement of his single-minded pursuit came in 1993 when he received a Visual Artists Fellowship from the National Endowment for the Arts.

After twenty years in Detroit, Becker was ready for a significant personal transition. Wayne State University and Detroit had been good for his development as an artist, and until this point, he had for various reasons turned down other job offers. By this time, his first marriage had ended in divorce, his two daughters were in college, and he had bought and was renovating a commercial building for his studio and living quarters in Ham-

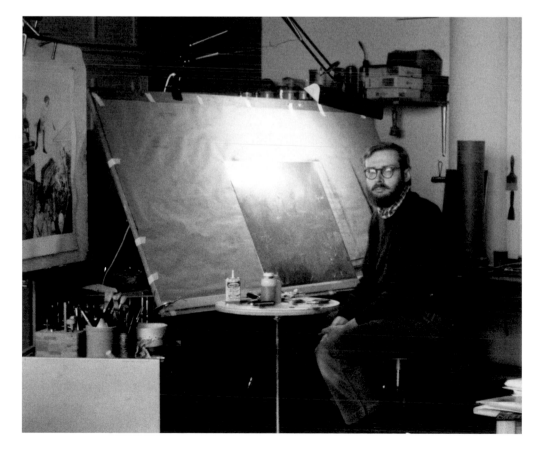

David Becker in his rented Detroit warehouse studio in 1980 prepares his plate *Right Turn* for a series of etches in the acid bath.
Photograph courtesy of David Becker.

tramck, a Polish community surrounded by Detroit. Providentially, at that moment, change was offered in the form of an inquiry from the University of Wisconsin–Madison. The art department was searching for a replacement for the esteemed John Wilde and wanted Becker to consider filling the position

The 1985 Madison offer appealed to both Becker's artistic and his personal sensibilities. "There were artists at Madison who were doing work that I could identify with and respected. Madison radiated an influence, and I thought that's the kind of place where I want to be." It also presented an opportunity for a change from the highly charged urban environment he had experienced in Detroit to the more laid-back, open setting of Madison and its environs. The move resulted eventually in a new wife (faculty colleague Patricia Fennell), a new daughter, and a new perspective. "Until we moved out in the country, I didn't know 'heavenly' skies existed."

Viewers of Becker's prints have always been challenged by what to make of what is seen. He is bemused by the dilemma and admits his own perplexity. He consulted a psychiatrist for five years while in Detroit and found the experience enjoyable and liberating for his work.[3] He has followed the responses to his prints and drawings with interest and finds in them a suggestive taxonomy. "Descriptions I have heard or read of the work, most of which either delight or offend me, are: allegorical, apocalyptic, provocative, prophetic, dream-like, surreal, fantastic, weird, frightening, disturbing, demanding, despairing, disgusting, irrelevant, inspiring, old, new-old, fascinating, morbid, medieval, bizarre, cathartic, mystery plays (I like that), and well-drawn."[4] Whatever the personal and professional considerations have been, Becker has pursued a singular vision, regardless of the varied responses his art has engendered. He believes that the university environment has continually supported the singularity of his vision. "I've had the luxury of the university as a patron of the arts. I felt I haven't compromised with imagery at all. I would ideally like to do work that is commanding in both imagery and formal structure, and when I catch glimpses of this happening it is truly fascinating."

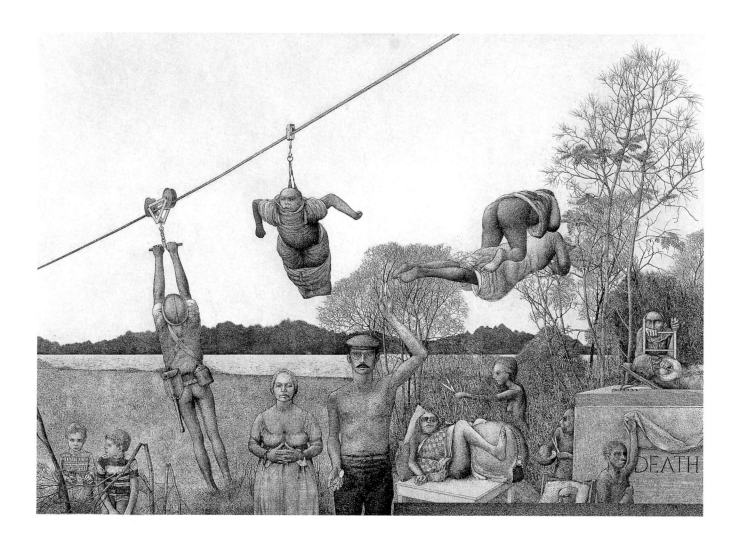

David Becker, *A tremble in the air.* Etching (1971) 17 × 23. *Courtesy of the artist.*

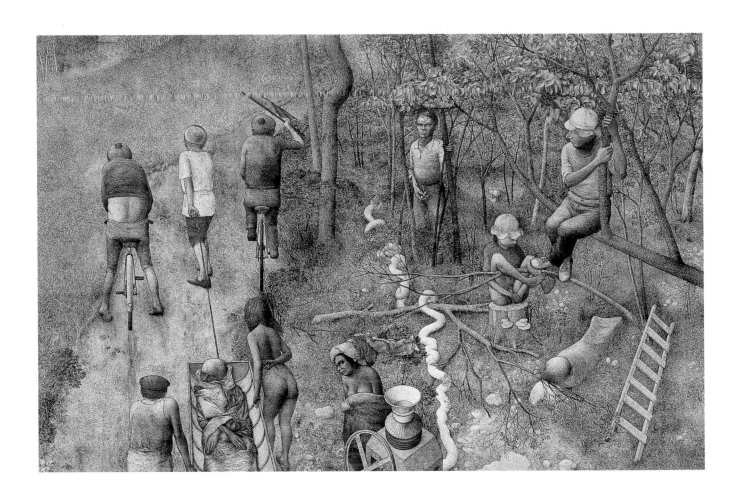

David Becker, *In a Dark Time*. Etching and engraving (1973) 16 x24. *Courtesy of the artist.*

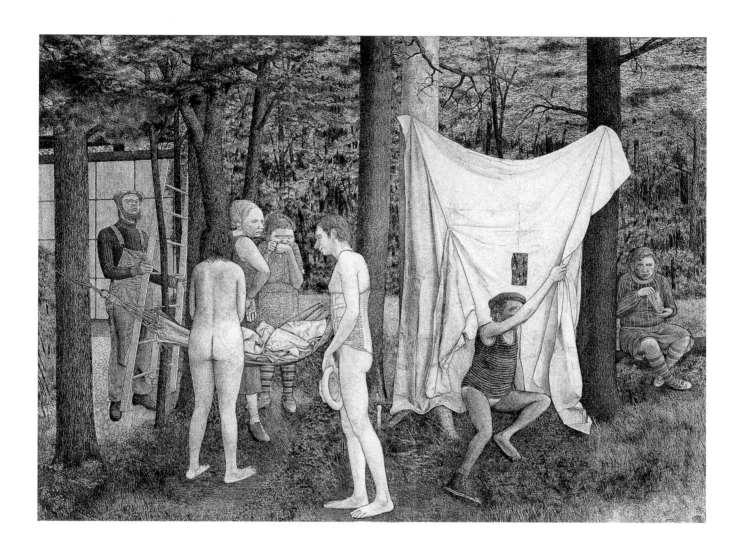

David Becker, *Union Grove Picnic.* Etching (1975) 18 x 24. *Courtesy of the artist.*

David Becker, *Monuments*. Etching and engraving (1979) 21 × 31. *Courtesy of the artist.*

David Becker, *Right Turn.* Etching and engraving (1981) 23 × 24. *Courtesy of the artist.*

David Becker, *Redemption*. Etching and engraving (1993) 21 x 33. *Courtesy of the artist.*

David Becker, *A foregone conclusion*. Etching and engraving (1985) 18 × 24. *Courtesy of the artist.*

David Becker, *Last Day*. Etching and engraving (1977) 23 × 19. *Courtesy of the artist.*

Exposure to professional artists has always been a primary part of the training of young artists, and artists who visit art schools form a huge company. For art students, meeting experienced practitioners, engaging in one-on-one conversation, and discussing little things like the systems that make a studio function and big items like the way ideas are isolated and developed are all welcome interruptions that break the monotony of the routine chores and projects of the print studio. It is refreshing to put down the charcoal or leave a dull task to go to the department gallery for punch and conversation with a visitor from New York. Art students love visiting artists, and most visiting artists, breathing deeply the heady air of admiration from young artists, love being the star attraction for the week. Seasoned artists experience a peculiar kind of high when showing work to an auditorium of bright young people who gasp at slides and applaud even mumbled comments.

Madison is far from the art marts. Faculty members occasionally take student groups to Chicago or New York; more often, an artist will come to Madison for a few days, a few weeks, or a few months. In some cases, a temporary staff vacancy allows for an interesting artist to be brought in to teach for a summer or semester. Often this kind of visit has brought into the print classes points of view that leave indelible impressions.

SOME VISITORS, SOME ALUMNI

MISCH KOHN

The visit of Misch Kohn in the summer of 1957 was a highlight for the print program in Madison. Alfred Sessler's print class was always taught in the summer session, but this summer, Sessler, grant in hand, was planning to spend the summer in his studio. He invited Misch Kohn, a friend from Work Projects Administration days who taught an influential print course at the Illinois Institute of Technology in Chicago, to teach his class for the summer. Kohn was well known in the print field for lithographs and especially for his wood engravings, examples of which were in many museum and private print collections. He was a soft spoken, agreeable man, a native midwesterner, with an extensive résumé as an artist. He arrived in Madison with his wife, Laura, and was looking forward to the university ambience and to doing some new prints.

Kohn's class met daily in the morning. In the afternoon and many evenings, he would work in the print studio with Dean Meeker, whom he knew from Chicago. Kohn wanted to try a new technique that he had picked up in Paris in the workshop of the French printer Roger Lacourière. Lacourière had been working on a new suite of etchings by Picasso and had invented a technique that he called sugar-lift etching, which allowed Picasso to make his drawings on the copper with a brush rather than with a point or crayon. The ink for the brushwork was a mixture of sugar syrup, India ink, and a little soap. After the drawing had dried, it would be covered with an asphaltum resist and then washed out with water, thus exposing the metal under the drawing ready to be aquatinted and etched. Kohn was eager to experiment with this technique during his Wisconsin summer.[1]

Dean Meeker was also pushing toward a major shift in medium. For his entire career in prints, he had taught and produced serigraphs. Like his colleague Colescott, he had decided to explore the possibilities of some form of intaglio. At the beginning of the summer, he was experimenting with filling squeeze bottles with asphaltum and drawing with this fluid on the plate, creating a dripping, drooling line from its nozzle, which was incredibly sensitive to the motion of the hand that was manipulating it. Kohn found Meeker's method fascinating. Meeker found Kohn's method fascinating. The result was a crossover. Kohn recalled, "I had never thought of drawing with a squeeze bottle, but it was very attractive. I had a machinist friend who made me a special nozzle for the squeeze bottle, which gave me more variation and flexibility of drool."[2]

Meeker decided to sacrifice drool control for expression and stayed with his original pure nozzle. He was very taken with the sugar-lift etching technique. He tried putting the sugar lift into a squeeze bottle and was excited with the results. The summer work resulted in major changes for both artists.

Kohn had a delightful time with Sessler's classes. Among his undergraduate students was Frances Myers, who would return to Madison after some years in San Francisco to get a graduate degree and eventually become a professor teaching etching classes in the art department. She remembers the brilliance of Misch Kohn as a demonstrator. In a con-

versation some forty years later, Kohn also remembered those demonstrations: "I have always enjoyed demonstrating technique to my classes, and I often do it on professional quality materials, so if it comes out good, I might use it. At Wisconsin that summer, everything I demonstrated turned out good. On my first demo, I did a half hour sugar lift, drawing in brush line on copper plate. I called it *Lion*, and I hate to tell you how many awards I won on that print."[3] Another of his most reproduced prints, *The General*, was made for his class as a demonstration of the *chine collé* technique, in which collage material is placed on the inked plate with adhesive paste on its upper side. The collage is taken through the press and adheres to the printing paper, and the etched work of the plate is superimposed over the printed surface. All this takes place in one action.

The summer of 1957 was marked by an unusually successful exchange of ideas among visitor, print faculty, and students. Misch Kohn himself carried away an impression of printmaking at Wisconsin that would have a later effect as well. As a member of the Guggenheim Fellowship selection jury for eighteen years, a remarkable tenure, he and his colleague Robert Motherwell awarded grants to three Wisconsin printmakers: Dean Meeker, Warrington Colescott, and Walter Hamady.

CLAIRE VAN VLIET

In the spring of 1965, Warrington Colescott exhibited at the Print Club in Philadelphia, where he met Claire Van Vliet, an assistant professor at the Philadelphia College of Art. He talked with her at length, visited her classes, and was impressed by the projects her students were doing. Van Vliet was a Canadian who specialized in art books. She made prints, but beyond that, she was a skilled typographer and had worked in the printing industry. Her students were making lithographs, etchings, and woodcuts and were combining their prints with text to produce books, brochures, and broadsides. Colescott was intrigued. Recently, he wrote to her recalling that "I was very taken with your classes, specifically with the range of printing experiences you were covering, and in general your bringing graphic design media into hand printmaking."[4]

Back in Madison, Colescott remarked on the courses he had observed in Philadelphia, and found his colleague Donald Anderson immediately interested. Anderson was a graphic designer who was attached to the print area and taught lettering and design courses that were required for the art major. He had an ambitious plan to upgrade his course offerings and to bring graphic design, or "print," closer to printmaking. This coincided with Colescott's own interest in art books containing original prints. Colescott was about to leave for a year on a Guggenheim and suggested hiring Van Vliet as his replacement. With Colescott and Anderson pushing it, the hire was approved, and Van Vliet arrived in the fall of 1965, aware of Colescott's hope that she would "organize the workspace in the intaglio studio and try to set up a book lab."[5]

This was not a typical assignment for a one-year replacement who was entering a strange department with no political allies, no quid-pro-quo resources, and a bare-bones budget; a one-year replacement is expected to teach classes, salute the brass and make no waves. Even Colescott, now safely in London, must have been surprised when during the first week of class, Van Vliet enlisted her students to clean an inch of nitric acid from the acid-room floor, had all the acid tanks replaced, and browbeat (or sweet talked) building-and-grounds personnel into repainting the intaglio studio. The staff dropped by, a little cautiously, to look. "At least it's not pink," an associate professor said to a full professor.

Van Vliet was driven by a sense of mission, knowing that she had Colescott's support, and the encouragement of Donald Anderson and Philip Hamilton, a recently hired graphic designer, and that the print faculty would not oppose her. She agitated for additional equipment. Before leaving for London, Colescott had arranged the purchase of a Vandercook letterpress; when it arrived, Van Vliet found a small room near the intaglio studio to house it—the beginning of a book course. Now type, furniture, and type storage were needed. On the advice of a friend on the Graduate School Research Committee, she applied for and was awarded a grant to fund a new seminar in which students were to research and write a manual on the use of office printing equipment for fine-art printmaking. The funds covered the purchase of type, an offset press, mimeograph, Xerox machine, and platemaker. Everything was in place by Van Vliet's second semester. The seminar was an attention-getting success. On a class trip to New York, one of the students, William Weege, personally sold an offset-xerox book to the Museum of Modern Art. Another student, Russell Gordon, did print work that forecast his future career in a range of print and painting activities. Weege proved so indispensable that the department hired him as a project assistant for the new offset course. This proved to be a steppingstone for him to an eventual faculty position.

Van Vliet has called herself an "organized slave-driver," but her Wisconsin students seemed to thrive under her pressures. The department chair, Harvey Littleton, felt her pressure as well; there were battles over her rank (visiting associate professor) and an Armageddon of a fight with the Wisconsin State Printing Contract administrators, who found her new facilities in violation of a state law requiring all printing to be put out for bids from private contractors. The offset and book and poster printing of Van Vliet's classes was consequently judged illegal. Firm as a rock and dragging Littleton along, she battled for her concept to a final victory. Printing fine art with the technology of the print industry was at last judged an acceptable domain of the university graphics area.

Van Vliet's year was an active one for the print area. A building that would house the now cramped art department was under construction, and a graphic designer, Philip Hamilton, and a lithographer, Jack Damer, came on staff at the same time as Van Vliet. Upon his arrival, Damer found that Van Vliet, needing a room for her book course, had appropriated the studio space supposedly reserved for him. He graciously agreed to make

do with a former maintenance room until the lithography studio in the new Humanities Building was ready for occupancy.

In spite of her tumultuous year (or because of it), the department invited her to stay. Colescott had moved from London to Rome, and it was anybody's guess when he would return to the tundra. An occasional letter, with wine stains, would arrive from him in an indecipherable Roman argot. Van Vliet's new classes were fully enrolled, but, for many reasons, she decided to return to Philadelphia. She missed her colleagues there, and, more important, the year of struggles at Madison had convinced her that she could stand on her own feet, that she was capable of producing her own art on her own terms without the subsidy that a school offered. It was a heady conclusion.

One of Van Vliet's final acts at Wisconsin was to participate in the hiring of Walter Hamady. Philip Hamilton and Hamady would divide the equipment and material that she had gathered, and each would add to it according to his special interests. Hamady brought with him his own publishing unit, Perishable Press Limited, and his own paper mill. One of his first acts would be to solicit a Graduate School research grant to fund a university paper mill, a project that would allow a hand-formed-paper course to be an essential part of Madison's print offerings.

Claire Van Vliet returned to Philadelphia in good spirits. She was deeply attached to the artists and her friends at the Philadelphia College of Art, and had missed the friendship of Berthe von Moschzisker, director of the Print Club, located a few blocks from the college. Philadelphia also offered the Philadelphia Museum of Art, with its magnificent print cabinet, presided over at the time by the print and drawing curator Carl Zigrosser and later by Kneeland McNulty. In a near suburb was the residence of one of America's premier print collectors, Lessing Rosenwald, whose home and print gallery were an art resource and whose generosity played a part in the city's print life.

Van Vliet had returned to Philadelphia, but not for long. A new independence had developed during her year in Wisconsin. She credits Dean Meeker with being influential in her eventual decision to leave teaching behind. "He made a point in the attention he gave to the business of art, the commerce of art: that an artist can manage his affairs and live on his work, as a self-employed professional. I found that very attractive."[6] Within two years she had packed up her Janus Press and had relocated in rural Vermont; she would live solely off the production and distribution of her books and prints. One measure of her success is her MacArthur Fellowship (the "genius award") received in 1993.

ATELIER 17

Beginning in 1956 with Warrington Colescott's Fulbright grant to London and continuing with Dean Meeker's 1959 Guggenheim Fellowship to Paris, the Wisconsin print staff increasingly became acquainted with European print studios and print artists. Colescott's

studies at the Slade in London and Meeker's work with Stanley William Hayter in Paris produced friendships with artists who were at the forefront of the new attitudes toward printmaking that were developing in Paris, London, and New York. Meeker and Hayter were both outgoing, exuberant men with a love of work and technique. Meeker surprisingly submitted to the ritual of passage demanded of all newcomers to Hayter's studio— producing the demanded series of little engraved plates. Meeker, the Guggenheim prize man and one of America's best-known printmakers, sat on a bench for several weeks in Hayter's workshop doing basic aquatint and soft-ground etching on tiny plates. His rewards were access to the studio and Hayter's friendship.

Another friend of Meeker's was the Indian artist Kaiko Moti, who, along with his countryman Krishna Reddy, had been working on what they were calling "viscosity printing," a process of color inking and printing images from deeply etched plates. Hayter remained unimpressed with their endeavors and even encouraged them to "quit wasting your time."[7] Eventually, as their experiments began to result in rather spectacular color prints, Hayter changed his mind and began to support their experiments. He brought their method into the mainstream of color printing in his workshop but doggedly refused to call it "viscosity printing" in favor of "simultaneous inking"; however, despite his best efforts, the "viscosity" label stuck and "simultaneous" was rejected, except within earshot of the maître.

Both Moti and Reddy were superb technicians. Reddy was a sculptor, and his intaglio plates were examples of tour-de-force metal working as he built layers of form coiled within the tiny available depth of the plates. Moti had a poet's sensitivity to thin transparent layering of color. He controlled the overlapping films of color with hard and soft rollers by rolling the relief surface with the hard roller and pressing ink down into the deeper intaglio with the soft roller; layers of ink rejected or accepted overlapping inks based on their viscosity. Much of Moti's effects could be labeled monoprint, for he used brushes, sponges, and small rollers to work freehand on his complex plates and then, with great skill, reproduced the result in editions for his publisher, Abe Lublin.

Hayter admired Meeker's serigraphs and reproduced one of Meeker's best-known prints, *Trojan Horse,* in his 1962 book on print technique.[8] Hayter told Meeker that he was interested in the screen-printing technique that he had learned during his period in New York and that he had experimented with it in various combinations with other print processes. In spite of his compatibility with Hayter, Meeker found Atelier 17 less than an ideal workplace, since he was used to his own large studio in Madison. Hayter's atelier was crowded and somewhat confining, so Meeker eventually did more work at Moti's cluster of studios in Cité Falguière.

At various times in the sixties, Meeker was instrumental in bringing both Moti and Reddy to Wisconsin for long visits to teach, and Hayter came several times for short lecture visits as well. At the exact time that Hayter's 1966 book *New Ways of Gravure,* with its detailed charting of "schema" to explain "simultaneous inking," was released for publication, his assistants were demonstrating the method to the print classes at Wisconsin, and

the author himself was scheduled for a workshop visit.[9] Through the years, the Atelier 17 connection remained a resource, a Paris studio base to be used after undergraduate or graduate study, for Wisconsin print students.

BIRGIT SKIOLD

During his Fulbright year at the Slade School of Art in London, Warrington Colescott was exposed to British printmaking at a very active time. The British Print Council had just been formed. Robert Erskine had opened St. George's Gallery in Bond Street and was promoting an exciting renaissance of British printmaking in which Colescott's mentor at Slade, Anthony Gross, was an active player as a highly respected teacher and print artist and the inheritor of a tradition at the Slade School that reached back to Alphonse Legros and John Buckland-Wright. He was very helpful to Colescott, and realizing that the American needed more studio time than his three days at University College London, Gross suggested that Colescott look up "that Swedish girl who has a printing shop in a Soho basement."[10] Somewhat warily, Colescott complied.

Birgit Skiold's basement suite was neat and organized in such a manner as to allow a small group of artists to work on plates and stones and rent press time for lithography or etching. There was definitely a social aspect to "The Basement," since Skiold had a wide circle of "chums" in the gallery business, on curatorial staffs, and among artists and print teachers. Among the many notables who dropped by Skiold's basement were Kathan Brown, who later founded Crown Point Press in Berkeley; the German artist Dieter Roth; the print curator of the Victoria and Albert Museum, Graham Reynolds; Rosemary Simmons of the Curwen Gallery; and the silk-screen artist John Coplans, who later founded *Artforum* magazine. The little basement room was often a crush of nubby tweeds, corduroy, mini-skirts and knickers, with Algerian wine spilling out of plastic cups over the wooden platen of the ancient star-wheeled etching press that served as the bar.

Connections that Colescott made in 1956 with the closely knit London art scene were added to and solidified during his return visits over the next few years. The liveliness of English printmaking was transported to the University of Wisconsin by Birgit Skiold, who taught lithography in a summer session in 1964; by the woodcut artist Michael Rothenstein, who made two visits to the Madison campus; by the book artist and typographer Ian Tyson, who taught a semester; by Jennifer Dickson, a former assistant to Hayter, who taught for a year; by Bartolomeu Dos Santos, the remarkable Portuguese artist who would follow Anthony Gross as instructor of engraving at the Slade School of Art and would come to Madison for two teaching visits; and by Anthony Harrison, the etcher at London's Central School. Harrison came to Madison for a symposium in 1964 as part of a fractious group including David Hockney, with Ossie Clark, the fashion designer and self-described "brilliant butterfly."[11]

As with Hayter's studio in Paris, Birgit Skiold's facility in London served as a convenient work space and social center for Wisconsin students and faculty on periods of leave and research in Britain. Skiold died in 1982, but her workshop was continued by the print-maker and writer Silvie Turner.

THE MONTHLIES

The visiting-artist program has always been a major focus in the art department's yearly planning; a certain number of visitors are invited specifically to interact with students in the print area. The overriding consideration for selection has always been the quality of the artist and the ideas behind a body of work, rather than any particular technique. In some cases, visiting artists have been people whose reputation has been made in painting or sculpture but whose ideas have particular interest for printmakers. For a time in the sixties, the department's visiting-artist committee had a big net and caught some big fish. During that time, it was decided not to replace a retiring professor but instead to bring to campus four major visiting artists during an academic year; each would be given a first-class studio and would be in residence for a full month. This plan was in place for several years, and it had a tremendous impact.

One of the most memorable years was when William Wiley and Wayne Thiebaud came from the University of California, Davis, and Jack Beal and James Rosenquist came from New York. Arriving for his scheduled residence, Wayne Thiebaud immediately repainted his studio dead white (walls and floor and ceiling), unfolded a chair in front of his easel, drew a line behind his chair, and put up a sign saying no one was allowed beyond that line and absolute silence was required of visitors. During the month, he finished twelve paintings and numerous watercolors and drawings. Conversely, Jack Beal drank Pepsi and talked to the students while he worked. At one point, he left his studio to go up Bascom Hill to join a student demonstration against Dow Chemical's recruiting on campus; he was tear-gassed in the ensuing fracas. William Wiley wandered, sometimes taking the students to the Union Terrace to drink beer while he talked about music. His intense interest in a wide range of topics sparked conversational exchanges with student groups that led to group drawing sessions. James Rosenquist assigned graduate students to work stations to do preliminary studies for projects that he was contemplating. When a certain quantity of designs were completed, he would lead a discussion of the possibilities captured and missed. The visit of each of these four artists was uniquely stimulating and had the effect of energizing normal class activity.

All four artists had interests or techniques that recommended them to the graphics area. Jack Beal had a diverse background in lithography and had collaborated with book publishers. During his stay in Madison, he worked with Walter Hamady, who would incorporate Beal's illustrations of poetry with text and publish the material at his small press.

Several books were produced during Beal's stay in Madison, and the supportive, working relationship that was established between Beal and Hamady continues. In addition, Beal developed close relationships with William Weege, who also collaborated with Beal on various projects after Beal's Madison period, and with Joe Wilfer, a graduate of the graphics area, then director of the Madison Art Center, and a pioneer exponent of handmade paper. Beal and Wilfer had similar personalities, characterized by a larger-than-life openness and exuberant generosity which propelled a relationship that continued beyond Madison and Wisconsin. Beal was helpful in getting Wilfer a brief appointment as director of the Skowhegan School of Painting and Sculpture in Maine, which led to a subsequent position in New York as director of the Spring Street Workshop, a new fine-art printing venture. Beal left Wisconsin as a friend of the department and in subsequent years welcomed faculty and former students to New York with both hospitality and a willingness to make introductions.

In the same way, William Wiley was a help to students who went to California in later years. He returned to Wisconsin several times to drop in for special events, to show his work in the area, and to collaborate with William Weege on posters. His artistic output has included a large body of print works in collaboration with various printers and publishers, including lithographs with Jack Lemon in Chicago at Landfall Press.[12] At Wisconsin, he was a familiar and friendly figure in the graphic shops, holding forth with the printmaking students on matters relating to a worldview defined by his personal mythology.

Wayne Thiebaud was just beginning to have an interest in etching at the time of his visit. He had brought with him a small copper plate that he had etched under the guidance of a neighbor in Berkeley, Kathan Brown, who, as he explained to Warrington Colescott, thought etching would fit his style. She had a small press in her basement and had been trying to get other Bay Area artists involved. It was a pretty little plate. Colescott put his studio assistant, Steve Weitz, on the project, and Thiebaud's plate was printed. For the rest of the visit, Thiebaud worked with Weitz on several other plates; this time the artist, with Weitz's help, did the grounding, the needling, the etching, and the printing. It was a beginning that Colescott recalled while viewing Wayne Thiebaud's technically resourceful print retrospective at the Associated American Artists Gallery in New York in the late spring of 1997. As a visiting artist, Thiebaud kept regular studio hours and would open his door on weekdays at 10:00 A.M. Students would crowd in, carefully staying behind his line on the floor, and observe him working on his painting. There were no props; a heavy silence was broken only by the whisk of the artist's brush and the slurp of the impasto. At times, he sat still, contemplating. Occasionally, a student would leave, backing out the door cautiously; someone else would quietly enter. Colescott, after attending one of these sessions, said that it was one of the most effective demonstrations he had ever seen—and without a spoken word.

In contrast, James Rosenquist's studio was a factory. Organized groups of students were busy with their tasks on the works being assembled. There were diagrams and grids, in-

struction sheets, and music to work by—not too disturbing, but with an insistent beat. The student workers seemed to move in cadence, with Rosenquist, the floor manager, orchestrating. As in Thiebaud's case, when the month was up, the art movers appeared, and completed projects were trundled to the trucks. Rosenquist's last act in Madison was to throw an enormous party that was still discussed by emeritus faculty in the University Club thirty years later. There were residual benefits to the Rosenquist visit. An invitation to come to his New York studio was accepted by several student groups. His Soho workshop was a corner walk-up, where Rosenquist genially entertained his guests with the usual art gossip and then with an unhurried discussion of the pieces he had on his work wall.

In retrospect, the system of Monthlies was an ideal. It was too good to last, and it did not. The money was taken for other things, priorities were reassigned, and the visiting-artist program shifted in form: more visitors, less time per visit.

ALUMNI: GENTLE MAFIA

The alumni of Madison's print area form a massive, networking band of workers in the print arts. They have been referred to, somewhat wryly by competitors, as the Wisconsin Mafia. They are indeed a nonlethal, gentle Mafia, a widespread diaspora that has found an entry into the professions that are a part of print art: teaching, publishing, exhibiting, and evaluating. These are people who have gained something of proven value in their university work and have thus been encouraged to maintain connections with fellow alumni, with their former mentors, and with the university. They are a source of support to graduates out in that shadowy real world, where experienced advice or a good connection can be invaluable at certain times in a career.

Teaching printmaking in a university has been a growth industry for many years. In the immediate postwar era, art training in the schools at every level was underdeveloped and understaffed. At some point in the 1950s, this began to change. The excitement and the curiosity of a new American art percolated down to a public growing interested in what they were seeing. New art needed new training and new facilities. Prints were solidly a part of this development. The job market for university teachers of printmaking suddenly came to life. Many of these jobs were to build print curricula within departments that had no printmaking. Graduates with advanced degrees in fine arts went out to meet that challenge and, having put together printmaking shops and an organized sequence of courses, settled down to teaching and making prints themselves.

Madison graduate Robert Burkert moved with his degree only as far as the University of Wisconsin–Milwaukee, where he developed a printmaking studio and became nationally known for his serigraphs. Richard Callner went from Madison to the Tyler School of Art in Philadelphia, became director of their branch in Rome, and finally was brought

into the department of art at the State University of New York at Albany as chair. Another print and painting graduate, David Pease, moved from studio teaching into administration and eventually became dean of the Yale Art School. With the spread of print art in the seventies, large numbers of female graduates successfully competed for university jobs nationwide; for example, Karin Broker went to Rice University; Judy Youngblood went first to Paris on a Fulbright to study with Hayter and then to the University of North Texas at Denton to take over printmaking; Robin Gibson went to Pennsylvania State University to initiate lithography courses; Phyllis Galembo, putting etching on hold, went to the State University of New York at Albany to concentrate on photography and to explore the religious cultures of Africa, Brazil, and Haiti; and Ann Marie Karlsen went to the University of California, Los Angeles to join a department that was rapidly expanding.

Talent, energy, and skills have led to fine careers. Diogenes Ballester, living in New York, became Puerto Rico's best-known printmaker. Graduating with a concentration in silkscreen, Marko Spalatin never wavered. He went to the small town where he wanted to raise his family, built a studio, and lived very well on sales and commissions from his serigraphs. This respected artist has never taught a single day.

Art Werger, who was hired as print professor at Wesleyan College in Macon, Georgia, is also among the most productive print artists to come out of Wisconsin. Werger's etchings in color and black and white have a formidable reputation; they are amazing statements of reality transposed into farcical dioramas. This master of multiple-plate etching has a record of awards, grants, and exhibitions that began while he was still at Madison. As a beginning intaglio student, he produced a set of etchings detailing completely the right side of State Street—every building, every utility pole, and every window on the mile stretch of the street that extends from the foot of Bascom Hill to the State Capitol. Bruce Nauman, a young undergraduate in 1962, transferred from mathematics into the art major for his junior and senior years. He studied oil painting with Santos Zingale and was a member of Alfred Sessler's printmaking class. He did work in etching and lithography and made prints that were characterized by introspection and sensitivity. Nauman has remembered appreciatively those Wisconsin faculty members who had experienced the Federal Art Project of the Depression years. It is interesting to compare the social criticism in the works of Zingale and Sessler with the critical implications in Nauman's later electronic constructions, as well as the ambiguous and culturally subversive messages in the text and drawings featured in his lithographs, drypoints, and etching; something was absorbed during Nauman's two years in the Wisconsin art department. Nauman has said, regarding his professors, "They held to the belief, nurtured in those years, that art should be socially relevant."[13]

Warrington Colescott remembers Nauman. "On Sessler's recommendation, I agreed to take him as a painting student in his senior year. There was no undergraduate studio available, so I set him up in an upstairs hallway. He was quiet, nearly inscrutable. I would meet him once a week, and at each meeting he had a finished group of paintings. His output

was prodigious. I talked technique, materials, ideas, art history, anything I could think of to establish a dialogue. Nauman's dialogue was with his work. Each week I would find that the previous week's paintings had been repainted and had spun out into six or eight new pieces, going in six or eight different directions. Every now and then he would sit in with my graduate seminar with a friend, Hart McNee (now a New Orleans jazz musician), and they would play extemporaneous jazz. McNee on flute and Bruce on bass fiddle: it made for some remarkable seminar meetings."[14]

The print area has launched many careers—some in prints, many in related areas, some in fields that only opened up in the sixties and seventies. Professional printing was hardly an option in America before the fifties; lithographers and etchers worked in a few lonely shops for meager incomes. Printers like Robert Blackburn and Letterio Calapai were barely surviving in New York; Tatyana Grosman, from her home in West Islip, Long Island, worked at convincing her artist neighbors to let her husband bring them lithograph stones to try; Kathan Brown carried copper plates to artists in Berkeley. As printmaking came alive across America, these ventures began to strengthen and would ultimately prosper. Universal Limited Art Editions (ULAE) took flight as Grosman's artists began exhibiting their lithographs and paintings and William Lieberman, print curator at the Museum of Modern Art, took an interest. June Wayne convinced the Ford Foundation to fund a lithography workshop, using her Hollywood studio on Tamarind Avenue as a base and a trademark. Her brilliant project brought printers from Europe and America to make lithographs with invited artists, both experienced and, more likely, unfamiliar with the art. Apprentice printers were trained as "master printers," graduating to found their own shops and become part of a new wave of successful print publishers.

As the publishing market opened up, a number of Madison's technically adept art majors began to try their luck in the printing business. Richard Royce, who had earned a master of fine arts in printmaking during Alfred Sessler's tenure and had been Warrington Colescott's studio assistant, established a publishing studio, Atelier Royce, first in New York and then in various West Coast locations. He did advanced and experimental printing, including sculptural editions of three-dimensional paper and sculptural objects.

Bud Shark did undergraduate work in lithography with Jack Damer, moved after further training into various printing jobs, and ultimately founded his own publishing house. He kept his operation highly selective and chose to work only with artists who fit his own criteria. Today, Shark has one of the most respected reputations in the country.

Nancy Brokopp, a strong young woman from South Dakota, had worked as an undergraduate with Lloyd Menard at that state's university. At Wisconsin, she did graduate work with Warrington Colescott and showed fine skills and a love of intaglio printing. Before finishing her degree, she left for New York, convinced that she could make a living as a fine-art printer; she was right. She participated in many publishing groups and finally

formed a partnership with Orlando Condesso in 1973 that has resulted in the completion of major intaglio publishing ventures.[15]

Lisa Mackie became a busy lithographic printer in Boston and New York. Remaining in Madison, Andrew Balkin became the master printer for his own specialized workshop, Andrew Balkin Editions. Slowly, with infinite pains, his shop produces portfolios of prints by invited artists who produce their intaglio prints with Balkin in his meticulously equipped studio. He started with regional and Chicago artists and has gradually broadened the focus of his portfolios.

San Francisco has a number of smaller fine-art print publishers, and printers from Madison have long associations with some of these. Madison graduate Gary Denmark is in charge of the monoprints produced in Palo Alto at Paula Kerkeby's Smith-Anderson Gallery. Another former Madisonian, John Stemmer, is master printer at the Experimental Workshop in San Francisco, directed by Anne McGlaughlin. He is a veteran "printer" at this workshop whose specialty is large-scale editioned work in materials ranging from cast paper to cast metals and plastics and monoprints.

Among the success stories are also some sad tales of talents chewed up in the high-pressure mix of art, big money, and the unstable ambience that artists attract. "Master printer" Ken Farley was a case in point. As a graduate student at Wisconsin, Ken Farley was an outstanding artist, skilled in printing and a valued teaching assistant in both lithography and etching. Coming from an Appalachian mountain settlement in Kentucky, Farley was quiet and shy, had "good hands," and was an original at transforming photo collage onto etching and lithography plates. After he received his graduate degree, he tried teaching and did well with his classes at Ohio State University. After a few years, however, he came to the conclusion that teaching would never be as rewarding for him as the work of platemaking and printing. He quit his university job and drifted into a period of work as a fine printer. His skills in printing color lithography allowed him entrance into a sequence of print shops, including Petersburg Press in New York and Gemini Graphic Editions Limited, in Los Angeles. He was a mainstay at Gemini for ten years, and Sidney Felsen, director at Gemini, gave him high praise.[16]

Farley worked as master printer on projects involving Robert Rauschenberg, Roy Lichtenstein, Ellsworth Kelly, Richard Serra, Claes Oldenburg, and an international roster of blue-chip artists. He worked with Bruce Nauman on a series of drypoints, Nauman's preferred intaglio medium. In all probability, they discussed their days in the print shops and jazz joints of Madison. In the Los Angeles world, close to the Tamarind lithography empire, Ken Farley was exceptional in his ability to shift from lithography to etching to silkscreen to relief, all of which were increasingly in demand by the artists who came to Gemini.

Considered in another way, Los Angeles was a dangerous locale for Ken Farley. He had

grown more involved with the drug culture in the city. His problems interfered with his work and, after ten years at Gemini, Farley quit to begin his own publishing business and to attempt to straighten out his life. While setting up shop in his downtown loft, in an area rampant with narcotic activity, Ken Farley was murdered in a botched robbery by a local addict. The killer made off with electronics and cash but paid no attention to the printers' proofs stacked under Farley's bed. These were bonus payments for his work with artists whose prints command huge sums—a stack of paper worth a fortune.

Handmade paper appeared at Wisconsin during the tenure of Walter Hamady. The paper mill that Hamady put in place became a major training ground for numerous print students, among them, one of his early apprentices, Joe Wilfer. Wilfer had studied with Raymond Gloeckler in relief printing, but his first love was paper. He had many gifts and was a man of enormous energy, capable of transferring his enthusiasm to others. His own handmade-paper mill, in a dairy barn in rural Dane County, the Upper U.S. Paper Mill, became an important center for paper research and spawned collaborative projects with Madison artists and visitors as paper became a new medium of graphic expression in the late sixties.

For a time, Wilfer remained in Madison, running his mill and organizing activities with artists of the region attracted by papermaking. By 1976, he was the director of the Madison Art Center. His shows spotlighted the art of the community and the state and made the underfunded art center a true cultural center for the city. His home was still a trailer parked near his paper mill, which, in some ways, acted as an extension of the art center. After successfully managing the move of the art center from the abandoned school building that it occupied for some years into an abandoned department store in downtown Madison and feeling he had perhaps exhausted his Madison possibilities, Joe Wilfer picked up his diverse projects and moved east.

As director of publications at Pace Editions, Wilfer was in charge of the new printmaking studio. He brought in as assistants two of his papermakers and printmakers from Madison, Kathy Kuehn and Ruth Lingen. His early projects were both bizarre and riveting. Working with Chuck Close, Wilfer designed a method of forming handmade paper of Close's photo-mimetic portraits in gray-scale squares of pulp. In the ceiling of an elevator car, Wilfer had noticed a plastic sheet of tiny squares that functioned as a light diffuser. He secured a sheet of the material and hinged it to a suction silk-screen printer. Using the Madison secret weapon, a plastic squeeze bottle, he filled the little squares with paper pulp in a pattern that reproduced Chuck Close's design and with his printer sucked the squares of pulp onto a backing of handmade paper. The sucked bits of pulp with their natural adhesives were thus laminated permanently into one piece. The action was repeated, producing an edition of portraits made of black, white, and gray paper pulp pulled from the segmented matrix. It was a startling success. Chuck Close enjoyed working with Wilfer and they dreamed up further collaborations.

Etching was enjoying a revival among publishers, and Wilfer participated in bringing Aldo Crommelynck, Picasso's favorite printer, to New York from Paris to direct the establishment of an intaglio printing division within what Wilfer now named the Spring Street Workshop. Wilfer and Crommelynck entered a period of collaboration that melded the best in wide-ranging French intaglio printing with Wilfer's off-the-wall ideas. In a series of collaborations with Pace's artists, new ground was broken in fine art print editioning. Wilfer's history at Pace is a continuous series of original and brilliantly conceived collaborations between artists and printing teams.[17]

Down the block from Joe Wilfer's Spring Street Workshop, over on Broome Street, is the Dieu Donné Papermill, another Wisconsin outpost. The owner-director is Sue Gosin, and the mill makes paper for artists nationwide, much of it on special order with unusual size, shape, or textural requirements.[18] The mill contains a gallery, an office complex, and classroom space. The workers Gosin has gathered are motivated by an obsession that paper is a venerated material.

Paul Wong, Gosin's artistic director and master papermaker, did his graduate work at Wisconsin and was the assistant for Jack Damer. At some point, the surfaces Wong was printing on became of equal importance to the medium being printed. He drifted deeper into a relationship with hand-formed paper, while continuing to work in lithography and monotypes. These were printed on his own paper, sheets of the greatest possible delicacy, laminated, shaped, dressed with collage, and undressed to reveal elements of the flip side. Wong himself works in close cooperation with artists who come to Dieu Donné to create papers for books and paper as art.

Dieu Donné's gallery features exhibits of experimental and untraditional books that play games with every aspect of the book as understood by Barnes & Noble. Gosin's own books are sometimes shown. These are illustrated with her etchings and mezzotints or with works done in collaboration with other print artists and are prized among students of the book arts. Copies are in many major libraries and private collections.

Pertinent to the larger picture of Madison-alumni accomplishment is the structure of juried and invitational print exhibitions sponsored by university galleries and print societies. These shows, and there are hundreds of them, to a certain extent determine the way print art is made visible to a larger public. Artists with a Wisconsin print connection have traditionally played a large part in this structure.

Some historic art and society clubs, like the Print Club in Philadelphia, have a history of juried exhibitions going back to the early 1900s. The National Academy of Design in New York recently hosted its 172nd annual, with a prominent section featuring graphics juried by print artists. The Society of American Graphic Artists (New York), the Brooklyn Museum, Bradley University, the Boston Printmakers, and Colorprint USA (Texas Tech University) all hold established, flourishing shows. The catalogs for their shows are circulated widely and generally indicate strong Wisconsin participation.

Printmaking as a career remains a remarkably open corridor, and the structure of competitive exhibitions plays a part in the openness. The popularity of the juried show continues and is another indication that printmaking is alive and healthy. Graduate students as well as print alumni have this populist venue in which to display their abilities before the guardians of the market. This access in addition to easy availability indeed make prints democracy's art, and it is therefore important to understand and appreciate artists driven to print.

Misch Kohn, *The General. Chine collé* lift ground etching (1958) 17 × 9. *Wisconsin Union Galleries, University of Wisconsin–Madison.*

176

(top) Birgit Skiold, *Untitled.* Lithograph (1964) 13½ × 18. *Collection of Warrington Colescott.*

(bottom) Wayne Thiebaud, *Boston Cremes.* Color linocut (1970) 13⁹⁄₁₆ × 20⅜. *Elvehjem Museum of Art.*

(top) Krishna Reddy, *Flight.* Color intaglio (1962) 13¼ × 19¼. *Elvehjem Museum of Art.*

(bottom) Kaiko Moti, *Birds on a Branch.* Color intaglio (1962) 13¹¹⁄₁₆ × 25¹³⁄₁₆. *Elvehjem Museum of Art.*

Stanley William Hayter, *Plongeon.* Color intaglio (1976) 23 × 18½. *Elvehjem Museum of Art.*

James Rosenquist, *Paper Head on a Nuclear Pillow,* from the Glass Wish Series. Color aquatint (1982) 23 × 16. *Elvehjem Museum of Art.*

Jack Beal, *Oysters with White Wine and Lemon.* Color lithograph (1974) 12¹⁄₁₆ x 16. *Elvehjem Museum of Art.*

Marko Spalatin, *Matrix IV.* Screen print (1990) 20⅞₆ × 20⅞₆. *Elvehjem Museum of Art*

William Wiley, *Spooky on the Line*. Lithograph (1979) 30 × 22. *Elvehjem Museum of Art.*

Bruce Nauman, Me. Lithograph (1963) 16 × 12. *University of Wisconsin–Madison Art Department Graphics Area Archive.*

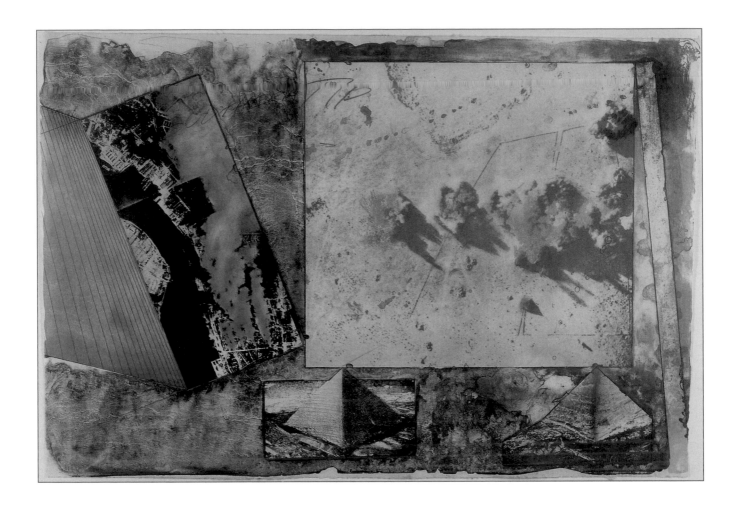

Paul Wong, *Southern Shelter*. Lithograph on Japanese paper (1977) 24 x 35½. *Collection of Warrington Colescott.*

Art Werger, *Flying Fish.* Etching in color (1998) 14¾ x 20. *Collection of Warrington Colescott.*

TANDEM PRESS

The University as Print Publisher

The opening of Tandem Press at the University of Wisconsin–Madison in 1988 can be seen as a culmination of the extraordinary print program that developed at Wisconsin in the postwar years, as well as an echo of a transition taking place in American printmaking.[1] The birth of Tandem Press coincided with the high-water mark of the print boom of the 1980s. On the national level, prints were selling at auction for record prices. New York's contemporary art dealers, whose print businesses had been growing steadily for two decades, were expanding their print showrooms to take full advantage of the vigorous market. Ten years later, a serious market contraction occurred. Many workshops and publishers were forced to close their doors in the early 1990s. Tandem's continued success is a notable exception and must be credited to the talents of the people who have run the press and their dedication to its mission.

Tandem Press was founded by William Weege, a product of the Wisconsin print program with an undergraduate background in civil engineering. During his art-student period, the department's visiting-artist program had been particularly vigorous, and Weege counted it an important and inspirational part of his development; as a graduate student, he worked closely with painters William Wiley and Jack Beal, and his contact with Ed Ruscha resulted in an invitation for Weege to join Ruscha in a collaborative project at the 1970 Venice Biennale.

Weege's creative and experimental work in prints and his strong record of exhibitions eventually resulted in his joining Madison's art department print faculty in 1971. As a faculty member, he transformed farm buildings on his property into print workshops— first, Jones Road Print Shop and Stable, which published from 1971 to 1981; then, at his second farm, Off Jones Road Press. He was convinced that actual work in a viable printing and publishing workshop was invaluable to students; the experience allowed them to see the possibilities of collaboration and gave them access to the various professional artists at work in the shop. Weege vehemently argued for the founding of a university print publisher that would lead the way in creating new art and, at the same time, training and seasoning young artists. Weege's predilection for workshop collaboration and ex-

perimentation with processes helped him make a convincing case to his department and college to allow him eventually to establish a fine-art press within the art department. So began a publishing venture with an educational purpose. Weege would be the first director of Tandem Press.

A delicate balance had to be struck. While Tandem would service the educational mission of the university, it also had to be a professional operation that would be attractive to working artists. Technical facilities were gathered and staff members were hired. Public support was necessary if self-sufficiency were to be achieved. Certain responsibilities were added to the activities of the invited artists beyond creating prints, including a requirement to lecture to the students of the art department and to the general public. Beyond that, the job description for visiting artists was open-ended. Artists, on break from press work, could be counted on to talk to art students about their works in progress. During other unscheduled intervals, the artist might visit student studios to offer critical advice. In this way, Tandem would broaden the visiting-artist program of the art department. However, the educational impact of Tandem Press has been greatest on those students who work there as interns and work-study assistants, as they share in the platemaking, printing, collating, and administrative tasks that keep the press self-supporting. They participate in the hands-on activity in every aspect of the process and experience the complete range of technical and political work necessary to run a complicated production—from maintaining equipment to the care and feeding of visiting artists.

Tandem's presses were set up in a factory building leased by the state of Wisconsin about three miles from campus. The main workroom is large, has a high ceiling, echoes with work activity, and houses furnishings and equipment strewn in a chaotic but workable fashion. There are drying racks; tables of various heights and strengths; presses for lithography, relief printing, and etching; as well as the jumble of equipment needed to service these media—storage units, shelves, spreads of color on glass sheets, rollers, daubers, grinders, and the etceteras of a busy print shop. Everywhere, on the walls and flat surfaces, are large, colorful proofs of developing, printed art. Along the hallway is a parade of mounted prints, finished state proofs by various of the artists who have been past visitors. The hall connects the main workroom with the office complex at the front of the building where the administrative offices and a large gallery, lined with print storage cabinets, are located. The ample gallery space is not merely an in-house convenience; Weege recognized that for Tandem to be self-supporting it needed to sell as well as print. The business of Tandem was planned as carefully as the technical facility.

From the outset of operations, the policy at Tandem was to invite major artists with established reputations to work on site for a time. Obviously, as an unknown, the press would have difficulty attracting the best artists. However, the art department's print area and the distinguished artists who worked there had gained a nationwide reputation, both for the prints that had been produced by these artists and for the fine young printmakers the program had launched into the profession. Further, the Wisconsin print area was a

highly successful graduate research center in color printing, demonstrated by faculty and students exhibiting their prints in major exhibitions. A connection with this program was made and emphasized by Tandem Press.

In the early days of the press, the art department's print area shared equipment, faculty, expertise, and the skills of its graduate students with Tandem. In some cases, the edition printing, such as Garo Antreasian's 1990 lithograph, was printed in the graphic area's lithograph shop by Jack Damer and students rather than in the Tandem space. Frances Myers's acid room and plate-making facilities were useful for the early etching projects that were done before the development of Tandem's etching facilities. Her graduate students in etching continue to be an important art resource in intaglio for Tandem Press. Raymond Gloeckler joined in on the cutting of woodblocks on some of the first collaborations. This kind of expert help and consultation was an important factor in Tandem's being considered seriously by major artists in its early days and in their responding positively to invitations offered.

Weege's intention was to make artists' stays at the press as productive and pleasant as possible. Being far from the art-market centers on the east and west coasts was a negative to some of the invitees. As an inticement, Weege determined to outfit the press with print equipment no other press could offer. Pushing against the technical limitations of the time, Weege arranged to have an etching press built that was the largest available in the country. Weege approached a local engineer, Mike Bunch, to design and build this giant press. Bunch had made his first press for his wife and then built seven or eight for various purchasers, including Weege's Off Jones Road Press. Bunch's Tandem design was based on Weege's specifications for a pressure of five hundred pounds per lineal inch. The rollers Bunch designed were six feet wide and able to apply the desired pressure over the entire width of the press bed, due to a maximum stiffening of the roller cores with numerous internal supports. The platen, constructed of a dense composition material, was six feet wide by twelve feet long.

Administratively, Tandem is provisionally under the aegis of the art department, and thus its governance and budget are overseen directly by the department and the university's administrative apparatus. As a somewhat unusual unit in the university, Tandem generates an occasional request that must be addressed by the dean of the School of Education. In recognition of Tandem's special needs, an associate dean has been assigned by the School of Education to deal with issues relating to the press. The associate dean is a member of Tandem's board.[2]

In practice, Tandem has two boards: the Board of Advisors and the Artistic Advisory Committee. The Board of Advisors is drawn from within and from outside of the local community. Its members are chosen for their expertise in areas of fine-art publication, but their advice and oversight often wander further afield. Beyond its normal review function, the board, with its mix of collectors, businessmen, artists, and administrators, has been therapist, oracle, and council of elders for the press. The Artistic Advisory Commit-

tee's work is more narrowly defined. This group, drawn from art faculty, printmakers, and art professionals, joins selected Tandem staff in advising on possible invitations, assessing completed projects, and planning future projects.

An important friend in Tandem's early days and until his death a permanent member both of the Board of Advisors and of the Artistic Advisory Committee, along with Warrington Colescott, Paula Panczenko, and William Weege, was Joe Wilfer. As a print-area student, Wilfer had studied with Raymond Gloeckler and Walter Hamady and had been an associate of Weege's in various paper and print exploits. Wilfer set up his own paper mill, the Upper U.S. Paper Mill, in 1974 in rural Oregon, Wisconsin. Wilfer's mill soon gained national recognition as a research facility for the creation of handmade paper, a collaborative effort of print artists and papermakers.[3] After eventually moving to New York, Wilfer established the Spring Street Workshop and became director of publications. Thanks to his wide acquaintance with artists and his knowledge of experimental currents in the print field, Wilfer was invaluable in advising Tandem's board on which artists to invite to the press. Wilfer encouraged high-profile artists to come to Tandem and encouraged Pace to use Tandem as a printer for projects that could benefit from Tandem's special facilities and employee skills; for example, Robert Stackhouse's pieces *Diviners* and *Approaching Diviner* were funded by Pace but co-published with Tandem. Julian Schnabel's prints for Pace were also printed at Tandem. In the Schnabel editions, Weege developed a way of embossing the prints with broad, paint-brush-like strokes of texture, to the delight of the

Raymond Gloeckler and the late Joe Wilfer in 1974 at the Upper U.S. Paper Mill in rural Oregon, Wisconsin.

Photograph courtesy of Raymond Gloeckler.

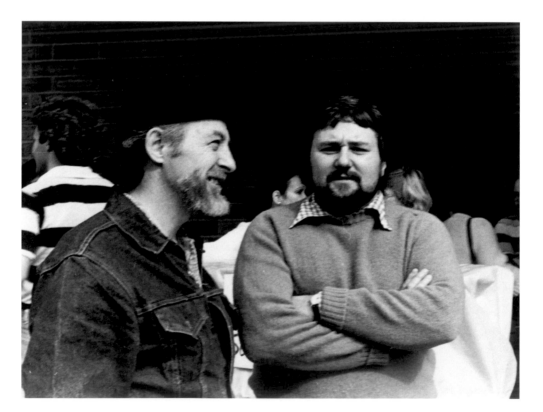

artist. Wilfer was responsible for bringing a major Pace project with Chuck Close to Tandem Press for the initial processing, the creation of the blocks by the artist, and the proof printing.

From the beginning, Weege planned that Tandem would "run itself." He knew that his other projects and teaching would draw his attention away from the constant supervision that the work of creating and editioning prints requires. In preparation for this, he hired Andy Rubin as master printer in 1988. Rubin came with experience as a printer at Gemini Graphic Editions Limited in Los Angeles, a noted publisher that had been set up originally by former Tamarind master printer Ken Tyler. Rubin had been part of a printing team at Gemini headed by Ken Farley, a graduate of the Wisconsin print area. Warrington Colescott met Rubin on a visit to Gemini, watched Farley's team print a large Rosenquist relief print, and recommended Rubin to Tandem as a talented young printer. Rubin's hardworking affability and perfectionism in editioning have made him an ideal collaborator on the most successful Tandem prints. He is able to work with experienced printmakers, contributing greatly to the collaborative effort, and has the ability to give an artist who has no printmaking experience a sense of the possibilities inherent in the process.

One reason for Tandem's continuing success has been the quality of its administrators. The first, Trudy Hansen, was recommended to Weege by his friend painter Sam Gilliam. Hansen's years of experience in curating the works of small presses included her founding the archive for Echo Press at the Indiana University Museum of Art in Bloomington. She arrived in Madison in time to participate in the organizing activities for a press, still unnamed at that time. Hansen came up with the name "Tandem," which underlined the fact that the press was a collaborator between the artist and the printer. As the work of the press began, Hansen established the system of print registration and the curating of the editions, saw to the finances of the nascent press, and proposed that the archives reside at the Elvehjem Museum of Art. An annually planned schedule of invited artists was to include one artist from the art faculty, one artist from the region, and five or six from around the nation. Every year or two, one of the previously published artists was to return for an additional work visit to complete any unfinished projects. Above all, Trudy Hansen set the professional tone that has served the press so well.

Tandem's visiting artists were paid an honorarium and a per diem and were given a share of the edition. In order to gain a ready market for its prints and to raise money for operations in advance of actual production, Tandem invited supporters to purchase subscriptions. To raise money for Tandem's first editions, twenty subscriptions were sold locally at ten thousand dollars each, for which buyers were given their choice of twenty thousand dollars' worth of prints from Tandem's stock. Financial pressures brought on by a changing market have been addressed by raising the subscription price to twelve thousand dollars for twenty thousand dollars' worth of prints. The number of subscribers grew to forty.

In 1989, Trudy Hansen moved to the Zimmerli Art Museum at Rutgers University and

Paula Panczenko and visiting
artist Gronk take a break from
Tandem Press duties on the ice of
nearby Lake Mendota in 1996.
Photograph courtesy of Tandem Press..

was replaced by Susanna Patrick. Changes in the art market and
in Tandem's position necessitated a restructuring of administra-
tion. When Tandem had been founded, at a time of strong print
markets, the emphasis had been on production and the curating
of the prints. As the market began to dwindle in 1989, it became
obvious that more emphasis had to be placed on marketing.
Paula Panczenko joined the staff at this time as administrative co-
director with Weege. Under her direction, financial problems
were addressed and new initiatives for outreach and public rela-
tions were put into play.

At this time, Panczenko set in motion a series of studies to an-
alyze all practices and policies, a process that involved experts
from industry and professors from the university's School of
Business. These studies spurred many of the changes necessary to
bring the press's costs into line with its income. As a part of this
effort, the press actively sought to raise its visibility through the
publication of a newsletter; greater exposure of visiting artists
through public events, lectures, and symposia; the representation
of the press at national conferences; and the sponsorship of sym-
posia on topics with which the press was engaged. Another tac-
tic to raise visibility was through participation in art fairs and
sales exhibitions in venues nationwide. Fairs like Art Chicago and the International Fine
Print Dealers Association fair in New York serve as intense, very public forums where the
people interested in prints can see Tandem's work in close proximity with work offered
by other dealers and publishers. Such excursions were taxing for the staff, particularly
given the size of many of the prints produced at Tandem; however, they were advanta-
geous in terms of immediate sales and in long-term name recognition.

As he had originally intended, Weege removed himself from the daily operations of the
press, and resigned as administrative co-director in 1992, although he intermittently con-
tinues to collaborate on various projects, and his interest in the press and support of it
continue unabated. In 1995, a new printer was added to the staff, Bruce Crownover, a
graduate of the art department's print area who had worked with Warrington Colescott
in etching and with Raymond Gloeckler in traditional Japanese woodcut printing. His ex-
pertise expanded the repertoire of skills available at Tandem to an invited artist.
Crownover has since become an associate master printer.

Although Tandem's financial situation is now stable, efforts are still being made to en-
sure the press's longevity. In order to become more immune to the vicissitudes of sales,
Tandem is currently raising an endowment called the Joseph Wilfer Visiting Artist Endow-
ment. This fund will support the visit of one artist each year, thereby easing the pressure
on subscription funds. The fund, initiated in 1995, was nearly halfway to its goal by 1998.

The artistic history of the press is one of remarkable achievement and quality. To make a selection of some of the particular achievements by the artists who have worked there is an exercise in personal preference, but some of the visits that have produced prints of widespread success should be mentioned. The first artist to work at Tandem was Sam Gilliam, a collaborator with Weege at earlier periods at Off Jones Road. His first print at Tandem, *Purple Antelope Space Squeeze*, was a departure not only from the usual print format but also from the standard definition of an edition. Before arriving in Madison, Gilliam sent Weege a drawing of the shape he wanted the print paper to be: roughly triangular in outline with a triangular hole in the middle. Graduate student David Johnson cast paper in the mold shaped to Gilliam's design to create very thick (up to three-quarters of an inch), soft sheets of paper. The paper was printed using dense litho ink transferred from carved woodblocks. Next, Gilliam collaged and painted handmade paper pieces, and produced prints using inked and uninked metal relief plates, welded found objects, and steel and zinc etched and aquatinted plates. Gilliam played with various arrangements of these many elements for the printing of each sheet of paper, altering the colors as he went from sheet to sheet, adding hand-painted details while the printing inks were still wet on the print, so that the wet inks mixed as the piece went through the press. The result was astounding, an infinitely varied edition, similar in shape, completely dissimilar in every other way. The notion of the uniqueness of each print in an edition was a cornerstone of Weege's philosophy, marking his own work and influencing the work in which he has played a part at Tandem Press.

Claire Van Vliet, a mentor to Weege during his graduate study at Wisconsin, while a visiting artist at Tandem, used a single plate to print *Wheeler Rock Series* but varied the edition with her choice of paper. Known for her work as an illustrator and publisher of her own books at Janus Press, she frequently used the medium of paper to create imagery of the Vermont countryside around her workshop. The artist started the process of making the paper for her print by tinting the viscous pulp which carries the fibers that are pressed into the paper. The different colored slurries were used as if they were paint to color the landscapes she was creating. The colored slurry fields, flattened and dried, supplied the broad washes of color especially apparent in the areas that depict the Vermont sky.

When Van Vliet arrived at Tandem, she prepared the etched plate that provided the linear structure to her prints. "Painting" each piece of paper differently with the pulp resulted in variant color arrangements from sheet to sheet, variant horizon lines, and variants in the way each sheet was registered with the plate. Since the plate was larger than the papers, the final prints are bleed printed, the plate encompassing the entire sheet of paper. Each print shows a slightly different scene, with various relationships of land to sky, and color and value shifts that imply changes of hour and even changes of season.

Etching has produced some remarkable prints at Tandem, including Robert Stackhouse's monumental *Diviners* and *Approaching Diviner*. In a cooperative venture with Pace Editions, Stackhouse came to Tandem with plans to do very large prints. His plans were larger than

the press's acid baths, and his plates did not fit. Andy Rubin and his assistants built a lip of bordering wax around the edge of his copper sheets and poured the acid directly onto the plate, essentially using the plate itself as an acid tank. Passages referring to the hull of a boat, Stackhouse's central thematic image, as well as the structural ribs of the boat were created in aquatint, stopping out areas with acid-resistant varnish and etching the open areas with granular textures that hold the ink in the printing as the image is transferred under pressure into the paper.

Judy Pfaff's prints at Tandem also went beyond the standard boundaries of etching. Pfaff transformed the expansive format of Stackhouse by creating long, horizontal prints that demanded close viewing; her audience was obliged to "read" them like a line of ideograms strung out along a wall. Her intaglio plates combine tightly drawn, linear elements, concentric ovals and circles, with flowing marks reminiscent of roots or seaweed. Her exotic inks glow, some with iridescent surfaces, others in warm tropical hues. In her print *Ar-oo-mm* the plates are butted end to end on a long, thin sheet of paper creating a print fourteen inches tall and more than six feet long, a design impossible without Tandem's giant press.

Art Spiegelman created *Lead Pipe Sunday #2 (Derby Dugan)* in 1997. Spiegelman is well known for his *Maus* comic books, which chronicle his father's suffering in Nazi Germany. Spiegelman also was involved in the publication of a seminal journal of avant-garde comics, *RAW* (which once called itself "required readings for post-literates"), which he edited with his wife, François Mouly. His works for Tandem show much of the same sensibility that informed *RAW*. Like a Sunday-comic supplement, the paper is printed on both sides, thus inviting the viewer to pick it up and handle it in an intimate exploration. The presumed protagonist of the print, Derby Dugan, sits among Easter Island–sized heads of famous cartoon characters pasted on one side of the print. On the reverse side, a cartoon car crash takes place. Created in twenty-four colors, the print is a testament to Spiegelman's drawing and wit and to Andy Rubin's lithographic expertise.

The artists who come to Tandem have the widest possible range of print experiences. Some, like Garo Antreasian and Ruth Weisberg, are technical masters; they have written the book—quite literally. Others have never before made prints. Learning seems to take place at all levels; artists bring their own goals and techniques, alternatively teaching and learning from the printers. The students who work as assistants acquire insight into their craft by being part of the creativity of others. They learn the relationship of midwife to the birth is exciting. A step or two back from the action are other groups, viewers, students from arts administration and from art history programs looking at the actual creation of art, something they had previously only read about. Also in the studio are students from the art department, not assisting but watching the work evolve as if it is an elaborate demonstration. Paula Panczenko has remarked that Tandem Press is her obsession and that "people see things here that change their lives."[4]

Sam Gilliam, *Purple Antelope Space Squeeze*. Relief, etching, aquatint, collagraph on handmade paper with embossing variant (1987) 43¾ × 39.

Photograph courtesy of the Elvehjem Museum of Art.

Claire Van Vliet, *Wheeler Rock Series #2*. Four-color *à la poupée* etching on handmade pulp painted paper (1989) 32½ × 44½.

Photograph courtesy of Tandem Press.

Chuck Close, *Alex*. Reduction print, silk-screen from mylar positives (1993) 79⅜ × 60⅜, published by Pace Editions, Inc.

Photograph courtesy of Pace Editions, Inc.

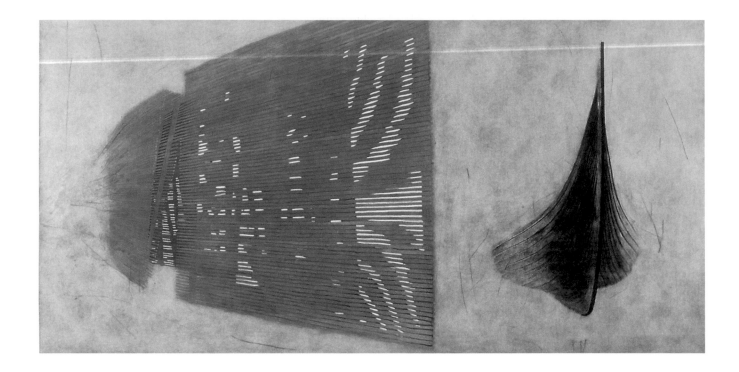

Robert Stackhouse, *Diviners.* Intaglio (1990) 54½ × 102, co-published by Tandem Press and Spring Street Workshop.

Photograph courtesy of Tandem Press.

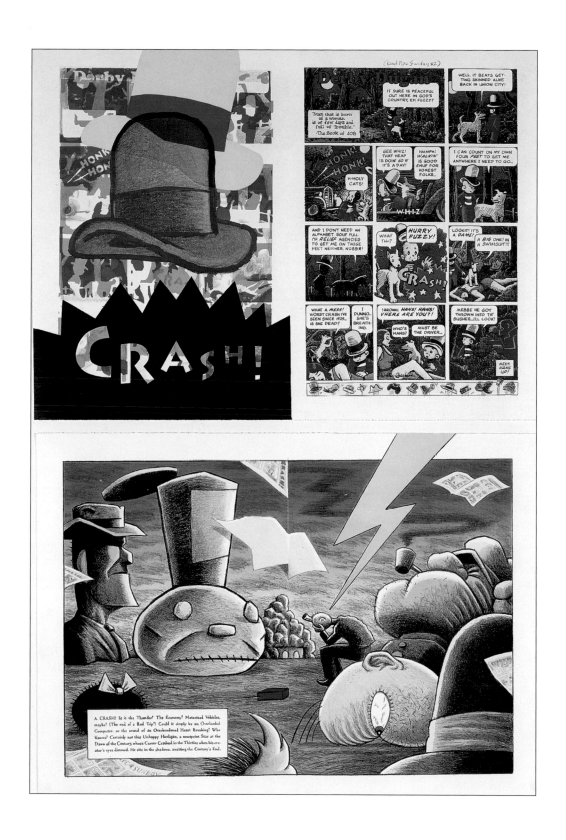

Art Spiegelman, *Lead Pipe Sunday #2*. Two-sided lithograph (1997) 21 × 33.

Photograph courtesy of Tandem Press.

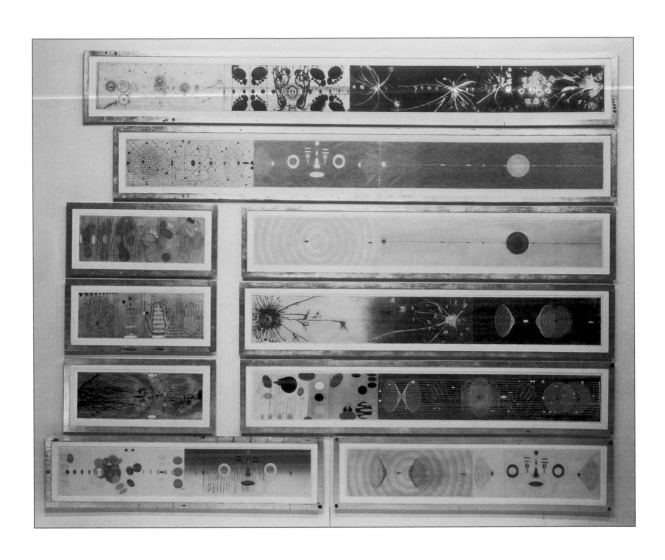

Judy Pfaff: *The Planet on the Table* (etching [1996] 14¼ × 114⅝);

A *Considerable Speck* (etching [1996] 14¼ × 107½);

Ar-oo-mm (etching [1996] 14¼ × 80½);

Eavesdrop (etching [1996] 14¼ × 80½);

The Drum and the Dance (etching and lithograph [1996] 14½ × 80½);

Croon (etching [1996] 14¼ × 54½);

Kaia (etching and lithograph [1996] 10 × 27¼);

Hand in Hand (etching and lithograph [1996] 10 × 27¼);

Eye to Eye (etching and lithograph [1996] 10 × 27¼);

Rattattoo (etching and lithograph [1996] 14 × 54½).

Photograph courtesy of Tandem Press.

EPILOGUE

WARRINGTON COLESCOTT

Bits and pieces from forty-five years of work as printmakers and associates in a research university are accumulated in this account, like debris from a smashed kaleidoscope. This is a print department that began at roughly the same time contemporary printmaking made its leaps from Europe to America, when Hayter moved his Atelier 17 workshop from Paris to Greenwich Village. Hayter's missionary zeal achieved a transference of enthusiasm for intaglio printmaking from a few specialists to a broad American public. After a year with Hayter, a young Argentine named Lasansky was hired out of that workshop to develop a program in intaglio printmaking at the University of Iowa. In Madison, in 1945, Alfred Sessler was hired to open a print class. He did not come from Hayter or from Paris. He came from Milwaukee and had been trained there.

It was a beginning. Prints and printmaking were growing more popular. At Madison, a faculty was gathering, a few at a time, as the demand grew. This young staff, all artists, had some experience in making prints of one kind or another and were personally involved with print production. They had no problem translating their studio work in painting or sculpture into the more elaborate, process-driven printmaking. They liked the challenge of process. As it turned out, they would all become artists of consequence. The post-Hayter print boom featured intaglio prints. The prints from Wisconsin reflected a wider faculty interest in other print media: silk-screen, lithography, relief printing, as well as etching. By 1950, there were courses in all these processes; by 1964, each course was taught by a specific professor hired to teach that medium.

In the early 1960s, collaborative work between artists and printers at the Tamarind Lithography Workshop in Los Angeles increased interest in lithography, and Tamarind's program of training lithographic printers would effectively create a new publishing industry. Tamarind's focus, however, was confined to a single method of printmaking: lithography. The other high-profile print center, the University of Iowa Print Group, remained devoted to intaglio. Between these specialist extremes, an aesthetic vacuum was perceived, and Madison filled the vacuum.

Having established its terrain, Madison began to attract kindred spirits: the unorthodox, the experimental, and the adventuresome. Madison's emphasis on research has resulted in printmaking that has kept the graphic area in the forefront of the national print renaissance, which reached its apex in the eighties. Tandem Press, with its focus on collaborative work, is now a ten-year-old resource, tried and tested, offering students invaluable practical experience. Throughout the graphics area, computer art and digital technology are being explored, aided by substantial investment in new equipment. These emphases have buttressed Wisconsin's position as a center of contemporary print activity.

Like moths, printmakers have a way of metamorphosing. A brilliant etching student of twenty years ago contacted me recently and asked to borrow my etching studio for a week. In the intervening years, she had become a director of documentary and independent films, familiar through showings on PBS. She was making a film about a woman printmaker who, after a period in Italy, came home to the Midwest and worked in her etching studio until her Italian lover convinced her to return to Rome. For a week I watched, enthralled, as the film crew took over and the director manipulated her actors, enmeshing them in my equipment, my process, explaining fine points of process to the actors, positioning them with the machines and the chemicals, and talking them through the intricate work actions. She showed her pretty leading lady how to stand over a tank of acid, brushing the gas bubbles from the copper plate with a turkey feather. In a like manner, she maneuvered her lighting tripods, positioned the sound mikes, ran actors in and out to make-up and script rehearsals, and manhandled the cameras. She had mastered the film process, the most elaborate and demanding of collaborations, and not only had retained her twenty-year-old knowledge of etching process, but also with a smooth dexterity had meshed my process with hers. Well, I thought as the vans roared off, here is an example of the value of broad-based training in complex creative process. Which is what we have tried to do all these years.

NOTES

INDEX

NOTES

1. Arthur Hove, "Warrington Colescott: Biting the Hand," *DepARTment Newsletter* (1994), a publication of the art department, University of Wisconsin–Madison.

2. Warrington Colescott, "The Artist's Statement: Warrington Colescott—Printmaker," *Wisconsin Alumnus* 68, no. 3 (December 1966): 10–11.

3. James Watrous, *A Century of American Printmaking, 1880–1980* (Madison: University of Wisconsin Press, 1984), p. 161. For additional commentary on this general topic, see also David Acton, *A Spectrum of Innovation: Color in American Printmaking, 1890– 1960*, with contributions by Clinton Adams and Karen F. Beall (New York: W. W. Norton & Company, Inc., 1990), p. 20 and *passim*; Judith Goldman, *American Prints: Process and Proofs* (New York: Whitney Museum of American Art, 1981), p. 53; the Museum of Modern Art, *Tamarind, Homage to Lithography*, preface by William S. Lieberman and introduction by Virginia Allen (Greenwich, Conn.: New York Graphic Society, Ltd., 1969), p. 8; Karen F. Beall, "The American Printmaker Comes of Age," in *Graphic Excursions—American Prints in Black and White, 1900–1950: Selections from the Collection of Reba and Dave Williams* (Boston: American Federation of Arts in association with David R. Godine, Inc., 1991), p. 14; and Warrington Colescott, "Wisconsin Prints and Printmakers," and Warren Moon, "Some UW–Madison Painters and Printmakers," *Wisconsin Academy Review* (March 1983): 6–9, 20–26.

4. "Bringing Life to Canvas: John Steuart Curry and the Rural Art Program," *The Art of Rural Wisconsin, 1936– 60*, exhibition catalog (Madison: College of Agricultural and Life Sciences, University of Wisconsin–Madison, 1985), pp. 6–9; Lucy Mathiak, "The Wisconsin Years of John Steuart Curry," *Wisconsin Academy Review* (June 1985): 53–56; and Patricia Junker, *John Steuart Curry: Inventing the Middle West* (New York: Hudson Hills Press, 1998). See also John W. Jenkins, *A Centennial History: A History of the College of Agricultural and Life Sciences at the University of Wisconsin–Madison* (Madison: College of Agricultural and Life Sciences, University of Wisconsin–Madison, 1991), pp. 112–113, 129–130; and E. David Cronon and John W. Jenkins, *The University of Wisconsin, A History, 1925–1945. Vol. 3: Politics, Depression, and War* (Madison: University of Wisconsin Press, 1994), p. 270 and *passim*.

5. Beginning in the late 1920s, the university encouraged the development of the visual arts in other ways. The primary leader in this regard was Porter Butts, director of the Memorial Union from 1928 to 1968. An art historian, Butts is the author of *Art in Wisconsin: The Art Experience of the Middle West Frontier* (Madison: Madison Art Association, 1936). When the Memorial Union opened in 1928, its facilities included a modest-sized art gallery, which served as the principal public art gallery in Madison for many years.

The Wisconsin Salon of Art was initiated in the fall of 1934 by the Memorial Union to promote "a finer relationship between the University and the citizens of Wisconsin" and "to secure as thorough a grouping as possible of the original creative work being accomplished in the State." The salon grew in importance as a major showcase for Wisconsin artists until it was discontinued in the mid-1960s. Meanwhile, the Union continues as the primary venue for the annual Student Art Show. A significant byproduct of the decades of gallery activity is the Wisconsin Union Art Collection, which has been described as "one of the largest collections of original Wisconsin art in the state."

For further information see Jody Schmitz, *A Reflection of Time: The Wisconsin Union Art Collection* (Madison: Wisconsin Union, University of Wisconsin–Madison, 1985); and James Watrous, *A Century of Capricious Collecting, 1877–1970: From the Gallery in Science Hall to the Elvehjem Museum of Art* (Madison: Regents of the University of Wisconsin System, 1987).

PRINTMAKING AT WISCONSIN: AN ERA OF EXCELLENCE

1. Elizabeth Robbins Pennell, *The Life and Letters of Joseph Pennell*, 2 vols. (Boston: Little, Brown, and Company, 1929), p. 277.

2. Jacob Kainen, "The Graphic Arts Division of the WPA Federal Art Project," in Francis V. O'Connor, ed., *The New Deal Art Projects: An Anthology of Memoirs* (Washington, D.C.: Smithsonian Institution, 1972), p. 175.

3. William Friedman, ed., *A New Direction in Intaglio: The Work of Mauricio Lasansky and His Students*, exhibition catalog (Minneapolis: Walker Art Center, 1949).

4. Warrington Colescott, "Alfred Sessler: A Memoir," in Patricia Powell, ed., *The Prints of Alfred Sessler from 1935 to 1963*, exhibition catalog (Madison: Wisconsin Academy of Sciences, Arts and Letters, 1988), p. 6.

5. Dore Ashton, in *Art Digest* 28, no. 14 (15 April 1954): 29.

6. James Watrous, "Colescott the Satirist," in *Warrington Colescott: A Retrospective Exhibition*, exhibition catalog (Vermilion, S. Dak.: University of South Dakota, 1991).

7. James Watrous, *A Century of Capricious Collecting, 1877–1970: From the Gallery in Science Hall to the Elvehjem Museum of Art* (Madison: Regents of the University of Wisconsin System, 1987).

8. Andrew Stevens, in Patricia Powell, ed., *Tandem Press: Five Years of Collaboration and Experimentation*, exhibition catalog (Madison: Elvehjem Museum of Art, 1994).

POSTWAR PRINTS: A MEMOIR FROM A PLAYER

1. Dos Santos became instructor of etching at the Slade School of Art when Gross retired. Today, retired himself, he maintains studios in Portugal and London and is considered Portugal's major printmaker. See José Sommer Ribeiro, ed., *Bartolomeu Cid Dos Santos: Exposição Retrospectiva*, exhibition catalog (Lisbon: Fundação Calouste Gulbenkian/Centro de Arte Moderno, 1989).

2. The Courtauld Institute is the art history department of University College London, of which the Slade School of Art is the studio art department.

3. Harvey K. Littleton has been described by Lee Nordness as the "virtual leader of the renaissance of creative free-form glass in the U.S." and by Paul J. Smith and Edward Lucie-Smith as "the founder of the studio glass movement." Littleton's efforts to transform glass from its primarily commercial use into an artistic medium took place during the time he served as a member of the University of Wisconsin faculty from 1951 to 1977. See Lee Nordness, *Objects: USA* (New York: Viking Press, 1970); Paul J. Smith and Edward Lucie-Smith, *Craft Today: Poetry of the Physical* (New York: American Craft Museum/Weidenfeld & Nicolson, 1986); Harvey K. Littleton, *Glassblowing: A Search for Form* (New York: Van Nostrand Reinhold, 1971); Joan Falconer Byrd essay, in Kelly Morris, ed., *Harvey K. Littleton: A Retrospective Exhibition*, exhibition catalog (Atlanta: High Museum of Art, 1984); and *Vitreographs: Collaborative Works from the Littleton Studio*, exhibition catalog (Gainesville, Fla.: University Gallery, University of Florida, 1992).

4. See Jane Kessler, ed., *Luminous Impressions: Prints from Plate Glass*, exhibition catalog (Charlotte, N.C.: Mint Museum, 1987). I described the incident myself in an article, "Littleton Prints from Glass," *Craft Horizons* 35 (June 1975): 28–29.

GALLERIA
Alfred Sessler: Ethos and Ethics

1. John Kienitz, preface in *Two Man Show: Joseph Bradley/Alfred Sessler* (Madison: Wisconsin Union Gallery, 1948).

2. Karen Sessler Stein interviews by author, September 13 and 19, 1995, tape index #493, Oral History Project, Division of University Archives, University of Wisconsin–Madison.

3. Karen Sessler Stein interviews.

4. See *Arts in Society* 3, no. 1 (1964): 88–89, 90, 91, 92 for statements by Robert Baxter, Nancy Eckholm Burkert, Robert Burkert, Otto Rogers, Carol Scheffleger, and David Ecker, all professional artists who had studied with Sessler.

5. Donald H. Karshan, *Picasso Linocuts, 1958–1963* (New York: Tudor Publishing Co., 1968), pp. x–xi.

6. Professor Sylvia Solochek Walters, letter to Warrington Colescott, September 2, 1996.

7. Patricia Powell, ed., *The Prints of Alfred Sessler from 1935 to 1963*, exhibition catalog (Madison: Wisconsin Academy of Sciences, Arts and Letters 1988).

8. Ibid.

9. Christopher Cordes, ed., *Bruce Nauman Prints, 1970–89*, catalogue raisonne (New York: Castelli Graphics/Lorence-Monk Galleries, 1989), chronology.

10. Nauman to Joan Simon, "Breaking the Silence: An Interview with Bruce Nauman," in *Art in America* 76, no. 9 (September 1988): 143. For further insight on this topic, see Robert Burkert, "F.D.R., WPA, and Wisconsin Art of the Depression," in Ralph M. Aderman, ed., *The Quest for Social Justice: The Morris Fromkin Memorial Lectures, 1970–1980* (Madison: University of Wisconsin Press, 1983); *Wisconsin's New Deal Art*, exhibition catalog (Wausau, Wisc.: Leigh Yawkey Woodson Art Museum, 1980); and Karal Ann Marling, *Wall-to-Wall America: A Cultural History of Post-Office Murals in the Great Depression* (Minneapolis: University of Minnesota Press, 1982).

11. Theodore F. Wolff, "He Loved and Painted Human Life," *Christian Science Monitor*, October 20, 1978, p. 28.

12. Sylvia Solochek Walters, letter to Warrington Colescott, September 2, 1996.

13. Karen Sessler Stein interviews. Santos Zingale interviews, 1992, tape index #428, Oral History Project, Division of University Archives, University of Wisconsin–Madison.

Dean Meeker: Art as Process

1. Unless otherwise indicated, all quotes by Dean Meeker are edited versions taken from transcriptions of taped informal conversations held on September 9 and October 14, 1994, at his studio in the rolling hills west of Springfield Corners, Dane County, Wisconsin. Present at the interviews were Meeker, Warrington Colescott, Arthur Hove, and Barry Teicher. The tapes, index #469, are included in the files of the Oral History Project, Division of University Archives, University of Wisconsin–Madison.

2. Sir Alfred D. Fripp and Ralph Thompson, *Human Anatomy for Art Students* (London: Seeley, Service & Co., 1923).

3. Actually, Fowlkes liked artists and the art department, according to Meeker and others. He did so not out of any great love for the arts, but out of the more pragmatic realization that art students would help beef up enrollments in the School of Education and thereby give the dean leverage in budget negotiations.

4. For additional comments on this, see David Acton, *A Spectrum of Innovation: Color in American Printmaking, 1890–1960* (New York: W. W. Norton & Company, Inc., 1990), p. 44; James Watrous, *A Century of American Printmaking, 1880–1980* (Madison: University of Wisconsin Press, 1984), p. 167; and John Ross, Clare Romano, and Tim Ross, *The Complete Printmaker: Techniques / Traditions / Innovations*, Revised and Expanded Edition (New York: Free Press, 1990), p. 133.

5. Research grants from the University of Wisconsin–Madison are awarded annually on a competitive basis. Proposals are evaluated by the Research Committee, a cross-campus faculty committee. Funds are provided by the Wisconsin Alumni Research Foundation (WARF) in response to an annual request from the dean of the Graduate School. The funds come from earnings on investments, licensing, and other interests. WARF was established in 1925 in response to an offer from Professor Harry Steenbock to turn over patent rights from his discoveries of the medical benefits of Vitamin D to help support university research. The first WARF grant was awarded during the 1928–29 academic year. See *The Wisconsin Alumni Research Foundation Story* (Madison: Wisconsin Alumni Research Foundation, 1990), and E. David Cronon and John W. Jenkins, *The University of Wisconsin, A History, 1925–1945*. Vol. 3: *Politics, Depression, and War* (Madison: University of Wisconsin Press, 1994), pp. 68–70 and *passim*.

6. Stanley William Hayter comments on this development in his book, *New Ways of Gravure*, Revised Edition (London: Oxford University Press, 1966). A simplified explanation can be found in Jacob Kainen, "Stanley William Hayter: An Introduction," in Peter Black and Desiree Moorhead, *The Prints of Stanley William Hayter: A Complete Catalogue* (Mount Kisco, N.Y.: Moyer Bell Limited, 1992), p. 16.

The two principal figures working with Hayter most responsible for developing and utilizing viscosity printing techniques were Kaiko Moti and Krishna Reddy. See Joann Moser, *Atelier 17: A 50th Anniversary Retrospective Exhibition*, exhibition catalog (Madison: Elvehjem Art Center, 1977), pp. 36–39. Hayter, Moti, and Reddy all spent time working with the art department as visiting faculty.

7. See essay in *Dean Meeker: Sculpture*, exhibition catalog (Washington, D.C.: Jane Haslem Gallery, 1973).

8. Quoted in Una E. Johnson, *American Prints and Printmakers* (Garden City, N.Y.: Doubleday & Company, Inc., 1980), p. 200.

Warrington Colescott: Narrative Marks

1. The structure of this piece and the artist's commentaries are based on two tape-recorded interviews conducted by Hove and Teicher—one on January 27, 1995, at the University of Wisconsin Armory, and the other at Colescott's studio on his farm near Hollandale, Wisconsin, on August 19, 1995—Tape index #483, Oral History Project, Division of University Archives, University of Wisconsin–Madison.

2. Roberta MacDonald was editor of the *California Pelican* in the spring of 1941. She had sold cartoons to the *New Yorker* while still a student and joined their staff upon graduation. Bernard Taper was *Pelican* editor for the fall semester in 1938 and has contributed articles on music and musicians to the *New Yorker*.

3. Marguerite Higgins, war correspondent for the *New York Herald Tribune* during World War II.

4. See *California Pelican*, vol. XLVII (1941) and vols. XLVIII and XLIX (1942).

5. See *Five Painters*, exhibition brochure (San Francisco: San Francisco Museum of Art, 1948).

6. Sylvan Cole was director of the Associated American Artists Gallery, a leading gallery among New York print galleries until its sale in the 1980s. He is now owner of Sylvan Cole Gallery, 101 W. 57th St. in New York.

Raymond Gloeckler: No Place to Hide

1. The interviews with Raymond Gloeckler were conducted in two separate sessions, August 19 and August 26, 1994, in Room 201 of the Armory at the University of Wisconsin–Madison. Those present on both occasions were Gloeckler, Warrington Colescott, Arthur Hove, and Barry Teicher. Raymond Gloeckler interviews, tape index #468, Oral History Project, Division of University Archives, University of Wisconsin–Madison. Additional quotes are taken from a lecture Gloecker gave in conjunction with the opening of the exhibition "Raymond Gloeckler: A Retrospective," De Ricci Gallery, Edgewood College, Madison, Wisconsin, March 5, 1995.

2. School systems wanted to attract males to elementary teaching, traditionally a woman's field. As a result, Gloeckler was paid an additional $300 on top of his base salary for being male and the head of a household, making his total compensation $3,000.

3. Gloecker's lack of enthusiasm for travel is a trait he shared with Alfred Sessler. See *Arts in Society* 3, no. 1 (1964): 85.

4. The use of the football analogy here is personal and appropriate. Even though he is slight in build by contemporary standards, Gloeckler played football in high school and was considered a strapping tackle at the university. He played for two years as a member of the University of Wisconsin's 150-pound-class football team that shared the Big Ten championship with Michigan in 1947 and 1948. He was named the team's most valuable player in 1948.

Jack Damer: Upping the Ante

1. The interviews with Jack Damer were conducted on December 7, 1994, in Room 201 of the Armory at the University of Wisconsin, and on December 21, 1994, in Damer's studio in Room 7549 of the Humanities Building. Those present on both occasions were Damer, Warrington Colescott, Arthur Hove, and Barry Teicher. Jack Damer interviews, tape index #473, Oral History Project, Division of University Archives, University of Wisconsin–Madison.

2. The Tamarind Lithography Workshop was an experimental lithographic workshop founded in Los Angeles in 1960 by June Wayne. It was later relocated to the University of New Mexico. For a complete discussion of its contributions to American printmaking, see Garo Z. Antreasian, *The Tamarind Book of Lithography: Art & Techniques* (Los Angeles: Tamarind Lithography Workshop Inc., 1971); and the Museum of Modern Art, *Tamarind: Homage to Lithography*, preface by William S. Lieberman and introduction by Virginia Allen (Greenwich, Conn.: New York Graphic Society Ltd., 1969). Also see *Tamarind 25th Anniversary Exhibition: October 8–November 2, 1985* (New York: Associated American Artists, 1985); *Tamarind Technical Papers/Tamarind Institute* (Albuquerque: Tamarind Institute, 1974–78); and *The Tamarind Papers: TTP* (Albuquerque: Tamarind Institute, 1978–).

Walter Hamady: Virtuoso Explorations

1. Francis O. Mattison, "The Perishable Press at Twenty," in *American Book Collector* 6, no. 5 (September–October 1985): 36. See also Mary Lydon, "The Book as the Trojan Horse of Art: Walter Hamady: The Perishable Press Limited and Gabberjabbs 1–6," *Visible Language* 25, no. 2/3 (1991); and Buzz Spector, "Biblioself-consciousness: Walter Hamady's Gabberjabbs," in *Walter Hamady: Handmade Books, Collages and Sculptures*, exhibition catalog (Racine, Wisc.: Charles A. Wustum Museum of Fine Arts, 1991). The latter essay is reprinted in Spector's *The Book Maker's Desire: Writings on the Art of the Book* (Pasadena, Calif.: Umbrella Editions, 1995).

2. As Gerald Lange has observed, "It was in the late fifties and sixties that several Americans began to experiment in the typographic book form with the sensibility of the contemporary artists. Two of these were Claire Van Vliet and Walter Hamady. . . . [Y]oung Hamady astounded and infuriated the conservative private press world with his typographic shenanigans and artistic stance. In responding to the reference of modern art and approaching the private press on their own terms, these bookmakers set precedent. For the 'book as art,' they have probably had more of a seminal influence on the current direction of fine bookmaking than any other contemporary bookmakers." ("From Where to Where? Some Abbreviated Suspicions Concerning Postwar Book Arts Movements," *Bookways* 15 & 16 [Summer 1995]: 62).

The broad field of artist's books (*livres d'artiste*), book arts, fine printing, and related topics has produced a lively, if sometimes incestuous, discourse. Examples can be found in the journal *Fine Print* (1975–1990) and its successor *Bookways* (1991–1995). Monographs that offer various perspectives and information include Joan Lyons, ed., *Artists' Books: A Critical Anthology and Sourcebook* (Rochester, N.Y.: Visual Studies Workshop Press, 1985); Harry Duncan, *Doors of Perception: Essays in Book Typography* (Austin, Tex.: W. Thomas Taylor, 1987); Riva Castleman, *A Century of Artists' Books* (New York: Harry N. Abrams, 1994); Johanna Drucker, *The Century of Artists' Books* (New York: Granary Books, 1995); and Buzz Spector, *The Book Maker's Desire: Writings on the Art of the Book* (Pasadena, Calif.: Umbrella Editions, 1995). Exhibition catalogs that offer further overviews include *Why Artists' Books?* (Cambridge; Mass.: Department of Printing and Graphic Arts, Harvard University, 1993); *The Art of the Book and the Book Arts Press* (Upper Arlington, Ohio: Upper Arlington Cultural Arts Commission, 1994); essay by Betty Bright, in *A Kelmscott Centennial: William Morris and His Heirs—Leonard Baskin, Claire Van Vliet, and Victor Hammer* (Minneapolis: Minnesota Center for the Book Arts, 1991); essay by Betty Bright, in *Completing the Circle: Artists' Books on the Environment* (Minneapolis: Minnesota Center for the Book Arts, 1992); *Keepers of Secrets and Truths Otherwise Unknown*, (Collegeville, Pa.: Philip and Muriel Berman Museum of Art, Ursinus College, 1994); essay by Johanna Drucker, in *Luminous Volumes: Granary's New Vision of the Book* (New York: Granary Books, 1993); *Books as Objects*, introduction by Thomas A. Vogler (Portland, Oreg.: Comus Gallery, 1993); *The Packwood Diaries: Artists' Books and Graphic Arts*, introduction by Thomas A. Vogler (Portland, Oreg.: Comus Gallery, 1994); and *Dressing the Text: The Fine Press Artists' Book* (Santa Cruz, Calif.: Art Museum of Santa Cruz County, 1995). See also "The Poet as Printer: William Everson and the Fine Press Artists' Book," *Quarry West* 32 (fall 1995). Hamady and his students added to the literature with the catalog for an exhibition they organized and presented entitled *Breaking the Bindings: American Book Art Now* (Madison: Elvehjem Museum of Art, 1983).

3. The interviews with Hamady were conducted by Colescott, Hove, and Teicher on December 20, 1995, at the Armory, and on January 31, 1996, at Hamady's farm. Quotes from other sources are cited in the appropriate endnote. Walter Hamady interviews, tape index #496, Oral History Project, Division of University Archives, University of Wisconsin–Madison.

4. The name of the press, as Hamady indicates in the colophon for his first book, *The Disillusioned Solipsist* (Detroit, Mich.: Perishable Press Limited, 1964), "reflects the human condition which is both perishable and limited." See *Two Decades of Hamady and the Perishable Press Limited* (Mount Horeb, Wisc.: Perishable Press Limited, 1984).

5. See Harry Duncan, *Doors of Perception: Essays in Book Typography* (Austin, Tex.: W. Thomas Taylor, 1983), pp. 5–18.

6. See the references to Hamady in the chapter "Some Visitors, Some Alumni" in this volume and the Damer interviews, tape index #473, Oral History Project, Division of University Archives, University of Wisconsin–Madison, *passim*.

7. "We are collages of our own gene pools." Lecture presented to the Friends of the University of Wisconsin–Madison Libraries, October 19, 1994.

8. In his taped interviews, Hamady explains, "Part of our program in graphics was that everybody had to make paper, once. You had to tear up rags, go through the procedures, and make a sheet of paper. [His instructor Larry Barker] didn't feel you could rightfully call yourself a printmaker or really comprehend what the hell you were doing with printmaking unless you knew how paper was put together."

9. The Shadwell name comes from the birthplace of Thomas Jefferson, one of Hamady's idols. *Hand Papermaking*, published in 1982, is book 102 from the Perishable Press. Timothy Barrett, in a review that appeared in the July 1983 issue of *Fine Print*, remarked, "It is no surprise to me that Hamady, through his students, has inspired much of the best work being done by new small presses in America." For background on Wilfer, see the Weege profile; Sue Gosin is the founder and co-owner of the Dieu Donné Papermill in New York.

10. This quote and a wide range of comments from Hamady's former students about his teaching style are found in *6451: Made in the Midwest: Walter Hamady's 6451 Students. The Development of a Midwest Center for the Book Arts* (Racine, Wisc.: Charles A. Wustum Museum of Fine Arts, 1993). For further evidence of his influence, see Janice T. Paine, "Wisconsin Book Artists: Reading the Fine Print," *American Craft* (April/May 1996): 54–61.

William Weege: Tools, Technology, and Art

1. See the artist's statement (p. 64) in the exhibition catalog for "University of Wisconsin–Madison, Department of Art Faculty Exhibition, December 9, 1994–February 12, 1995," Elvehjem Museum of Art. Unless otherwise indicated, the quotations in this profile are adapted from the William Weege interviews, conducted by the authors on September 20 and 27, 1995, tape index #494, Oral History Project, Division of University Archives, University of Wisconsin–Madison.

2. Throughout his career at Wisconsin, Donald Anderson (1915–1995) taught courses in watercolor, lettering, and graphic design. He also published two widely used textbooks. His *Elements of Design* (New York: Holt, Rinehart and Winston, 1961) was one of the first texts of its kind and sold more than 85,000 copies. It was followed by *The Art of Written Forms* (New York: Holt, Rinehart and Winston, 1969). In addition, he contributed a major essay on calligraphy to the *Encyclopedia Britannica*, 15th ed., and collaborated on two limited-edition books: Giovan Francesco Cresci's *A Renaissance Alphabet: Il Perfetto Scrittore, Parte Seconda* (Madison: University of Wisconsin Press, 1971); and *The Trajan Letters, de Caratteri di Leopardo Antonozzi, Libro Primo* (Madison: Meles Vulgaris Press, 1972). These two books received national awards as did his *Have Wrench/Will Monkey* (Madison: Meles Vulgaris Press, 1975), a whimsical book with illustrations of tools in various positions.

3. Georges and Rosamond Bernier, ed., *The Selective Eye: An Anthology of the Best from L'Oeil, the European Art Magazine* (New York: Random House, 1955–1957).

4. The most popular poster was one advertising an anti-military ball. Traditionally, a winter dance would be sponsored by the ROTC units on campus. Morris Edelson, a candidate for a Ph.D. in English, organized an alternative event as a protest against what he and others saw as a flaunting of a militaristic posture. Edelson was more widely known beyond the campus as the editor and publisher of the literary magazine *Quixote*.

5. See David Acton, *Jones Road Print Shop and Stable, 1971–1981: A Catalogue Raisonne* (Madison: Madison Art Center, 1983), pp. 13–14.

6. Ibid.; see also Michael Bonesteel, "Stars over Barneveld," *New Art Examiner* (January 1977): 16.

7. Acton, *Jones Road Print Shop and Stable, 1971–1981: A Catalogue Raisonne* (Madison: Madison Art Center, 1983).

8. See John Loring, "American Prints from Fuses to Fizzles," *Art in America* (January/February 1977): 32.

9. The development and subsequent evolution of Tandem Press is covered in the chapter that begins on p. 187 of this volume.

10. Gregory Conniff, "Il Tempo Veloce di Bill Weege," *Carte d'Arte*, no. 1 (1992): 12.

Frances Myers: Keep Your Bags Packed

1. Quotes by Frances Myers are based on interviews with Hove and Colescott recorded by Teicher at her studio in rural Hollandale, Wisconsin. Frances Myers interviews, June 4 and 12, 1996, tape index #500. Oral History Project, Division of University Archives, University of Wisconsin–Madison.

2. Jay DeFeo (1929–1989), a San Francisco painter whose excruciatingly detailed painting *The Rose* became famous as a visual symbol of the mystic sources of the Beat artists' concepts. See "In the Heat of the Rose," *Art in America* (March 1966).

3. Bruce Conner (1930–), San Francisco artist. His Batman Gallery was a noted center for Beat art activities. See Jack Foley, *Oh Her Blackness Sparkles! The Life and Times of the Batman Art Gallery, San Francisco 1960–65* (San Francisco: 3300 Press, 1995).

4. Excerpted from the essay by Suzanna L. Brown and Nicholas Parrie, *Visual Sonatas: Black and White*, exhibition catalog (Dallas: Aion Fine Art Gallery, 1987).

5. Essay by Greg Conniff, *Figurative Graphics, Graphic Figuration: 7 American Artists*, exhibition catalog (Cologne: BBK Gallery and Amerikahaus Gallery, 1991).

6. From Tim Porges's essay "The Art of Frances Myers," *Wisconsin Academy Review* 43, no. 2 (Spring 1997).

David Becker: A Singularity of Vision

1. Michael Welzenbach, *Washington Post*, April 28, 1990, p. C2.

2. See Hilton Als, "Wagstaff's Eye," *New Yorker* (January 13, 1997): 36–43.

3. Becker's psychiatrist was interested in his work to the point where he traded therapy for prints. Becker, in his taped interviews, looked back fondly on the experience: "I enjoyed it because I found there's nobody else you can blab to. Who else is going to listen to you like that?" David Becker interviews by authors, September 18 and October 14, 1996, tape index #501, Oral History Project, Division of University Archives, University Wisconsin–Madison.

4. Statement is in *Views 86: The Art Faculty*, exhibition catalog (Madison: Elvehjem Museum of Art, 1986).

Some Visitors, Some Alumni

1. Material on Misch Kohn's 1957 visit came from three interviews by Colescott: with Misch Kohn in Hayward, California, on August 14, 1996; with Dean Meeker in Mt. Horeb, Wisconsin, on September 15, 1996; and with Frances Myers at Mantegna Press, Hollandale, Wisconsin, on December 5, 1996.

2. Colescott interview with Misch Kohn in Hayward, California, August 14, 1996.

3. Ibid.

4. Colescott letter to Claire Van Vliet, October 25, 1997.

5. Letter from Claire Van Vliet to Warrington Colescott, November 20, 1997, detailing her impressions of her 1965 experience at the University of Wisconsin–Madison.

6. Ibid.

7. Hayter to Moti, quoted by Dean Meeker in interview with Colescott, see note 1.

8. Stanley William Hayter, *About Prints* (London: Oxford University Press, 1962). Meeker's serigraph print *Trojan Horse* (1958) is illustrated (pl. 42) but mislabeled as *Crowd*.

9. Stanley William Hayter, *New Ways of Gravure*, Revised Edition (London: Oxford University Press, 1966), p. 150, contains a detailed methodology of "simultaneous inking," including diagrams ("schema").

10. Anthony Gross, *Etching, Engraving and Intaglio Printing* (London: Oxford University Press, 1970). Gross mentions that "Brigit Skiold, in founding the Charlotte St. Workshop has encouraged artists in England and from abroad to make prints." He also mentions Colescott ("invented a modern mythology") and Meeker ("witty silk-screen prints") in a short list of American printmakers.

11. Robert McG. Thomas, Jr., "Ossie Clark, 54, Icon of 60s: British Designer Defined Mod," *New York Times*, August 12, 1996.

12. See Joseph Ruzicka, *Landfall Press: Twenty-five Years of Printmaking* (Milwaukee: Milwaukee Art Museum, 1996), pp. 182–87.

13. Paul Schimmel, *Bruce Nauman*, exhibition guide, (Los Angeles Museum of Contemporary Art, 1994). See also Neal Benezra essay, in Joan Simon, ed., *Bruce Nauman*, exhibition catalog (Minneapolis: Walker Art Center, 1994); and interview with Christopher Cordes, in Christopher Cordes, ed., *Bruce Nauman Prints, 1970–89*, catalogue raisonne (New York: Castelli Graphics/Lorence-Monk Galleries, 1989), pp. 25, 131.

14. Warrington Colescott interviews, January 27 and August 10, 1995, tape index #483, Oral History Project, Division of University Archives, University of Wisconsin–Madison.

15. Trudy Hansen et al., *Printmaking in America: Collaborative Prints and Presses, 1960–1990* (New York: H. N. Abrams in association with Mary and Leigh Block Gallery, Northwestern University, 1995), p. 48.

16. *Coagula* (Sept. 5, 1993).

17. *Collaborations in Paper and Printmaking: The Joe Wilfer Show*, exhibition catalog (Plattsburgh, N.Y.: Plattsburgh Art Museum, State University of New York, 1998), contains a good biographical listing and an essay by Jennifer Bernstein, which is the most thorough essay to date on this important print figure. Also note observations by co-curators Ruth Lingen and Diane Fine in the same catalog, p. 3.

18. "How the Mill Began," *Pulp*, no. 21 (Sept.–Nov. 1996): 1. This publication is a newsletter of the Dieu Donné Papermill.

TANDEM PRESS: THE UNIVERSITY AS PRINT PUBLISHER

1. The authors are indebted to Andrew Stevens, curator of prints, drawings, and photographs at the Elvehjem Museum of Art, for the major contribution of background material that he supplied for this chapter. For additional information, see his essay in Patricia Powell, ed., *Tandem Press: Five Years of Collaboration and Experimentation*, exhibition catalog (Madison: Elvehjem Museum of Art, 1994).

2. Dean of the School of Education at the time Tandem was established was John R. Palmer. Dean Henry Trueba followed, and the current dean is Charles Read. Associate Dean Henry Lufler has consistently represented the School of Education on the Tandem board since that board was established.

3. *Collaboration in Paper and Printmaking: The Joe Wilfer Show*, exhibition catalog (Plattsburgh, N.Y.: Plattsburgh Art Museum, State University of New York, 1998).

4. This reflection by Paula McCarthy Panczenko is derived from two recorded interviews made at Tandem Press on January 28, 1997, as she reviewed her experiences at Tandem with Colescott, Hove, and Teicher. Paula Panczenko interviews, tape index #303, Oral History Project, Division of University Archives, University of Wisconsin–Madison.